I MAKE MY OWN RULES

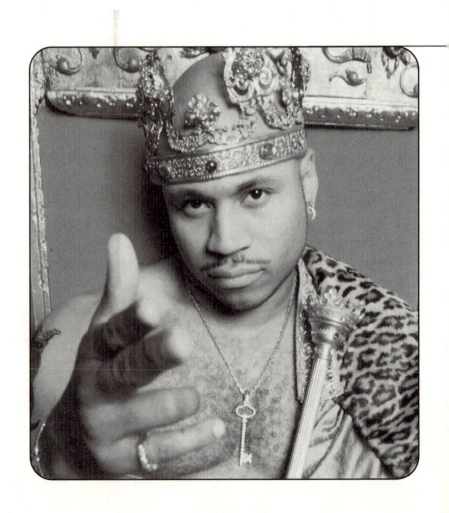

I MAKE MY OWN RULES

LL COOL J

with Karen Hunter

St. Martin's Press ⚹ New York

ILION
BOOKS

ISBN 0-312-17110-2
Book design by Gretchen Achilles

FIRST EDITION: SEPTEMBER 1997

10 9 8 7 6 5 4 3

To the youth of America, and
to everyone who has ever struggled or had hard times,
but knows that through hard work
and faith they can make it.

CONTENTS

INTRODUCTION

KNOW WHAT I'M SAYING

*It's our first time together and I'm feeling kinda horny
Conventional ways of making love kinda bore me . . .*

A sea of women line the stage, screaming. I'm standing close to the edge, just close enough to make them think they can touch me. Sweat is pouring off my naked chest and I'm feeling this moment. It's the Apollo Theater in Harlem, the second show of a one-night headliner there for me. I have been doing performances like this for about 14 years and it never gets tired. The look on those faces at the stage, the wild hysteria, and of course, the screams, keep me going. I grab a bottle of spring water, open it, and pour it over my head. And they really go wild. Show time.

Know what I'm saying?

On stage, I'm LL Cool J. Most people know me from my rap records and my weekly television show, *In the House.* I have six platinum albums, quite a few movies, and a pair of Grammies sitting on my grandmother's living room table. I've got clothing endorsements, a charity camp for kids, even a Coke commercial.

LL Cool J stands for Ladies Love Cool James, and besides the 2,000-plus baseball caps that I alternate from day to day, that's the me most people see.

But I'm a lot more than an entertainer who wears hats and rolls up his pants leg. I'm a father with three beautiful children. I'm a husband with a wonderful wife. I'm a healing victim of

abuse who has made many mistakes along the way. My real name is James Todd Smith, and in real life, I am a man.

From Hollis to Hollywood, but is it good?

I started writing this book for myself. As therapy, an emotional and spiritual cleansing. There were issues in my life that I had never really dealt with, pain that stayed hidden in seemingly unreachable parts of my mind. I had to dig deep into my psyche and find myself—find the pain, find the suffering, find the strength, find the weakness—so that I could grow up, become a man, and do right by my family.

This book became my means to keep it real with myself. To face the person I was becoming by dealing with the person that I once was. But as I started writing, opening old wounds, and seeing just how vulnerable I really was, I realized that this book is not just about me. This book is about thousands, no, millions, of people—young and old, black and white, Asian and Latino—who have experienced some of the same things I have. The pain, the suffering, the addiction.

I realized that my experiences, while powerful to me, were not so unique in the grand scheme of things. There are kids today going through the abuse that I experienced. Men and women today who feel insecure or are being ripped off and discriminated against. Parents today who are raising children who are in trouble. This book is for them, the less fortunate, those who weren't born with a silver spoon in their mouths but want their children to be born with one. This book is to let them know they are not alone.

This book is for racist people who look at other human beings as subhuman animals that exist for the sole purpose of being the labor force and refuse to see the connection. It's for children who feel unwanted. For young people who are confused and struggling to come to grips with the reality that they

face every day—violence, crime, murder, AIDS, teenage pregnancy, alcohol abuse, drugs.

This book is for the hip hop community, which for so long has been misunderstood. It's for rappers to see where they're at and where they can be. I also want people to gain a better understanding of rap and not look at it as one dimensional. Not all rappers are negative. Not all are criminals. Just because you see one young man being hustled into a police car, bent over in handcuffs and wearing baggy jeans and a baseball cap, that doesn't mean that everyone who looks remotely similar to him, or is culturally connected to him, deserves to be hustled into that police car too.

This book is for the downtrodden: the poor, the orphans, those who are incarcerated when they really should be educated. It's also for America's youth—one of our most valuable resources—but one that is not always fully explored.

This book is about being African American in the United States, which is a strange paradox. We're of African descent, but don't learn enough about what African is. And, because of certain racist sectors, we're not always 100 percent accepted as Americans. Our people have been force-fed an American culture and taught to hate themselves. But inside them African culture is brewing, because it's never been fully realized.

Have you ever seen a black kid get on an elevator, making music with his mouth, and the white people start looking at him like he's crazy, wondering why he can't keep still? He doesn't have a Walkman or a radio, he's just moving to a beat inside his soul. That's the same drum the slave owners tried to abolish back in the eighteenth century. It hasn't gone away, it's just been transformed. It's the same vibe.

Other groups in America—the Italians, the Jews, the Asians, the Irish—know where they come from and what their cultures are about. And it makes it easier for them to embrace America on their own terms. It's not an either/or situation.

Too many black people are struggling to fit an African key into an American lock. It just doesn't fit sometimes. We've got to learn to embrace our culture before we can be confident—and accepted—as Americans and make that key fit. Not all African history and culture is great—Africans participated in the slave trade. But a lot of it is great. And we have to be real about that too.

I have a constant reminder, a tattoo that stretches the length of my left calf. (I started rolling up that pants leg as a fashion move, but now I do it as a reminder to stay spiritually grounded.) The tattoo is seven symbols from Ghana and Côte d'Ivoire. And every day I look at them. They keep me grounded and remind me of where I come from, the essence of my existence. The top symbol stands for the presence of God and protection. The one under that one means bravery and fearlessness. The third one represents creativity, wisdom, and the complexities of life. There's a heart in the middle that's for love, goodwill, faith, and patience. The next one means parental discipline tempered with patience and kindness. The one below that means strength and humility. And the last one symbolizes faith and determination. These are attributes that I would advise any child, any person to try to attain.

This book has been hard for me to write. I know a few critics will try to take advantage of my honesty, which is probably why honesty and celebrity don't always go hand in hand. Even my advisors suggested that I leave certain things out. But I feel that if sacrificing my privacy can provide an example that will help others achieve their goals, it will be worth it.

So I'm writing this book for understanding. I write this book for inspiration—to show that not every child who's abused has to be a negative statistic. I write this book for anyone who thinks they can't make it, to show them they can.

Lastly, I write this book for my family. I want my children and my children's children to know that I did a lot of things,

some good, some bad. I wasn't perfect, but I tried to make a difference.

I was inspired by King Solomon, of the Old Testament. God asked him, ''What is it that you want, I'll give you anything you want.'' And Solomon replied, ''Wisdom.'' All he wanted was wisdom, the ability to discern right from wrong. And God ended up giving Solomon all of the wealth and riches of the world. No king was as rich before him and no king will be as rich after him.

At the same time, Solomon's weakness was women. Because of his weakness for women, he got turned around and began praying to the wrong gods, worshipping idols and losing everything. The lesson for me from that is that I really have to stay focused and remember what took place in order for me to be where I am today.

In other words, I have to always remember where I came from and keep my pact with God.

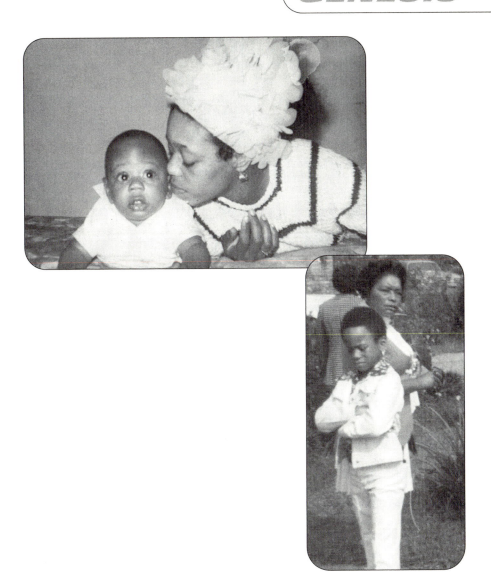

THE CRADLE

It took four hours of labor, sweating, and pacing. Four hours of straining, thinking, and writing. I put on the O'Jays and went to the bathroom. I put on a Grandmaster Flash 12-inch and lay down on the floor. I put on the Furious Five and looked out the window. I was in North Babylon, Long Island, in the living room of my mother's house, alone and making what turned out to be one of the biggest decisions of my life: whether or not to change my rap name from J-Ski to Cool J. Around this time it seemed like every other rapper had a *ski* on the end of his name. There was Luvbug Starski, Busy B-Starski, Mike-ski, and a whole bunch of assorted Skis. I wanted to be different.

J-Ski just wasn't getting it. But I was feeling Cool J. To me *cool* would never be played out. It seems like *cool* has been around since the beginning of time. Each generation uses cool, and it's still, well, cool. So after going through this long process, I gave birth to Cool J. I spent all night going through my school notebooks and a small suitcase full of scraps of paper that I had written raps on. Every place I had written J-Ski, I erased it and wrote, "Cool J." To me that was making it final, like getting married. I had made that kind of commitment to Cool J.

I couldn't wait to go chill up on Merrick Boulevard with my homeboys and try out my new tag. The first person I told about it was my man, Playboy Mikey D, who I used to write rhymes with. "I like that Cool J," he said, "but you need something in front of it. Something like Playboy. How about Ladies Love?"

I looked at him and started smiling. Yeah, Ladies Love Cool J. It was working. I kept letting it roll off my tongue. "Ladies Love Cool J, Ladies Love Cool J."

I liked the *feel* of it. I also thought it was a paradox, because the ladies were definitely *not* feeling me then. I was 14 and I was either a pain in the a** to girls or simply didn't exist. The ladies were hating J-Ski. But I figured if I turned it all around, maybe the ladies would love Cool J.

It took two days of labor and love, but in 1982 somewhere between Long Island and Queens, LL Cool J was born.

Physically, I came into being 14 years earlier, as James Todd Smith.

It was right around Christmas, 1967, at about two in the morning on a Saturday. The brand new Buick 225 was swerving down Pioneer Drive two blocks from the Southern State Parkway in Bayshore, Long Island. My father, James Smith, was driving. A chocolate brown man with thick muscles and coarse hair slicked back with Conkalene, he was cursing at my mother, Ondrea. They had been at a party, where he had accused her of flirting with another man. She *was* looking good that day, in a light green satin dress with a lace collar. Her dark hair hung off her shoulders, and her honey-colored face was made up to perfection.

It got so bad at the party that my mother actually picked up a pair of sewing scissors and tried to stab him. So they had to leave, but they fought on the way to the car and continued to battle as my father drove off.

"What the hell were you looking at him for?" he growled.

"Jimmy, what are you talking about? Stop talking crazy."

"Who you calling crazy?"

He started slapping her up, leaving more than one imprint of his hand on her face. She kept swearing at him, but by now

she was crying. He kept cursing at her, calling her all kinds of things, things a real man shouldn't call his wife.

The brown Buick began to swerve as it approached the off-ramp of the Southern State. When my mother opened the door, the car was going about 30 mph.

"I'm getting out of here," she said, hoping he would come to his senses.

"Well get out then," my father said, swinging at my mother again with one hand and trying to steer with the other. She ended up on the highway, cold, scraped up, and dirty in her new green dress. Oh, yeah—she was also nine months pregnant with me.

I was born at 8:46 P.M. January 14, 1968, at South Side Hospital in Bayshore. I weighed seven pounds, four ounces, and my right arm was paralyzed. Maybe it was from my mother rolling out of the car while she was pregnant. Maybe it was from the forceps the doctor used to pull me out of her womb. Maybe it was just one of those things. But one thing's for sure, the nerves in my right arm were damaged.

By the time I came home from the hospital my mother had forgiven my father, again. He somehow convinced her that he didn't mean to go off on her, that he would never go ill on her again. He said he wanted us to be a family. But, like most of his promises, that frame of mind didn't last long. He even used my bad arm as an excuse to yell at my mother.

"You can't even have a healthy baby, Ongie," he would say. "Look at him. Maybe if you weren't so stupid, he'd be okay."

My mother absorbed this, but she never paid much attention. She knew she didn't deserve it, and she loved me. She used to lotion me down every night until I looked like a little greased pig. And when she put me to bed, she would dress me in a onesie and pin my sleeve to the mattress, so whenever I tried to move, I would be forced to exercise my bad arm. After a few months, I waved my arm for the first time. And within a

year it had gotten so strong it was almost perfect—just the way my life appeared from the outside.

After I was first born, we lived in a tiny house in Brentwood, Long Island. Of course, I don't remember it, but my mother told me it had a small living room that you entered as soon as you came in the front door. There was a heating grate in the floor of the entryway, where she would dry clothes by hanging them over a chair. Two bedrooms—one for my parents and one for me—were right off the living room. It was all on one level and looked like a little doll house.

In less than a year, like the Jeffersons, we were "movin' on up" to a bigger house in Bayshore. My father had gotten a loan through the Veterans' Administration, and he got a great deal on a high ranch. This is the house I remember. It had a big yard in the front and one in the back. And there were always people over—family mostly.

Music was a big part of our house too. My father used to write songs and he played the keyboard. He even had a record label at one time. He always wanted to be a musician. And my mother loved listening to music. She used to play her 8-track tapes and her 78s, the O'Jays, the Main Ingredient, Harold Melvin and the Blue Notes, the Whispers. We always had a nice stereo system.

There was a barbecue pit where every spring and summer my father would cook hotdogs and quarter-pound hamburgers, chicken and ribs, and corn wrapped in aluminum foil. Every Fourth of July my father and his friends would buy a whole pig, soak and clean it in our bathtub (ain't that nasty?), and cook it whole in a big pit out back. Back then, women wore midriffs and hot pants, and the fellows had shirts with the huge lapels.

One summer, I taught myself how to ride a bike on the street outside our house. I was just a little kid, and my parents bought me a bike that they didn't expect me to ride until I got older. But I surprised them. The bike was blue and silver and

almost as big as I was. And even though it didn't have training wheels, I would roll it outside in front of our house every day and try to ride it. My mother would crack up as she sat on the front porch with her friends, watching me fall all over the place trying to ride this big old bike. By the end of the summer, though, I was riding it. I guess I was always determined to do things no one thought I could. (Later, I even taught myself how to juggle. To this day I can still do it.)

That same year, my father bought me a puppy that I called Pup. I didn't go anyplace without him. He was one of those mixed breed mutts, a little guy with short brown hair with a patch of white, and real cute. Pup was my true friend and the first thing I had that I felt belonged to me. Everywhere I went, Pup was right behind me wagging his tail and looking up at me. I would put his little leash on him and take him for a walk with my mother whenever I could.

One day while we were going out to play, he fell through a missing floorboard in the porch. His leash got stuck on a nail, and he started making this horrible squeal. I ran down under the house to try to save him, but by the time I could get him, he had choked to death. I cried for days. My father buried him in the backyard, one of the few nice things he ever did for me.

From the outside we were an all-American family, with the house in Long Island, dog, and cute little kid. But inside that house was pure hell. Because my father was a straight up Dr. Jekyll and Mr. Hyde. To almost everyone around him, he was Mr. Responsible, a family man who was taking care of business. He and my mother were the perfect couple. They partied, went out, and entertained.

But my grandfather wasn't fooled. He hated my father, and he hated the way he treated my mother, his only daughter, his only child. Pops would show up at my grandparents' house looking like a pimp—hat cocked to the side, a cigarette hang-

ing out the corner of his mouth. And he always had something smart or ignorant to say.

My parents met in 1966 at Pilgrim State Hospital, where they were both nurses' assistants. My pops had just gotten out of the navy, and my mother was studying to become a nurse. My mother thought my father was like one of those romantic guys she used to read about or dream up listening to her Marvin Gaye records. At the time, my pops was a sharp dresser, he always seemed to have a pocketful of money—he was always working or starting a business—and he always had a nice car. That year it was a '65 Mustang. "Mustang Sally" was the popular song, and my father loved to sing that song and drive his car.

They got married a year later. There was no ceremony, no bridesmaids, no ring bearers, no flowers, no nothing. They found some minister on Straight Path in Wyandanch to perform the marriage. My father wore a pair of blue slacks and a shirt with big lapels. My mother had on a black skirt and a pink sweater—like they were going to dinner or the movies or something.

My father left the hospital to take a job driving a truck, which paid twice as much. But the extra money and all the entertaining they did didn't make them happy. The fighting between them was off the hook—every night was another round. They would fight over the dumbest things. One time, my pops wanted to get a loan to buy a truck, and Moms didn't think it was a good idea, so he choked her for not co-signing his plan. It was like he couldn't discuss his feelings and he had to get violent. And there I am, right in the middle.

I hated my life sometimes. Being an only child made it harder because I was all alone. Sometimes I would sit in my room and drift off into Lala Land, staring at the colors in the wall, or the patterns in the hardwood floors. I'd pretend I was someplace else, in a different family with lots of brothers and

sisters. I would make up an entirely new life, while my parents fought and cursed each other. There was a lot of emptiness and loneliness.

There was one time when my parents left me at home by myself. When I was about four years old, I remember waking up in what seemed to me the middle of the night to go to the bathroom or call for my mother for a drink of water. No one answered. I ran from room to room in that big dark house in complete terror. After realizing I was home by myself, I lay in my mother and father's bed and cried, staring into the closet, thinking the clothes in the dark were shapes moving or monsters or something.

After a while my moms just got fed up with my father. She got tired of him embarrassing her, hitting her in front of her friends, and cursing her out, so she decided to move back home with my grandparents, who had just bought a house in St. Albans, Queens.

The day we left was kind of weird. My pops was standing calmly at the top of the stairs as we headed for the front door. I remember looking up at him and seeing a tear in his eye. Maybe somewhere, I thought, underneath the anger, the violence, and the evilness, was a man who really loved us in his own way. If he did, he had a funny way of showing it.

BLOOD

It was the sound of my mother's moans that I remember waking me up. I was four years old and I was asleep in the back room that I shared with my mother in my grandparents' house. But those moans, they ripped right through me. In the kitchen, there was blood everywhere. It was splattered on the refrigerator, on the floor, on the walls—deep, dark red all over the place. There were bullet holes in the wall and in the refrigerator. I had no idea what was happening. I don't even remember hearing the gunshots. I guess I slept through them. But the moans woke me up.

My grandfather, who was on the floor in the dining room holding his stomach, yelled for me to get back, and I guess I did. Because he didn't know if my father was finished shooting, and at my height the next shot that came through the side door might have hit me in the head.

We moved to St. Albans in 1972. My grandparents' house sat on Ilion Avenue, not far from Farmer's Boulevard. It had trees and nice homes, almost like the neighborhood where I lived in Long Island, except a lot more urban. It was a different vibe. I spent most summers during my childhood here. Every Saturday during the summer months, people would be out mowing their lawns and planting flowers. Kids would be running around playing football and skelley, and girls would be jumping double Dutch. And I loved it. It felt like home. That was the only place in the world where I felt safe and truly loved. To this day, when I come back to New York, I stay with my grandmother in that same house on the corner.

When I got older, I moved from the front room to my own room in the basement. My grandfather had fixed it up into a nice bedroom for me. But you know me, I added my own touches: posters of Bruce Lee and, later, Run-D.M.C. and *Jet* magazine's "Beauty of the Week." I had sheets up for privacy like walls, because the washer and dryer were also downstairs. My man Al Monday airbrushed graffiti on one concrete wall—the skyline of New York and my name in lights. The background was gray, like dusk. And it's still there. Even though I have since had the basement completely remodeled, with marble floors, a bar, and a Jacuzzi in the bathroom, I kept that wall of graffiti. That room, that house, was where I created my hottest joints. And still do. I still get that feeling, that creative rush in that house.

But it wasn't the house as much as the love that came from that house that made it into a home. My grandparents were real people. My grandfather was more of a father to me than my real one. Even before we moved, I had to visit them a lot. Me and my grandfather would watch old movies and wrestling every weekend. Gorgeous George was our favorite. He was the man. My granddad used to say, "That wrestling stuff ain't real." But every weekend we'd be there watching it.

My grandfather, Eugene Griffith, was five seven, light brown with brown curly hair. His parents were from Barbados, where they lived until they settled in the Bronx in the 1930s and then eventually in Corona, Queens. My great-grandfather was black as coal and owned a medallion cab and several buildings in Corona. My grandfather was just as hardworking in his job at the post office and as a custodian for the city school system. They had my mother, their only child, in the 1940s, and moved from Long Island back to Queens shortly after I was born.

As he got older, my grandfather, who was also an auxiliary policeman, really got into fixing things. On the weekends he

would take me everywhere with him—to the hardware store, to pick some lumber for shelves, all kinds of places. He was always fixing something. And I was his little helper. He was like the busiest person in the world between his job and his work around the house. But he was never too busy for me. If I had a question, I don't care what my grandfather was doing, he would stop and listen to me as if I were the only person in the world. He was very affectionate and never raised his voice.

At night my grandfather would sit in his favorite chair, a black leather recliner that had worn out over the years, in the front room, where he would listen to jazz and eat peanuts. He always had a handful of those Planters peanuts that he would flick into the air and catch with his mouth. And every night he would have one glass of Scotch with his cigar and later his pipe.

You could always tell where my grandfather had been in the house because he always left the smell of that pipe and Old Spice or Brut, which he seemed to bathe in every day. I can never forget that white bottle with the blue ship on it, or the plastic green bottle.

My grandfather added another side to my love for music. He was a musician, a saxophone player, who was really into jazz. He loved Duke Ellington, Billie Holiday, Cannonball Adderley. Some nights my grandfather would blast jazz at ridiculously loud levels in the basement. At times I thought the house would explode and come down on our heads. My grandmother would yell down the stairs, "Gene, turn that s*** down!" My grandfather would yell back, "Oh, shut up, Ellen." They'd go back and forth like Alice and Ralph Kramden from *The Honeymooners*. They were hilarious.

For the most part my grandfather was calm and even tempered. He didn't yell much. And I can't even remember him really getting mad. Good thing, too, or he and my grandmother could never have stayed married so long. He was her perfect complement.

My grandmother is a tiny woman, about five one, maybe smaller. But what she lacks in size, she more than makes up for in ferocity. As strong-minded and independent as she is, though, she has always been there to hold down the family. I guess you could say she's from the old school. She would cook her husband's dinner every night, clean the house. The type of woman who would set the table the night before, so when my grandfather woke up, everything would be ready and breakfast would be served. She paid attention to details, the little things he liked that made him happy. She really knew how to take care of her family and be a caring mother—especially for me.

It was also my grandmother who taught me my first rhyme:

**If a task is once begun, never leave until it's done.
Be the labor great or small, do it well or not at all.**

Little did she know she was preparing me for hip hop!

My grandmother was a real character back in the day. (And she still is, even now.) When she wasn't cussing somebody out, she was in church. We went to St. Bonaventure, a Catholic church across Merrick Boulevard. She would drop me off there every other Saturday when she went to get her hair done. I had to go to church every Sunday too. I sang in the choir. Can you picture it? I even wanted to be an altar boy. I wanted to carry the bell, light the candles and the incense, and help with communion. Communion was my favorite part of Mass. I loved those wafers. I sometimes tried to get back in line to get another. I figured if I was an altar boy, I would have access to all the wafers I wanted. And I couldn't wait until I was old enough to get some of that wine. But by the time I became old enough to be an altar boy, I was so heavily into rap that it was a struggle for me to even go to Mass every Sunday.

It's funny, I can't really relate to the Baptist, Methodist, or gospel church experience that most black people have. Catho-

lic church is so different. Nobody really catches the Holy Ghost, and the services are very subdued, just a lot of kneeling and praying. We did have one lady in our church, though, who alway used to catch the Holy Ghost and speak in tongues. I was maybe ten or eleven and I thought she was absolutely out of her mind. People just didn't do that in our church.

When my grandmother left me at the church on Saturday, I would get into all sorts of mischief. I used to have those priests cracking up with my antics. One time, I made all the fathers some coffee, but there weren't any spoons. So I went around to each cup and stirred their coffee with my finger. They thought it was hilarious.

After my grandmother picked me up, we would hang out all Saturday until my grandfather came home from his auxiliary police gig. I enjoyed the time I spent alone with my grandmother. We were like buddies.

She's a great paradox: tough on the outside and tough on the inside, but at the same time one of the nicest people you'd ever meet. And if she likes you, she'll do anything for you. She could be your best friend and your worst enemy at the same time.

I don't care what anybody thinks about my grandma, I always have her back. One time, I was maybe nine, we were on this church trip and she got into an argument with a church sister over the food. I think they were arguing over the macaroni salad or something. The argument got heated, and before you know it, my grandmother was cursing this lady out. The lady started looking like she wanted to get physical, like they were going to fight. So I picked up a golf club and told the lady, "Back up, or I'll turn this club into a wooden turban on your head!" I think it cracked them up more than it scared anyone, but that was the kind of relationship I had with my grandmother. I was her watchdog and she was mine.

Years later, when I began to rap and people started know-

ing me and wanting to just drop by the house and chill, she was the one who stood at the door and told them to go away. It was hard to know who was who and focus on what I needed to do, so she became the police of the house.

She was also the one who saved my mother and my grandfather the night my dad decided to start shooting at them. On that fateful evening, hardly anything was stirring outside. It was August and broiling, even at 1 A.M. My mother was working her night shift at the Northport VA Hospital, 3 P.M. to midnight. She had on her white uniform and those white shoes with the thick rubber bottoms. And my father was waiting as she pulled her brand-new Monte Carlo into the driveway on the back side of the house. At this time of night it was deserted. Like a ghost town.

As soon as he saw my mother's headlights coming toward the driveway, my father slipped out of the bushes and got into his car, which was parked on the other side of the house. He knew which way she'd be coming, since it was the same every night. Her routine was also the same every night—pull up to the gate, get out of the car, open the gate, pull in, get out, close the gate, and pull into the back. My father had more than enough time to get into position.

He had been trying to win her back for months. And she wasn't hearing it. She was finally getting some peace in her life, putting things back together. Unfortunately, he wasn't taking no for an answer.

"Ondrea, I'm sick of your motherf****** s***!"

My mother had her key in the door when she turned around and told him to get out of her face. But she had no idea he had a 12-gauge shotgun.

The first blast caught her in the lower back. My granddad, who was in the front room doing his usual routine—eating peanuts and listening to jazz—came to the door when he heard the commotion and tried to close it. He took a blast in his stomach.

To this day, my grandmother says she was glad my grandfather caught that second shot. If he hadn't, my mother would have taken it, and it might have killed her.

That's when I came running out. The smell of gunpowder was still in the air. It was stinging my nose, like someone had just lit a match, only ten times as strong. My mother was lying there between the kitchen and the side door, making this horrible moaning noise. My grandfather was sitting against the wall, holding his stomach, yelling for me to get back. But my father wasn't done shooting. He emptied the shotgun and just sat in his car looking drained. A park-by shooting. My grandmother ran outside to his car and started cursing him out. Do you believe this? She remembers that he actually apologized for shooting my grandfather. He said he was only trying to get my mother!

Grandma was cursing him out and getting into action at the same time. She called the police and an ambulance and was giving out orders. I ran to get towels from the bathroom. When I pushed them into my grandfather's stomach, I could see where his flesh had been ripped apart. It was oozing out, so Grandma decided not to wait for the ambulance. To this day I don't know how she managed it, but that little woman found the strength of ten men and got my mother and grandfather into the backseat of her car and to Mary Immaculate Hospital. As Grandma always said, when you need the strength, He supplies it.

My mother and grandfather both survived, thank God. And my father fled to California, where he changed his name. Police reports were filed, but he was never prosecuted. After a while (and after she was sure he wasn't coming back), my mother decided to not pursue it either. For my sake, she told me.

The way my family handled that incident—no charges pressed, that forgiveness—showed love in a way I have never seen since.

The experience was rough, but it taught me that no matter how bad things are, if you can't change them, you might as well move on. It taught me that stuff happens, and you have to get over it or it will kill you. That's what I see happening to a lot of young brothers and sisters today. They let their circumstances dictate their future. They allow the media and everyone else to either feel sorry for them or tear them down—both lethal blows. And they don't move forward. Brothers and sisters sit at home and blame the white man for their troubles. Or they say they can't get from under the thumb of oppression. I know from experience that it ain't easy to get up when you want to wallow in pity, but I also know that it's worth it.

My grandmother sure could have given up hope when they told her she might lose her husband *and* her daughter. But she didn't. She was right there fighting all the way.

I can honestly say that every bad thing that's ever happened to me taught me something valuable about life, things that made me a better person. From the way my family dealt with the shooting, I learned forgiveness and gained inner strength. That lesson helped me become who I am today.

Later, because of my family's forgiveness, I was also able to learn some things from my father firsthand. Some of them were even good. Once I had put this incident behind me, I thought we could have a real father-son relationship, as strange as it sounds to those who are less forgiving. He even managed my career for a few years. Eventually, though, he showed himself to me just as my family saw him. This time, he almost ruined my career. (More on that later.)

Sometimes, people just are who they are. And just because someone is related to you by blood doesn't mean they will love you. It takes more than sperm to make a man a father.

The most important lesson I got out of all this, though, was that no matter how bad you think things can get, they can al-

ways get worse and only you can make them better. For me, both happened. That incident in the kitchen of my grandparents' house was only the beginning of the rest of my childhood—and the rest of my life.

IMPOTENT DEMON

My grandfather recovered quicker than expected. He had intestinal damage and they ended up removing about ten feet of his intestines. In a few weeks he was home, but he was never the same again.

My mother almost died. The shotgun pellets entered her lower back and fanned out. Several grazed her spinal column, and for a while she couldn't walk. She spent more than six months in the hospital recovering. During the first month, my grandmother took me to see her in the hospital every other day. I could only wave and smile at her through a glass partition, because they didn't allow little kids in intensive care.

After three months she was able to go from a wheelchair to a walker. From the walker she went to a cane, and then to a leg brace. At each transition, Roscoe was there. She met him a few months before the shooting at Northport VA Hospital, where she worked in the pharmacy. Roscoe was an assistant to a physical therapist. After the shooting he made it his mission in life to help my mother recover.

All the doctors told her she would never walk again, but Roscoe made her believe she could. And she did, which is a testament to her determination. Another trait I inherited from her. But from that point on, he had her head. With her gratitude, he wormed his way into her life. And my mother, feeling empty and vulnerable, just let him. She fell in love with the man she thought gave her the ability to walk again. I ain't mad at her, though, 'cause I know how that is. If you thought someone saved your life, you might fall for them too.

Roscoe was totally different from my father. He was always joking and playing around and laughing with my mother. Roscoe was one of those pretty boys. He had hazel eyes, a curly Afro, and a thick mustache. My father was big and tall, with big muscles and a thick waist. Roscoe was little, about five seven, the same height as my mother, and he wore platform shoes. I don't remember when I first laid eyes on him. It was like he was always there after my mother got out of the hospital. But I knew from jump he didn't like me, and I was definitely not feeling him. I must have been a threat to him.

Maybe because I was even smaller, he thought he could take out his frustrations on me. Maybe he just had a Napoleon complex because he was short. (All he ever talked about was this cousin of his who was "six feet four and two seventy-five" as if to show that somewhere in his genes was a big person. But that gene definitely missed him.)

Maybe he was jealous of the relationship I had with my mother and her family. Maybe I was an obstacle, getting in the way of his freedom with my mother. Or maybe I was just someone easy to take out his frustrations on. Easy target—little Napoleon's punching bag. Whatever the motivation, though, there's no real explanation for how he treated me.

When my moms got completely healthy she started working two jobs—the Suffolk County Developmental Center in Melville, Long Island, from 3:20 P.M. until 11 P.M., and the St. Alban's VA Hospital from midnight to 8 A.M. She had an hour to get from Suffolk County to Queens. Some nights she had to depend on Roscoe to drop her off and pick her up because he was using her car. Some nights he was late. Sometimes he made her wait for hours. He was too busy getting high, cheating on her, and beating on me.

My mother had a small, brick-and-tan house built for us in North Babylon. She had to work the two jobs just to pay the mortgage, and was carrying most of the weight. That left him

at home with me the majority of the time and it was on—playtime for him. His idea of big fun was beating on me.

Roscoe beat me for just about anything. He would beat me for watching television, for lookin' at him funny, for looking out of the window watching other kids play. He didn't need a good reason. It was just a power trip. While my mother worked, Roscoe was home abusing her son. He was usually home when I came in from school, and it was like, "Let the games begin!"

He'd make me take off all my clothes and put my arms up on my bunk bed with the *Star Wars* sheets while he beat me. It was like the scene in *Glory* when Denzel Washington was getting beat down like a slave, except I was like eight years old. He'd even pull me out of the shower to get a beating. He didn't care how he beat me or with what.

He would rotate beating me with extension cords, vacuum cleaner attachments, and fists. He would punch me in the chest and knock the wind out of me—and then tell me to "raise up," get up for another punch. One time he threw me down a flight of stairs in our house. He even beat me for looking in the refrigerator. There's nothing worse than being hungry and staring into an empty refrigerator because your mother's man ate all the food after smoking a pound of weed—and then getting a beating for being hungry. Yo, it could freak you out.

It's around this time that I started wearing hats all the time.

Sometimes Roscoe would snort coke. It wasn't unusual for me to come home from school and see a mirror with a bunch of white lines on it on the kitchen table. At first I didn't know what it was, but I figured it out pretty quickly. I suspect he also used to deal coke on a very petty level. One time he even told me, "Boy, go in the back room, I'll be in the kitchen cutting up this white stuff." He was always owing someone down the street, asking for an ounce on credit, an "o-z" on credit. Some father figure.

Maybe that's why I never got too into that drug thing. It was so much in my face. It was always around me growing up, and I identified drugs with pain and negativity. Pain is an understatement.

One time, he put me on punishment during Christmas for no particular reason. He just said, "You ain't having no Christmas this year." So I put my bike—my same old Raleigh bike from back in the day—under the tree that year and pretended it was new. I washed it, though.

Living with Roscoe was like being a little kid who gets to play in the daisy field every day. But every evening that kid has to go home and sleep in a cemetery with a dragon. It was the most horrible experience. I was defenseless and I didn't understand. The pain went so deep.

Our house was on Lakeway Drive, on a nice block with lots of trees and parks and kids. Across the dead end street were a bunch of pine trees and these dirt hills, little mounds where we used to play tag. One day after school, I was playing by myself (I was a loner for the most part) when I got tired. I lay down on one of those dirt mounds, put my foot up on a tree, my hands behind my head, and just watched the clouds floating in the sky. It was one of the most peaceful moments in my life. I never got much sleep in the house. I was always on edge, never knowing if Roscoe would drag me out of bed in the middle of the night with some crazy excuse for a beating. On this particular day, I found some peace.

Not for long.

After I fell asleep, Roscoe started calling me. He thought I was playing games when I didn't respond. The next thing I knew, he was hauling me off the ground by my arm. And he had that fire in his eyes. The beating I got that day was with the vacuum cleaner hose. How did I spend my summer vacation that year? I got beatings.

He put me on punishment for the entire summer—three

whole months. When other kids were riding their bikes, playing kickball, and going to Disney World, I was in the house. Every day I would look out of the window and watch the kids play. He beat me for that, too. I couldn't go outside. I couldn't even look out the window. I couldn't do anything. I just got beatings and more beatings. It was rough.

Another time, one winter, I did something really bad. I asked for something to eat. He had just cooked himself this lumberjack meal—steak and potatoes with gravy, the works— and I had the nerve to ask for some. Roscoe beat me and threw me outside with no coat. I had to stay out there for about four hours. It was one of those winter days when the sun was out. It was bouncing off the snow, making it seem like it was even colder. Kids were walking by and looking at me, shivering with no coat. I just sat on the stairs and started crying. It was so humiliating.

Even worse than the beatings, though, was the mental torture. Roscoe made me his personal slave. He would make me do things like take off his shoes and funky, nasty socks at night. I would have to bring him juice and cake. He took advantage of the trust my mother put in him, and no one knew about it.

This went on for about four years. The more cruel the torture, the more fun it was for Roscoe. One time he was smoking weed in the living room and I was asleep. He kept calling me, waking me up for no reason.

"Todd! Get me something to drink!" I'd get out of bed and get him something to drink and go back to bed. For about ten minutes.

"Todd! Turn off the light in the kitchen!" I'd get up and turn off the light and I'd hear him snickering as I marched back to bed. Another ten minutes passed.

"Todd! Come here and change the channel!" I'd do it and hear him laughing under his breath. He was really enjoying

himself. That was one of the many ways Roscoe had fun. The more he could be cruel, the more fun for Roscoe.

The only break I got was when I went to my grandparents' on the weekends. But that was like getting teased. For two days love and fun, the rest of the week hell and torment.

It was like I was living two totally separate lives. In Queens I was the normal little boy in a close-knit family environment, where there was plenty of food, laughter, and love. During the week I was this crazy kid, living with this crazier man whose sole purpose seemed to be to make my life a living hell. It was a tale of two Todds.

I remember one weekend when I couldn't visit my grandparents because they were going somewhere and wouldn't be home. I wanted to go so bad and they knew it. They wrote me a letter telling me not to worry, that I could come the following weekend. But I just sat in my room with the letter and cried. When Roscoe came by he said, "What are you crying about, punk?!" He read the letter. "This ain't no reason to cry."

The only other place I felt secure was at the McCulloughs', who lived near us in North Babylon. When I couldn't stay at my grandparents, the McCulloughs gave me some peace of mind and joy. I don't know whether they knew it or not—Mrs. McCullough has since passed—but they really helped me maintain my sanity.

They lived in a big brown-and-beige house at the end of our street. I first met them while coming out to see our house as it was being built. "Wow, they're big," I thought. Mr. McCullough, who was a dispatcher for the Transit Authority, was about six three and huge. Mrs. McCullough was almost six feet tall and thick, not fat, just real healthy. They were very majestic.

They were both from South Carolina and they used to grow their own vegetables—tomatoes, okra, beans, and greens—on

the empty lot next to their house. But what I loved most was that their house was always filled with kids.

They had two kids of their own, and at any given time, about six to eight foster kids. The family I never had. Ivan and Andy were their biological kids, but there was also Wayne, Eric, Todd, Raynard, Tracey, and Kenny. There were more before and more after, but those were the kids I grew up with.

Besides the kids, the thing I remember most about the McCulloughs' house was the food. There were always big pots of greens cooking on the stove, fried chicken, barbecue, and macaroni and cheese that I can taste even now. I would sometimes eat dinner over there while my mother worked. All of us kids would sit around the big wooden dining room table with these huge smiles on our faces and these soggy paper plates in our laps. That was the best. They gave me a lot of love along with the chicken and greens.

That house was always full of activity too. Some kids would be in a room playing Monopoly or Uno. Others would be outside in the wading pool, which wasn't more than three feet deep but could sure cool you off in the summer heat. Others would be watching TV or playing football in front of the house. There was always something to do. And you know I would do almost anything not to have to go home and be with Roscoe.

In that house, I could get lost. I could hide behind all those kids and just be another child, not Todd the slave or Todd the whipping boy or Todd the niggah, which was Roscoe's nickname for me. Maybe the McCulloughs knew what was going on when my mother wasn't home. Maybe that's why they treated me so well. It was like they were making up for what I didn't get at home. Whatever it was that made them treat me like family, though, I loved them for it.

I treated them like my real family, too. I used to fight the kids like they were my brothers and sisters. I got into a fight once with Wayne because a cat got hit in the street in front of

their house and its eye was hanging out and he was laughing. I didn't think it was funny. (I'm sure there would be a lot of kids on Wayne's side, though.)

One time I tried to run away from home with my man Kenny, who was the same age as me. He was dark-skinned and thin but had muscles even at a young age. Of all the foster kids at the McCulloughs', Kenny had the most problems. Although I didn't know exactly what was going on with him—kids don't get too deep with things—I know he had a helluva life, and I could relate. We had a connection no one else understood.

He and I used to sit around and write rhymes together. We even had a little group for a hot minute. I called myself Silver Streak and he was Solid Gold. I learned one of my first rhymes hanging out with him:

> **When you get off the wall and you bust your balls and you skipbideebop di do,**
> **I'm gonna rock ya up, I'm gonna rock ya down,**
> **I'm gonna do it just for you.**
> **For those of you who don't know me, I'll be the famous rappin' rapper T.**

Kenny was the brother I never had, and we shared so much pain. We never really talked about it. But it was there.

So one day we decided to run away. I was escaping Roscoe, of course, and I guess Kenny was escaping his past. We didn't have any real plans about what we were going to do once we got away, but we were going to take the train to Brooklyn where Kenny had an aunt. She would take care of us until we found jobs. We were about 11 or 12, but we were dead serious.

I stole about $20 out of a drawer where my mother kept her secret stash (like we were going to get real far on that). I crawled out of my bedroom window and met Kenny on the street. We stopped off at Church's chicken around the corner

to buy a two-piece dinner with a biscuit. As soon as we walked out of Church's this car screeched up next to us. Guess who? Roscoe.

My stomach dropped.

"Where the hell do you think you're going?" he said.

I think I wet my pants. He grabbed the chicken and threw it in the garbage. I was upset about that because I was really hungry. Then he grabbed us and threw us in the car. When we got home, I already knew the routine. I took off all my clothes and stood with my hands on the railing of my bunk bed in my *Glory* stance.

It was around this time that things started coming to a head. My mother, who had been too busy working to see what was going on or just refused to believe it, finally started to wise up. Once or twice I tried to tell her the things he did to me, but she thought I was exaggerating. You know how kids can make things up. So eventually I just gave up. He made sure not to do any of the real brutal stuff in front of her, anyway.

One day, though, he got bold and beat me in front of my mother, and she went bananas. She jumped on his back and scratched him up pretty good. She busted his lip and told him never to touch me again. (He was running around crying, "Look what you did to my lip! Look what you did!")

But the man had game. In a few days he had charmed himself back into her good graces and it was on again. And the beatings continued as usual. I never told anything after that. It's a damn shame that I had to go through so much before she finally listened.

I'm not mad at her, though. I understand that Roscoe had her head so wrapped up she couldn't think straight. And she was still healing, psychologically, from the shooting. Still, the experience taught me that no matter what, you really got to listen to your kids. You have to be willing to understand where they're coming from. Now that I'm a parent myself, I don't beat

my kids. I talk to them. At most, I gave them a little spanking when they were young. But now that they're old enough to understand, we talk. It's important. I want my kids to have a happy childhood. I don't ever want them to go through what I went through.

Eventually my mother left Roscoe. Partly it was because of what he had been doing to me, but mostly it was because she busted him cheating on her with a white woman. He said he was only her friend because she had multiple sclerosis, but it was definitely more than friendship. So we moved back "home" to Queens to live with my grandparents again.

You know how glad I was to have Roscoe out of my life, but the damage was done. I was doing all kinds of wild things by then and getting in all kinds of trouble.

FOUR

JUNIOR CRY SCHOOL

Roscoe helped me twist up my school life, too. After a while, it was like Roscoe, like Todd. He would beat me, and I would turn around and beat up the kids at school. Naturally, I got a reputation around my way for fighting all the time. I would fight anyone, anywhere, anyhow. I didn't need a reason. Like Roscoe, I became a bully. Win or lose, I saw his face every time I snatched some kid's lunch money, chocolate milk, or cookies.

When I was nine years old I had a fight with this kid at school. I don't remember why we were fighting, but whatever he did (and he probably didn't do anything much), my response was totally extreme. Besides winning the fight, I kicked the kid in the mouth three times. Back then, I watched a lot of Bruce Lee movies, and I used to practice his moves in my grand-parents' basement. So I used my *Enter the Dragon* moves on this kid as I gave him repeated roundhouses to the ear, nose, and throat. It was pretty ugly—for him. An older kid came down the street out of nowhere and broke it up. He looked at me, completely disgusted. But I didn't care. In my mind I had just exorcised some of the demons that had been haunting me.

I couldn't fight back in my house; I was defenseless there. But on the streets I wasn't going to let anybody else beat me, not without a good fight. By the time I was 13, people around my way were calling me a wild man.

What I see now is that Roscoe's constant beating changed me. I went from this normal kid who got straight As and loved school to a troublemaker. Not that I was ever the quiet type in

GENESIS 37

school. But I wasn't really bad when I was young, just mischievous. Mainly because I was bored most of the time.

I can remember in the first grade during reading time, the teacher started some book about a cat. She began reading, "The yellow cat jumped . . ."

Before she got to the "yell" in yellow, I blurted out, "Stop reading so slow!" That was the first time I was thrown out of class. But it definitely wasn't the last.

In the fifth grade, I used to shoot spitballs and would crawl around on the floor, like I was going through a cornfield or something, all the way to the front of the room. When the teacher would look down, there I was, looking up her dress. I also had these Shurikan Chinese stars I used to throw into the bulletin board. When the teacher turned her back to write on the front board, I would throw a star at the side bulletin board. I got thrown out of class for that too.

But all of that was in good fun. School was a break for me, a place to laugh and learn. During the Roscoe era, though, it became torture. Just like home.

When we moved to North Babylon, I found myself in a predominately white school. It was a different world—a real culture shock for me coming from my grandparents' Queens neighborhood, which was almost all black. I had never felt like a minority and never really experienced racism.

The first time was in the sixth grade. I was walking down the hall behind some white kids, and one of them said something about "niggers." They all started laughing, and one of them turned around and saw me. They were like, "Sorry." I couldn't believe it. So that's what they really think of me. Of course, the word *nigger* was nothing new for me. I heard it every day from Roscoe, which if you think about it is really unfortunate. He was constantly barking out, "Niggah, clean the yard," "Take off my shoes, niggah," "Niggah do this, niggah

do that." But hearing it at school made me realize how terrible it was to have to hear it at home.

Things were getting bleaker for me by the day back then. I was angry in my school. I was always fighting in the neighborhood. My childish mischief turned into sheer terror for the other kids. I was a bully. I didn't care who I fought or why. I was turning into a prepubescent Roscoe.

And it certainly didn't help matters being shuffled back and forth from Queens to Long Island. There was a tug of war between Queens and Long Island, my grandparents and my mother. I would spend one year in Queens schools and then one year in Long Island. But I spent most of my middle school and junior high school years in Queens, at Susan B. Anthony Intermediate School 238.

There was this girl who used to tease me constantly during my first year of junior high. She was bigger than me and very fat, no slang intended. She teased me about everything, from the size of my head to my skinny legs. And she was relentless. Now, I was raised never to put my hands on a girl, so I warned her to leave me alone. But I think she must have liked me or something because she wouldn't stop. Every day she pulled on my shirt, smacked me in the head, kicked me in the shin, and hit me. She was the worst, a walking nightmare. Just the sound of her voice gave me goose pimples the size of Milk Duds.

I used to carry this bag to school that my grandfather gave me. The kids in school in Queens used to tease me about it because it had black and white stripes and kind of looked like a pocketbook. So they called it my jail bag. I kept a lead pipe wrapped in black masking tape in the bottom of it, just in case. I also used to attach a big safety pin to the inside of my jacket and slip a butcher knife through the pin so that the hilt caught on the pin. I look back now and realize how foolish it was. But that was the mindset. And fear drives you to do some strange and stupid things.

Where we lived was nice, but up on Farmer's Boulevard where we had to pass to get to school was a nightmare. Older kids would wait for us on the corner to take our money, our bus passes, or whatever we had. So I kept my bag and my butcher knife close by. I was shopping on Jamaica Ave. one time for some sneakers. I had my bag and I was heading to the E train, and these guys came up to me and asked what I had in the bag. I pulled out my butcher knife and they started running. It came in handy that day.

One day we're about to leave a class, and the fat girl who had been harassing me for what felt like an eternity grabbed my bag and tried to punch me in the nuts when I wouldn't let go. That was it. I went buck wild and punched her in the face. She fell forward on her nose and I started punching her in the back of her head and kicking her in the a**. It shook a little. And I was yelling, "I'm sick of you!" the whole time. The teacher tried to stop me and I turned the teacher's desk over. I was crazy. I was also suspended.

Before he suspended me, the dean looked at me and said, "You got trouble. Do you know who her brother is?" I didn't. But a couple of days later I found out. He showed up at my house. And he was big. Someone, who was no longer a friend after that, had showed him where I lived. He said, "I hear they call you pretty boy. You running s*** in two thirty-eight, huh? We going to see about that."

I'm thinking to myself, Pretty boy? That must be what *she* was calling me. Because I knew I wasn't no pretty boy and I wasn't running anything, anywhere. What was he talking about?

"You beat up my sister. Now I'm going to *do* you."

He was a patient thug, not wanting to get busy in front of my house. But the next day he and a couple of his boys came up to the school. I was sitting outside, chilling on a bench, with

my face resting in my hands. I didn't see them coming. One of the guys tried to kick me in the face but hit my hands.

I stood up. I didn't have the butcher knife on me, but I had Plan B—my switchblade—and I pulled it out of my jacket. They all backed up. But then I thought, Yo, I don't want to stab one of these kids and kill him. So I put away the knife and we started fist fighting. The gym teacher, Mr. Asher, broke it up. So me and these guys had an ongoing beef for the whole summer. They lived on the other side of Farmer's, so it was no problem as long as I didn't cross that line and vice versa.

One week, my man Cal wanted me to go with him to check a girl who lived on that side of town. Cal also had some beef with somebody over that way who had shot at the ground in front of him for no reason the last time he was over there. So he wanted to go over there and settle the score. But Cal was real scared.

I had a plan. I told him not to worry.

Farmer's.
(© Mariah Bowen, 1997)

"Yo, so what if the kid is a little bigger and a little taller. Just get a handful of salt, and when he starts coming at you, throw it in his eyes and beat him down." I'm coaching him the whole walk over there. He's got the salt, and he's sweating bullets. We get there and we see the kid, and he's coming toward us. Cal throws the salt. But he was sweating so much that the salt had mashed into one big lump, like a little pebble, and it just hits the kid in the forehead.

"Oh, so you want to throw rocks," the kid said. And he commenced brutalizing Cal on every level. It was one on one, and you know the code of the street is you can't jump in on a one-on-one fight. When they stop, Cal is just a mess. So I say to this kid, "I'm going to fight you for my man." So it's me and the kid that got the best of Cal. I don't waste any time; I hit him in the face and hit him again. He backs up.

"Aw, that's weak," the kid said.

Yeah, right. I'm getting ready to smooth him out good when one of his friends steps in, says he wants to fight me. I say, "Yo, he just beat up my man." And the kid, whose name was Bammy B, says back, "Yeah, but that's *my* man." So we start it up and a crowd starts forming. It was like the whole neighborhood was out there ready to jump in.

"Hit him in the chin," the crowd kept yelling.

So the kid starts aiming for my chin. Every time he aims for my chin, I make him miss. I'm ready for it, obviously. One time he tries to hit me and I catch him with a left hook—and he goes right through the open window of a parked car. There's a man in the driver's side and he pushes the kid back out of his car. The kid steadies himself and says, "You got heart. This is Bammy B, boy! This is Bammy B." And he charges me. I tackle him onto the ground and the other kid who was fighting Cal pulls me off. I'm going buck wild at this point, but I also notice that this fight is getting a little out of hand. It's turning into a

mob scene—kids, old ladies, dogs, cats. So I catch Cal's eye and we start jetting.

All I hear is, "Yo, get 'em!" The whole neighborhood is chasing us. It was like something out of movie. We made it almost across town, and we had to stop because we were tired. Cal asked me if he was bleeding and I told him he was but he'd be okay. A couple of the guys from the crowd caught up with us. I saw them and got in gear. They caught my man, but I kept on running.

That was the worst. I admit it. I can't front. I went out like Jell-O. (Forgive me, Cal.) They took my man up to the park, which was like their headquarters. I went home and was sitting in the living room with this wild look on my face. I was worried about Cal, thinking about all the crazy things they might be doing to him. My moms came in and asked me what was wrong. I said, "Nothing." But she kept asking me what was the matter. So I broke down and told her what happened.

My moms was always a trooper. She said, "All right, then, let's go get him." We get to the park and they have Cal in a parked car. These two girls are trying to protect him from a mob of people jumping up and down on the car, hitting it with bats. It's crazy.

My mother runs her car up on the curb and honks the horn, and I start yelling out for Cal to make a break for it. The mob turns to our car. And when they do, Cal jumps out and we swerve around, pull him in, and drive off. People are screaming things like, "We're gonna f*** you up. I'm a get you!" But we got away—that time.

Around this time I joined the Five Percent Nation, a religious sect that believes the black man is God. This guy in my neighborhood hit me off with some of the doctrine. It talked about humanity beginning in Africa, and how the black man was the first man on the earth. So the black man is God because all humanity originated there. I felt power belonging to this

group and I was looking for that. I wanted to belong some-where, and there was a family vibe with the members. We had a crew, a clique of people, who had my back. My Five Percent name was Lord Supreme Shalik.

But it wasn't all good. Being a Five Percenter was nothing more than a license to be brutal. At its core there is strict reli-gious doctrine, but we weren't following that. We were just using the Five Percent label as a shield to do our dirty work—fighting and eventually robbing.

At a point in time, I even started carrying guns that I had taken from my grandfather's closet. Since he was an old army man and an auxiliary policeman, there were guns all over the house. I started off just holding them, feeling the steel in my hand. One time, though, I was in the attic, my favorite hiding place, holding one of the guns and just pretending I was shoot-ing it off. I put some ammo into it just to feel like I was the man. But it actually went off. I was like, "Oh God!" Yo, I was so glad nobody was home and nobody was hurt. I was so scared at first. But then I got this rush. I wanted to shoot it off again. And I did.

Some afternoons, I used the attic wall as target practice. I thought if I shot out of the window, I might accidentally kill somebody. But if I shot into the walls, the bullets would stay there. I covered up the bullet holes with some boxes and my Pope John Paul poster. (By the way, I sang for him with the St. Bonaventure choir in 1979 at Shea Stadium. We did "Ave Maria." Ain't that wild?) There are still holes in the attic walls where I shot off that .38.

I would carry guns, just waiting for someone to mess with me so I could put a cap in them. I was a very troubled young man. In those days there were a couple of bullies in the neigh-borhood, older guys who used to steal our lunch money and terrorize us. One time I was walking with my piece in my pocket and one of them started bothering me. I pulled the gun

on him. I know he must have wet his pants, running and ducking behind cars. I don't think I would have shot him. But, then again, I don't know for sure.

One of the guns I carried wasn't even loaded. But having them gave me a sense of protection and a sense of power. Fighting also gave me that power. So did terrorizing and abusing others, I'm ashamed to say.

When I was in junior high, I used to go out to different high schools in Long Island to mug kids. We would go to Long Island, where the kids had more things to take, and we would snatch their leather bombers and sheepskin coats. We would go up to Elmont High School and go on robbing sprees. I didn't need the stuff. My family pretty much gave me what I wanted. But it was a power thing. I used to sneak the stolen goods into my closet, and when my grandmother or mother asked me where I'd gotten something, I'd say, "My man gave it to me to borrow." Like they were gonna believe that.

I was a really confused kid who wanted to be cool, who wanted to fit in and simply didn't know how to. I wanted to be down, to be part of the crew. And I thought being cool meant I had to drink a few forties, rob a couple of people, carry a knife, carry a gun, and be menacing. Now, how ridiculous was I?

I guess I was good at being ridiculous. I was ruthless. If a kid gave us a fight giving up his stuff, he would get an old-fashioned beat down. After getting hit two or three times, the guy would just hand over the jacket.

There are a lot of kids like I was. I know now I was far from being cool. The way I used to act was real corny. It was impotent. I became powerless to control the violence that had taken hold of me. I became the same impotent demon that was abusing me. I was abusing other people and myself just like Roscoe did to me. It was an evil cycle.

I'm not trying to excuse myself from the violence I was perpetrating by blaming Roscoe. I just eventually realized I had

become Roscoe. I wasn't just abusing other people, though, I was also abusing myself, doing his work for him. And at the end of the day, I started hating myself.

My mother was fed up. She thought I needed a man in my life. So she got in contact with my father in California and asked him to take me for the summer. But he was too busy, so he suggested she send me to stay with my uncle, his brother, in Florida. It was one of the worst experiences of my life, no disrespect to my uncle. And I've had a few.

My uncle lived in Tampa, one of the most uncomfortably humid parts of Florida. There were alligators and mosquitoes everywhere. And it was unbelievably hot. The heat was vicious. I was miserable.

I called New York every day, begging to come home. And my moms kept saying no. But I was calling my friends just to keep up on everything that was going down around my way. I think I ran their phone bill to about $1,000 that first month. And they were poor, seriously broke. They didn't have air-conditioning. If I sat in a tub and ran cold water to try to cool off, they would complain about the water bill—it was that tight. I was going nuts.

What made it even worse, my uncle's wife had a niece who lived down the block, and she had a crush on me. She said I looked just like Leon Isaac Kennedy from those *Penitentiary* movies. I was like, "Thanks." She was nasty, heavyset, and I think she had a couple of teeth missing. I had a choice of sleeping on this urine-smelling mattress where some old lady had died or this stinky black pleather (you know, the fake plastic leather) couch. It was so messed up that you woke up with this black gooey stuff all over your body because the heat would melt the pleather.

This girl really liked me and I thought about getting involved in some extracurricular. I opted for the nasty mattress because it was more comfortable and there was no way that

couch could hold both of us. So, one night, I get in that funky bed with this girl who is not my type. I was absolutely not attracted to her (no offense), but I was willing to give it a shot. Plus I was bored beyond belief. I look at her face and she smiles this toothless grin. Yikes! I close my eyes and I try to do it, but I'm like cooked linguine. Ain't nothing happening. No matter what she does, it just isn't working. So I kiss her to try to console her, and she says, "It's okay. Just hold me." While I'm holding her, the radio in the background is playing New Edition's "Is This the End?" I'm thinking, It just might be.

After that, I decided I would just leave that alone. I wrote rhymes, ran up my uncle's phone bill, and fantasized about my aunt. She wasn't my blood aunt, just my aunt by marriage. She would walk around the house with these short, short Daisy Dukes on. She did a lot of gardening in those shorts and would be bending over a lot, and you could see everything. It was torture for me. I would get the hose and run it over my face to cool off. And this heavyset girl with missing teeth would pop her head in my bedroom window looking for love. "Nah!" That was how I spent my summer vacation. I didn't have many fights down there, but it was definitely brutality.

When I came back for school that fall, I continued getting in trouble—cutting class, fighting, cruising the hallways, and generally wreaking havoc. I was in the principal's office every other day.

One time, I took the master key off a guy who had stolen it from the janitor's key ring. It opened every room in the school. I used to forget my books, and I would let myself back into the school to get them. On my many travels, cutting class, I found this tiny room about the size of a small coat closet. It had a mattress in it and a little lamp and a small table. That's where I would cut class and take my afternoon nap—in school. Even then I had to get my sleep.

On other days I would use the master key to spy on the

girls. There was a maintenance box in the boys' bathroom that led inside the walls where electricians would change the fuses and stuff. I would climb through that door into the wall and wiggle around through the wires and the grates until I got to the one in front of the girls' bathroom. Me and my man, Shorty, would sneak in there all the time and watch girls going to the bathroom and listen to them gossiping. It was fun. One day we went in there and we heard the girls giggling.

"We know you're in there, James," one girl said.

In school they always called me James. At home, in Queens and Long Island in the neighborhood, they always called me Todd. In my football world they called me Jimmy. Todd and James always separated who I knew and where I knew them from. Anybody I knew from school would say, "What's up, James?" Anybody I knew at home would be like, "What's up, Todd?" So there was always that duality with the names.

After the girls shouted us out, a few seconds later we heard footsteps and keys jingling. It was too late to make a run for it. We were cold busted. The security guard escorted us to the principal's office.

As the principal walked me out of the school—I was suspended—he had his arm around my shoulder, and he was smiling at me. "You're a very creative boy, James," he said.

About this time, I could have easily turned into a guy going buck wild because I had literally gone crazy from being abused. I could have easily gone in that direction, and I now see how that happens to so many kids.

But on the plus side, I had my grandparents, the church, the McCulloughs, and my mother to keep me somewhat grounded. And I was involved in some activities—karate, wrestling, gymnastics, and especially football. I played little league football for about four years in Long Island. I started out as a nose guard and as I grew I played tailback. I even won a couple

of rushing titles. But you always need someone to show you the way through a rough road. And there was Mr. Asher.

Joel Asher, my gym teacher at I.S. 238, taught me another side to being a man. He now coaches August Martin High School girls' basketball team—which has taken the city championship seven of the last nine years, including this year. But back then, he was Mr. Asher, a father figure.

Of course, my grandfather was there. But Mr. Asher was younger and he was around me every day. The fact that he was white was beside the point. He was a symbol of strength. He got me interested in football, basketball, and boxing, sports I still love today. But more importantly, he was the first man other than my grandfather who conducted himself like a man and showed me respect. And he didn't take any crap.

He used to have this plastic bat that he used to threaten us with. Everyone was afraid of him and his bat. But he wasn't abusive with it. And we all knew that behind that plastic bat was love. He really cared about us and he wanted us to do well and act right.

He wasn't beating us down so that he could feel good about himself or make us small. He wanted to make us stronger. That's the difference between Mr. Asher and Roscoe. That's the difference between Mr. Asher and my math teacher, who always used to tell us how stupid we were and how we would never amount to anything. He was the absolute worst.

Then there was Miss Beberman, my Spanish teacher and the first teacher I had a crush on. She used to wear these tight pants every day and she had nice legs and a nice *culo*. (I guess I learned something in her class.) I would sit in her class with my head down on my desk and peek through my folded arms. I was going through puberty at the time, and just about anything excited me.

While other kids were conjugating, I dreamed of copulating. (Do I hear lyrics?) Miss Beberman used to blast me for not

paying attention. But she used to also say to me, "James, one day I'm gonna see you in the papers." Little did she know it would be for having platinum albums, winning a Grammy, having a television show, or starring in movies. Thank God.

It was around this time that I started getting more and more into rap, which was big in my neighborhood. I would listen to tapes with kids from around my way up on Farmer's, where the hottest new joints were always available.

One day while I was walking the halls at 238, this kid was walking in front of me singing "Super Rhymes" by Jimmy Spicer. "And whenever you say disco, I say the beat," he rapped. "It tastes like honey and I say it's sweet."

Yeah. I followed him down the hall in a trance. I said to myself, "You know what? I like that." And as this kid walked out the school doors onto the street singing that tune, my interest in school walked right out with him.

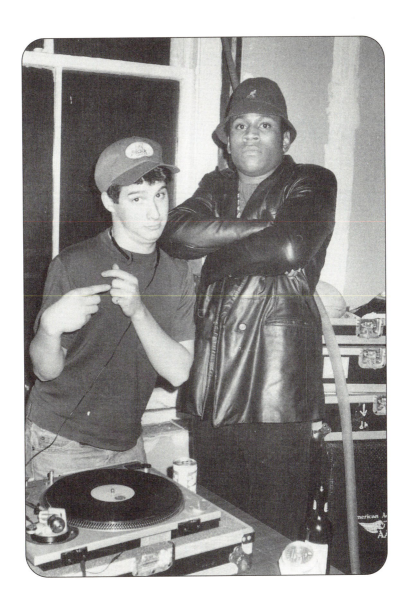

PLEASE LISTEN TO MY DEMO

All I ever wanted was a dirt bike. A motorized dirt bike. I was 11 years old, and it seemed like every cool kid in the neighborhood had one. So I wanted one too. I begged and begged and it looked like I was making some headway. My grandfather said, "I'll think about it." That was as good as "I'm getting it" to me.

But instead of waiting for my own, I wanted to practice, anticipating getting one. One of my friends let me ride around on his. I almost got killed, but it was a blessing in disguise.

My man gave me strict instructions on how to ride it. Something was wrong with the throttle and he had a shoelace tied around the throttle lever and around the handlebars so that you could pull the string and give it gas. But he told me, "If you stop, it might cut off. So don't stop." So I didn't.

I was riding down Jordan Avenue in St. Albans and, because I didn't want the bike to cut off, I ran right through a stop sign and was hit by a car. I flew into the air and landed in someone's front yard. I wasn't hurt too bad, I was just disgusted. I left his dirt bike right there and walked home. I was scratched up, though, and bleeding. I tried to hide my injuries from my grandparents, but somehow my grandfather found out about the accident. That was the end of my dirt bike dreams. But he had something better in store for me.

I had just come in one night, not long after, licking my wounds and feeling sorry for myself, when my grandfather called me upstairs to the attic. He was with his best friend,

I NEED A BEAT **53**

Mr. Jacobs, who was like an uncle to me. I said hello and my grandfather pointed to the corner. There sat two turntables, two speakers, a mixer, and a microphone.

Yo! My eyes popped like ten feet out of my head and my mouth fell open. I was amazed. I couldn't believe my grandfather would do that for me. He was this West Indian man who was very frugal. I knew he couldn't understand why I would want to have equipment to "scratch up some records," as he would say. And he definitely couldn't justify spending $2,000 for some 11-year-old to do that. To him it was just ridiculous. But my grandmother convinced him, and they went together to pick it out. He set it up for me in the basement in like an hour, he was such a wizard at fixing things.

And that was the start of my rap career. With the equipment, I was able to experiment with sounds and tracks. I was able to create music and rhymes. I could stop dreaming and start doing. That dirt bike became a distant memory.

When I got my equipment all hooked up I couldn't wait to run across the street and tell my man what I had gotten. All he could say was, "So!" He was so jealous because he wanted equipment too. But I didn't care. I just went back into the house and started doing my thing.

New York City rockin' . . .

If getting equipment gave me the tools to perfect my craft, the Sugar Hill Gang gave me the inspiration. It was 1979 and the Sugar Hill Gang was blowing up the charts with "Rapper's Delight." They had taken Chic's "Good Times," a song that had been out for a while, but was still rocking, and turned it into a rap song. It changed the face of music and it was the Sugar Hill Gang, along with Afrika Bambaataa and the Zulu Nation, who got me into rap. A lot of people look back at Sugar Hill as some corny group, but to me they brought rap to a whole other level. They put rap on the map.

I was 11 when I first saw the Sugar Hill Gang perform. It was at the old Harlem Armory, not too far from the Apollo. They had been promoting this concert for more than a month in my neighborhood. There were flyers on every tree, light post, and brick wall in St. Albans and I wanted to be there. Because for the first time, there was a form of music that literally spoke to me. Sugar Hill had my voice. They rapped about things I could relate to or wanted to relate to. They rapped about women and money, and about money and women. They had checkbooks, credit cards, cars, and clothes.

But I couldn't have cared less about the cars, the clothes, and even the women. What they really had that I wanted most was the power to say whatever they wanted. I mean all of those things were nice, but I never got into rap for the cars, the clothes, or the women. I got into rap for the power. I wanted to be heard. I wanted to make a record and hear it on the radio. It was just that simple.

I begged my mother every day for a good two weeks to take me to that concert. And every day the answer was, "No!" Sometimes, it was even "No, and don't ask me again." The night before the concert, though, my mother came into my room and pulled out two tickets. Yo! I couldn't believe it. I loved her for that. I loved her anyway, but I really loved her for that. I was so excited, I could barely sleep.

The next day I got up early and got dressed in the flyest gear I had: jeans, a real tight, tight, tight red T-shirt, and a jean hat. (Of course I wore a hat!) All I could think of was how good the show was going to be. I made Moms take me there two hours early so I could see the groups arrive. We got to the armory early enough to get a spot at the barricade, right out front. It was so early, they hadn't even opened the doors yet. More and more people started showing up, so I hugged that barricade like my life depended on it. I didn't want anyone to get in front of me. I saw the Crash Crew come in with their

matching Crash Crew jackets, looking like a real group. I was in awe. I stood around for at least an hour and a half just checking everything out.

When the doors finally opened, I ran in and got right up front next to the stage. My mother went to find a seat. But I wasn't about to sit in a seat. I had to be where the action was. I didn't want to be looking over anybody's head. I wanted a clear shot at hip hop.

Besides the Crash Crew, the Funky Four Plus One also performed. I remember their whole act. It was pure energy, and it was exciting. And the crowd was feeling it. Sometimes, though, it seems that all good things must come to an end. While the Sugar Hill Gang was performing, someone shot off a gun and all hell broke loose. People were running and shoving and pushing. I jumped over the barricade and crawled under the stage, and all I could see were all kinds of feet shuffling and running, trying to get out, and people were screaming and yelling. I don't know how, but somehow my mother found me and grabbed me and dragged me out of there. Nobody was hurt—it turns out someone just fired a gun into the air—but I wasn't really surprised when she told me that was the last time she was taking me to a show. She obviously had not felt the excitement and exhilaration I had experienced. And she was not about to go back to another show where people got wild and rowdy and started shooting off guns and freaking.

Stuff like that happens at rap shows today. That's why insurance is so high and that's why ticket prices are ridiculous. I wish miserable people would stop making everyone else miserable. Then again, you know the cliché: misery loves company.

But then, I wasn't thinking about the consequences of actions like that. Frankly, I didn't even care except for the fact that my moms said she wouldn't take me anymore. I figured she wouldn't have to, though—because I would be up on that stage the next time.

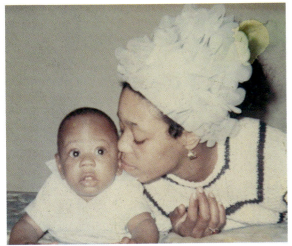

That's a photo of me and my moms. She's whispering sweet nothings in my ear, showing me some early love.

I came from a musical family. There's my grandfather (second from right, bottom row) in his jazz band.

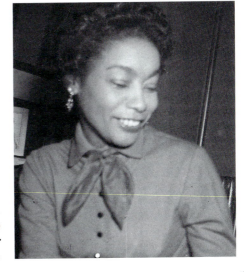

That's my grandmother. She's still beautiful, even though she's now in her eighties.

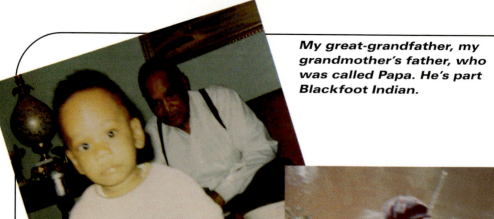

My great-grandfather, my grandmother's father, who was called Papa. He's part Blackfoot Indian.

This is me, fishing. I never did catch anything, but it was a good try.

My grandfather at the hardware store, getting ready for another project.

Me and my moms. She must have mentioned something about ice cream just now.

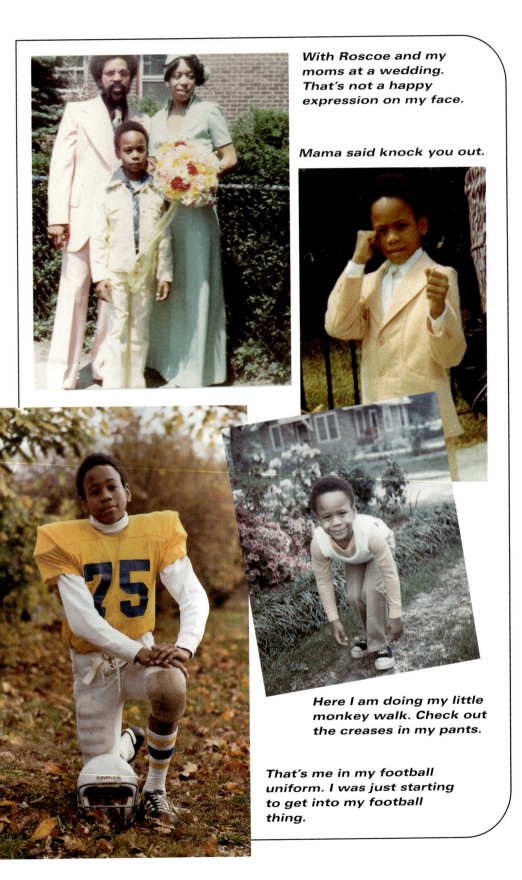

With Roscoe and my moms at a wedding. That's not a happy expression on my face.

Mama said knock you out.

Here I am doing my little monkey walk. Check out the creases in my pants.

That's me in my football uniform. I was just starting to get into my football thing.

At a point in time, I let my afro grow out. . . .

Me and Santa. I'm digging his hat.

Here I am, trying to get my rhymes in order, a man with a vision.

Me and Adrock. I got mad love for you, Adrock, baby.

(Ricky Powell)

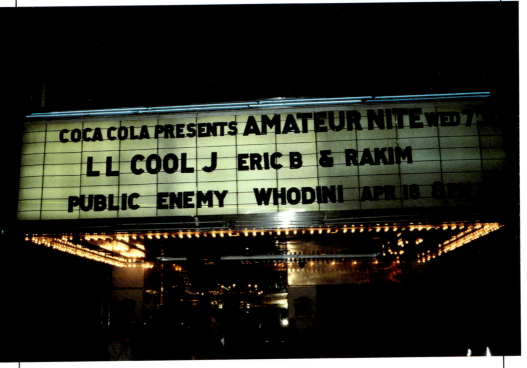

COCA COLA PRESENTS AMATEUR NITE WED 7
L L COOL J ERIC B & RAKIM
PUBLIC ENEMY WHODINI APR 18

My name in lights—the marquee at the Apollo.

(Ricky Powell)

Me with my boys: Bobcat, Cut Creator, and E-love, in the "Bad" days.

(Ricky Powell)

Cut Creator. The one and only.

Run (from Run-D.M.C.) is always making somebody laugh. Love you, baby!

(Ricky Powell)

I'm crazy cut here, rocking the mike.

(Ricky Powell)

That smile says it all. That's me and Simone, spending some newfound cash in Aruba.

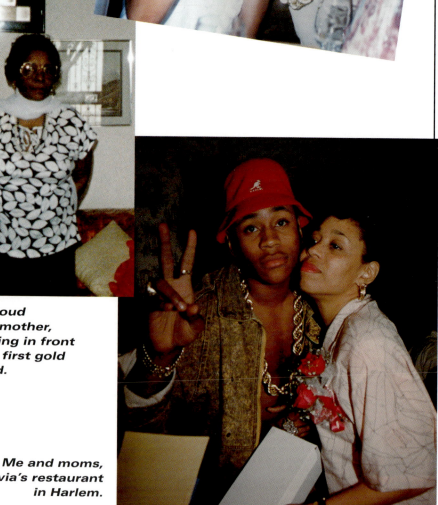

My proud grandmother, standing in front of my first gold record.

Me and moms, at Sylvia's restaurant in Harlem.

Me and Kidada.

Me and Brian Latture with Ed Koch, the former mayor of New York. (Mayor's Photo Unit—Joan Vitale Strong)

Loungin' with Cornell and Simone—my main man and my main girl.

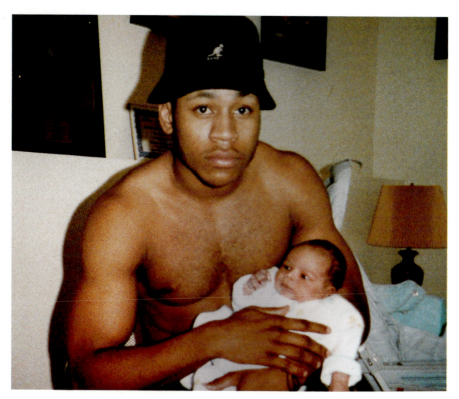

Fatherhood scared the hell out of me, B.

Guess what I was thinking.

I was the coolest—literally— spelling my name in ice cubes.

Living real large.

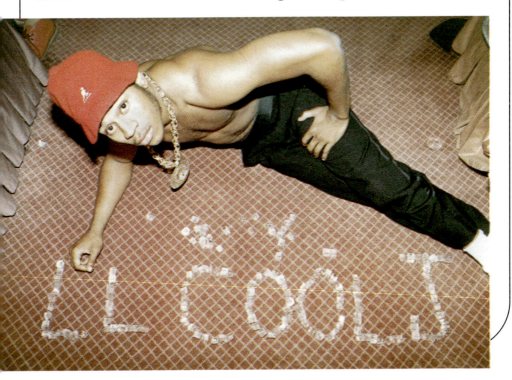

Quincy Jones (right), my mentor, Charles Fisher, my other mentor, Simone, and me at Rock the Vote.

Me with President Clinton at an Americorps signing.
(Official White House Photo)

Najee, Tally, and Daddy.

Simone. Ain't she hot?

I know you've all been wondering. The chainsaw marks, the deformities, the burns . . . must be in the back. (Lynn Goldsmith)

I do. Finally.

(Ron Thomas)

My four babes. This photo was a Father's Day present to me.
(Lauder Photography)

Smith family Christmas. Peace, y'all.
(Lauder Photography)

That concert gave me a yearning to go where I am now and to do what I'm doing today. I could see myself up on stage with the mike in my hand, people screaming and rocking, and me just loving it. Sometimes I used to sit in my room and imagine I was a teacher in a classroom with a thousand students. And I'd be teaching in rhymes. Now that it's a reality for me, though, I realize it's much more and much different than I ever imagined. And then some.

I came home after the show and practiced my stuff in front of the mirror. At first I hated my voice. It was nasal and just didn't sound good. It didn't sound like the guys on the records. But I kept practicing, trying to say words that sounded best coming from my voice. I know that sounds funny. But think about it: Can you hear Busta Rhymes on his record *Woo-hah!* telling you he wants to kiss a woman gently on her neck? I don't think so. Or Chuck D from Public Enemy: "Bass, I want to make love!" It doesn't work. But I kept listening to the great rappers and what made them great. And I found that each of them was doing rhymes that accommodated their voices. So I had to find mine. And I did.

A hip-hop creature, concert feature
Amateur teacher, my rhymes reach ya
When I commence with excellence
It eradicates levels of pestilence
Upon a plateau
No mortal can go
Mythological characters stand below

After that, I thought every rhyme I ever did was the bomb.

For the first time in my life I had power. No one could tell me to shut up. I could say something, anything I wanted, and not be afraid. I could be as powerful as I always wanted to be.

The music and rhymes helped me escape all the pain. It was an opportunity to dream. One thing about a pen and piece of

paper—nobody can stop you. You can just go wherever you want to go in the world of lyrics and words:

I'm on the move. It's 1765—no one knows that I escaped the plantation and built a spaceship and flew here. I can write that. Know what I mean? *Psyche! I'm really in Bed-Stuy. Just kidding, I'm on another planet—the mirror image of the Earth. Everything here is the opposite, except there's only one sex and we mate mentally.* Yeah, through words I could go wherever I thought to go.

I would come home from school some days (I had my own keys, and if I forgot my keys I would climb in a back window that I always kept unlocked) and if Roscoe was out I would play some of my mother's record albums on the sneak. My mother didn't know it then, but I was in love with music. I kept this secret so no one (like Roscoe) could spoil it.

Sometimes I would stare at a record and imagine what the world was like inside the vinyl: happy people having parties, having fun, laughing, loving. My reality at the time was that reefer, cocaine, and dirty magazines were all lying around the house. But I was getting high off Harold Melvin and the Blue Notes, Marvin Gaye, and the O'Jays.

When I went to my grandparents' house on the weekends, my grandfather was still cranking up his jazz at high volume. Miles Davis, Wes Montgomery, Richard Groove Holmes, and Freddie Hubbard were in heavy rotation in the Griffith household. It used to bug me out when I was a kid, but by now I was digging all that jazz. I would even listen to the Beatles and the Rolling Stones, and even the Smothers Brothers. You believe that? Well it's true, and I was learning to appreciate all kinds of music. I preferred some genres to others, but I could recognize what was good and what wasn't so good.

At home I would try to sneak a little Richard Pryor when my mother wasn't home, for comic relief. Homeboy cracked me up. I loved his Mudbone routine, and he had jokes that were

just off-the-wall crazy. He had this one routine about a pet monkey and a chandelier and a female monkey and . . . well, all of Richard's jokes end nasty.

Richard was crazy. I would usually go to school the next day and run his jokes for the kids. (I wish I could run a few of my favorite jokes here, but the early stuff, the really funny stuff, is a bit too off-color.)

Of all the different types of music, R&B was where I discovered what true love, the kind of love that I wasn't getting at home, was all about. One song that stuck out was "Brandy." That guy really missed Brandy, and I could relate. I would lie on the living room floor and be missing my grandmother and my grandfather listening to it. I found out later that it was all fiction and that Brandy was a dog or something. But it didn't matter to me then. I was feeling the soul of that song.

Meanwhile, rap was getting strong, and I was getting hooked. There were a lot of underground rap tapes circulating in my neighborhood in Queens and even some in Long Island, and I listened to them all: Kurtis Blow, Grandmaster Flash and the Furious Five, and, of course, the Sugar Hill Gang. With each new group, I got deeper and deeper into it—and it got deeper and deeper into me. It was an escape into a fantasy world. The images were so vivid and so much better than the real life I was living. I was just hypnotized. There was power in this rap music, and it put me under a spell I've never come out of. Rap spoke to me, and in it I found myself and the power of my voice. Rap music was my escape from a living hell.

I guess I started rapping with kids around my way in Long Island when I was about nine, when Kenny and I began writing rhymes in the McCulloughs' backyard. Before long I was spending more time working on rhymes than I was on homework.

By the time I was 13, I was itching to start my thing on the underground rap circuit where acts like Luvbug Starski before

me became famous. And more than anything I knew I wanted to make records. So I spent most of my time in the basement making tapes. I was determined to be heard.

Jay Philpot was one of the most popular DJs in my area. There were others, the Disco Twins, who were known Queens-wide, and the Albino Twins, but Jay was Mr. Farmer's. He was like a big brother to me and just about all the other kids in the neighborhood. He had the biggest system around with huge speakers, the best turntables, and the latest mixer. Several up-and-coming DJs in the neighborhood got together, calling themselves Ebony Sounds, and they all chipped in to buy the equipment. But it was stored at Jay's house because there was no disputing it: Jay was the man in charge. When Jay got on the turntables, he did his thing. The scratching, the mixing, and that bass, you could feel it all the way to Ilion Avenue. He drew a crowd wherever he went.

I wanted to grab the mike and rock with his beats so bad I could taste it. All summer I had been begging Jay to let me get on the mike. But he looked at me as a little snot-nosed kid. He kept telling me, "Maybe next year, kid." I couldn't wait until next year. Next year is forever when you're 13. I had been prac- ticing and writing rhymes for almost two years. As far as I was concerned, I was ready.

I finally wore him down by the end of the summer. He was doing a block party at 113th Avenue and came and got me. They set up the equipment and my fingers were itching to grab that mike and rock the party. But they were having technical diffi- culties. There was a short in a wire and they couldn't get it working. On the other side of the block, a rival DJ crew already had their sound pumping. I walked across the street and asked them if I could get down. They handed me the mike.

"Good Times" was mixing with "Dance to the Drummer Beat," blaring out of the Cerwin Vega speakers. The kid on the turntables was scratching some ill beats. Then he looked over

at me. I was up. I ran down a routine I had rehearsed in my bedroom and in my head in school, when I should have been paying attention to Miss Beberman.

I rapped. People started looking up at me, stopping what they were doing. Even Jay had to pause and check to see if it was really me. I let it all roll out. It just flowed.

And when I said, "Throw your hands in the air," they did. And when I said "Somebody scream!" the block lit up with the high-pitched screams of the ladies. I knew then that I had a captive audience. After the show Jay blasted me for being a traitor. I was supposed to rock his set. But I was hungry. I couldn't wait for him and his crew to figure out what was wrong with their equipment when there was a crowd just waiting to be "Johnny Blazed." I was too young to understand the bad politics involved in breaking camp and performing on a rival set. I didn't care. I was just hungry. And those guys were willing to give me a chance.

But even though Jay was angry, I knew he couldn't believe this little kid was rocking like that. And Jay was hard to impress. He was five eleven, 240 pounds, and nobody messed with him. He was the state heavyweight wrestling champion and he later won a scholarship to Syracuse University. He wanted to be a teacher. And he was serious.

He was the one in the neighborhood who was always breaking up the fights. (He had a few, too.) Like one time I got into a fight with this guy who had just moved onto our block from Brooklyn. The kid wanted to fight because he thought he could. When I was coming up, I had a real innocent-looking face. I couldn't grow facial hair for the longest time, and I didn't have the size on me that I have now. Guys used to always try to punk me because I didn't look like a tough guy. Big mistake. This kid was one of them. He was short and stocky, and I was kind of tall and real thin. He was so short I couldn't reach him to hit him and he couldn't reach up to hit me. So we're standing there

in the street, swinging at each other and missing and generally looking stupid. And then one by one his whole family comes out, acting like they want to jump in and help him. There were like 1,100 of them living in that one house, like 1,100 people crammed in a phone booth.

Jay jumps right in the middle. He told them I had to fight the guy one on one. Then he took the belt off his Lee jeans and said if anyone jumped in, he'd whoop their a** with his old school belt buckle. Nobody jumped in.

Because I was a little mental, one time I even tried to fight Jay. We were on the road together in Philadelphia at the airport hotel. I thought he disrespected me about something—it didn't take much back then—and I jumped on him. But—with like one hand—he pinned me down on the bed. (I bet he couldn't do that now.) He got up and I chased him, and he ran into the bathroom and locked the door. I was so mad he wouldn't fight me that I was kicking and banging on the bathroom door. I should've been glad Jay didn't come out. If he had, I definitely would have gotten lumped up.

After that command performance at the 113th Avenue block party, though, Jay started taking me places with him. He would come over and ask my mother or my grandmother permission to take me to a party to work with him. We might make $50, but I would do it for free, for the attention. I did it for the love of the music, the love of holding the mike and rapping. By the beginning of the winter, Jay had dropped out of Syracuse and enrolled at City College. We started doing parties every other weekend.

By now I was 14 and really feeling this thing called hip hop. I wanted to perform all the time. I would hang out in joints like the Brown Door, an underground club in Queens, and listen to what was hot and try to get down. I would be at house parties, basements, anywhere I could rhyme and just hold the mike.

At the same time, I was buying or listening to every piece

of rap I could get my hands on. I also started thinking about a record contract. I would go to record stores and write down the labels of every rap record they had. Then I would send a tape to each label—CBS, Sugar Hill, Island, Tommy Boy, Electra, Profile, Enjoy. I imagined myself getting signed to any one and becoming a huge star. But two weeks later, the letters started coming in. Most of them started the same way: "Thank you for your interest in CBS Records, but . . ." Always that "but."

Within a few months, I was getting so many letters that had the "but" in it that it wasn't even funny. In the beginning my mother and grandmother were right there with me, consoling me. But after a while, I was so frustrated I didn't want them to know. So I started hiding the letters, or just throwing them away. They knew what I was doing, but they never imagined where it would end up.

None of the record companies were feeling my art. The letters kept coming in. Sometimes I wanted to cry, but I didn't. If I had cried that would have meant my spirit was broken and I would have quit. But something inside me told me to keep trying. And I persevered.

I can really relate to what young artists go through, hell, what anybody goes through trying to make something happen in their lives. That's why I hardly ever turn down a budding rapper who wants some advice or who has a tape they want me to listen to. Because I've been there. I know what it feels like to be turned down and rejected—especially when you know you're good.

So one day I'm sitting in my room with yet another rejection letter (I think it was from Sugar Hill) crumpled up, with this look on my face. My moms comes in and sees me with the paper. I told her there was no reason to continue. It seemed like nobody was going to give me a break.

During this time I had all kinds of false hope. First Jay kept

talking about his friend's cousin who worked at Electra who was going to get us a deal. Every other day it was this friend's cousin getting us a deal. We're still waiting on that one.

Then this guy named Sam Curry who had produced Hassaan and 7-11, a group that had a couple of big hits like "Living in the City," had gassed me up. He told me he was going to get me a deal. He even sat down with my grandmother and explained what he was doing. I thought it was going to happen. He took me into the studio with Hassaan to get a taste of what I would be doing. And I was hyped. I sat there one evening in the Power Play studio in Long Island City, Queens and wrote a piece of "I Need a Beat" while they were recording. I was that inspired.

But Sam Curry never came through, and I had enough rejection letters to start a really good fire. And I was ready to give up. It was my mother who told me to keep going. And she decided to do her part in fulfilling my dream. She used her income tax return—about $600—and bought me a drum machine. I know how hard it was to part with money back then, but that drum machine was to change my life. I took it over to my man Frankie's house. Frankie, who we called Finesse, was another brother who could rock the turntables. He had some fly equipment and I needed him to do the scratches for "I Need a Beat."

Thinking back, I really appreciate my family. It just shows how important family support is. I mean every step of the way, my family was there to give me that little extra push or that big push to make sure I fulfilled my dream. That's love.

We didn't even know how to program the machine. We ended up doing it manually, taping the beat on a cassette and then, while playing the cassette, rhyming over it onto another cassette. After we got the beat and the rhymes on to one tape, Finesse came behind and did the scratching, and boom, we had a demo. It wasn't great, but it was better than the other 50 or so I had sent out.

My last shot was this dude named Rick Rubin. He was a student at New York University who was making a name for himself as a producer. He had produced "It's Yours" by T-La Rock and Jazzy J, a pretty big rap hit. I found the 12-inch at the Record Explosion on Jamaica Avenue and copied his name and address off the back. I sent him my new demo.

When I didn't hear from him right away, I called him. He also had his phone number on the back of the 12-inch. I can still remember the number: 212-420-4770. I called him every day. Sometimes I got the answering machine:

"This is Rick, nobody's in right now, leave a message. *Beeeeeep.*"

When I did get the real Rick on the line, I didn't waste any time with formalities like, "Hi, my name is Ladies Love Cool J [a mouthful, isn't it? That's why I shortened it to LL] and I sent you a tape." I just cut to the chase: "Rick, did you get it?" was all I would say. Every day I would call him to see if he got it.

"Rick, you get the tape yet?"

He would say, "Not yet."

"Rick, you get it?"

"Not yet."

Little did I know, my tape was sitting in his junky dorm room, in a big box of tapes with hundreds of other wanna-be rappers.

SIX

ESCAPE TO PLANET HIP HOP

I came home from school and ducked into my grandparents' house through the side door. I couldn't tell you what I was wearing (but I know a hat was on my head!), I don't know what the weather was like, or even what day it was. All I remember is walking through that door and hearing those words that I had been waiting to hear for weeks. Make that a lifetime. "Some guy named Rick called," my grandmother said. But I heard: "Todd, you made it!"

Rick Rubin had finally called. Suddenly, it seemed that all those months of writing, sending out tapes, getting rejection letters, writing, sending out more tapes, getting rejected again and again had paid off. One telephone call made all the pain and torture and perseverance mean something. It was one of the happiest moments in what seemed to be a hard-luck life.

I called Rick and he said, "I got it!" He told me to come down to his office, which turned out to be his dorm room at NYU in Greenwich Village. He was going to school and producing rap at the same time.

I caught the F train into Manhattan and was sweating the whole 50-minute ride. The train was hummin' as usual. But despite the nasty subway smell, the ride was pretty sweet. I got off that train and entered what was, for me, a new world. I had never been to the Village, and it almost put me in a culture shock. In Queens, everything was laid back and similar. The same people did the same things in the same places all the time. Here, all kinds of people were walking around, and I had

no idea who they were, where they were going, or what they were up to. But none of that really mattered, because the only thing I was thinking about was meeting with Rick Rubin and cutting a deal so I could finally become a rap star.

In life, though, nothing is ever easy. Right when I was standing on the verge of getting it off, my grandfather had gotten sick, and was in and out of the hospital a lot. I guess getting shot was finally catching up with him. He was having liver and kidney problems. So this meeting with Rick Rubin was even more important to me. I wanted to accomplish something big, not just for me, but for my grandfather, who always had my back and who always believed in me. On one of his last trips to the hospital he had been lying in the bed with the radio on in the background. A song came on, and my grandfather said to my grandmother, "There's Todd on the radio." She knew it couldn't be me and said, "That ain't Todd!" He yelled at her. "You shut up," he said. "It is too Todd." Maybe being sick and lying in the bed with a lot of time to meditate, he could see where I was going to be even before it actually happened.

I found Rick Rubin's dormitory on University Place. The building had a doorman and I had to wait for Rick to come down to the lobby to get me. As I stood there, I thought of all these great things to say, like, "Yo, man, I'm ready to be a star," and "There's plenty more where that came from." Then maybe I would hit him off with the rap I'd written the night before. But when he was finally standing there in front of me, all that came out of my mouth was, "Yo! I thought you were black!"

I had been speaking to Rick for weeks and I could have sworn he was a black man. But there he was, a white Jewish guy. This was a rap producer? Hell, no. I had always thought that rap music was produced by blacks. It was our music, our vibe.

But obviously I was wrong and I shrugged it off. Hey, I

didn't care if Rick Rubin was purple and worshipped penguins. He could have been Ronald McDonald, as long as I got a record deal.

He laughed at my reaction to him and invited me up to the tiny room at the end of the hall. Mattresses were on the floor and records and tapes were thrown everywhere. I could see how my tape would have gotten lost. In fact, if it wasn't for Adrock of the Beastie Boys, I might still be sending in those tapes. (You should see how many Def Jam gets now.) Anyway, Adrock had been chillin' in Rick's room, rummaging through all the tapes, and somehow he fished mine out and played it. I guess he liked what he heard and brought it to Rick's attention. My man Adrock: Good lookin' out, baby!

Rick and I talked for about an hour and we did another demo on his equipment. He knew how to program *his* drum machine. I began to see what real production, even in a dorm room, was all about. I made up a rap right on the spot and we called it "Catch This Break." The hook went like this:

If you're looking for a jam that'll make you shake,
Buy this record and catch this break!

When we finished, we took the tape over to Russell Simmons' office on Broadway. Rick had told me that Russell was the man, the money man, and could make it all happen.

Russell sat behind an old wooden desk in an office the size of a closet. A receptionist, Heidi Smith, was out front. It was a far cry from the high-tech, super luxurious, corporate-style offices Russell has now. He listened to my demo and scrunched up his face. "Nah! It's the same old thing," he said. "That's just like the Treacherous 3 and everybody else! It's the same old thing."

But even though I had just met him, Rick had my back. He convinced Russell to give me another shot. So we went to a real

studio and recorded "I Need a Beat." My man Finesse, who did the scratching on my demo, wanted to come, but his parents were hassling him about wasting his time with this rap thing. He was going to LaGuardia College and they told him to make a decision—go to school or be a fool. He said he really wanted to go to the studio with me, but he decided to listen to his parents and go to school that day. Now I can admire that decision, but back then it was like, "Okay, next!" I called this kid Phillip, who I knew through my underground connections. He was a decent DJ who rocked over in Corona, Queens. He was the original Cut Creator and is featured on "I Need a Beat."

At the studio, I pulled out all the stops. I even called my grandmother, who has become my music consultant over the years. I played the cut over the phone, and she told me it needed more bass. Even though she wasn't particularly into rap, she knew music. (She didn't have a choice living with my grandfather.) And I knew if I could put down something my grandmother liked, I would have a hit. She hasn't disappointed me yet! Six platinum albums.

Russell really loved "I Need a Beat," and the next day he and Rick formed Def Jam. They came up with some deal that would benefit them more than me. But of course, I signed anyway. I didn't care at all. I really would have done it for free (don't tell Russell). I just wanted to rap and hear my joint on the radio. Looking back on it, they were just being businessmen, very good businessmen. It's all part of the game.

"I Need a Beat" wasn't out a week before I did hear it on the radio. DJ Red Alert gave a lot of underground rappers their starts by playing their demos on the radio even before they had contracts and stuff like that. And he was playing my song on KISS-FM while he was talking about something. I don't know what he was saying, but I know that it was my record he was talking over and man, was that an honor.

The first time I heard the entire record was on a Friday

night countdown on KISS-FM. I was hanging out on Farmer's Boulevard with a couple of my friends at a video game arcade. When it came on, I just walked out. Someone came out and said, "Man, they're playin' your joint." I just nodded. I stood outside on the street while everybody else was inside in the game room enjoying my record. I wanted to feel that moment all by myself, to relish it. I was standing there smiling, in a daze. You know those shots in the movies where the camera pans around the guy? He's in focus and everything around him is blurry, out of focus. That was me. It was like time had slowed down, the Earth was spinning half time and it was just me and my record. I felt so good, I felt I had kissed God.

Rick and Russell set up all of these performances for me all over the city. I had one problem, though, which was who to take with me—Phillip, who was Cut Creator, Finesse, or Jay Philpot, who had been down with me from Day One. Finesse eliminated himself. So it was down to Phillip and Philpot. I had to do this promotional (that means free) appearance at a club one night, so I brought both Phillip and Jay. Phil did "I Need a Beat," and me and Jay did some of our old school, from-around-the-way stuff. Jay and I just clicked. The crowd went wild. I know that's a cliché, but that's what happened. I felt their energy.

I don't know where Phillip ended up. But from that day, Jay Philpot became Cut Creator. Our first professional (meaning paid) performance together was a concert at Manhattan Center High School in Harlem. They turned the cafeteria into a concert hall by pushing the tables together to make a stage. The show was supposed to start at 7 P.M. on a Saturday. And we were supposed to be there by 6:30 P.M., but the axle broke on Cut Creator's old Cutlass. Luckily, we weren't too far from the school and walked the rest of the way. It was June and already hot as hell. But we got there on time.

Jay was paranoid about leaving his car in Harlem—like

somebody was going to steal a busted-a** Cutlass with a broken axle. Right before the show he ran down the street to check on it. But when it was showtime, the only thing we were thinking about was rocking the house.

We hadn't rehearsed. We didn't have to. We had been performing together for so long, doing block parties, that we knew each other's moves and everything. I ran out on stage—Cut Creator was already out there at the turntables—and I could feel the anticipation of the crowd. They were so hyped. I couldn't believe it. It's one thing to rhyme for your peeps around the way, but it's another thing to see total strangers going bananas for you.

My single "I Need a Beat" had only just dropped, but it was playing on the radio in heavy rotation. I was feeling like I was becoming the man. And when I started doing my thing, the girls started doing theirs. They were screaming and looking like they were gonna pass out, like the women at a Michael Jackson concert. I'm wearing these tight-a** sweatpants, the ones with the double white stripe down the side. They call them booty chokers now, but back then, that was the style. I had on my white Pumas and a matching Kangol, pulled down real low on my head. The ladies were letting me know what I already knew—that I was looking good. Hmmmm . . .

After the show a bunch of girls were waiting for me at the stage, yelling "LL, LL!" Yo, I was getting bum rushed for my autograph! I signed napkins, school books, arms, legs, just about everything. I looked over at Jay and gave him a look that said, "Oh yeah, this is it." And I had a permanent smile on my face.

After the show, we had to worry about getting home, because Jay's Cutlass had died. It's hard enough getting a cab to go up to Harlem, let alone getting one to get out late at night. So we had to think fast. Jay decided to call the police and tell them somebody hit us and kept on going. With the condition

Jay's car was in, it was believable. They came, took a report, and called us a tow truck. We ended up spending most of the $300 we made that night for the tow and getting home. But I didn't care. That whole experience had been priceless.

Russell set up more and more concerts and promotional appearances. He also hooked me up with Cornell Clark, who was helping him manage other acts like Kurtis Blow and the Fearless Four, who were just coming out. Cornell was this strange guy who was into everything. He was a choreographer, nutritionist, singer, a martial artist. You name it, Cornell would swear he had done it.

To me he was hilarious. The first time I saw him, I couldn't stop laughing. He didn't mean to be funny, he just was. I was with Jay, hanging in Russell's office at Def Jam, and in walks this man with about 15 folds on his face, like one of those wrinkly dogs, a shar-pei. When he talked, the different sections of his face all moved in different directions. He was the funniest-looking guy I had ever seen.

He introduced himself with a lot of bravado, confidence, and lisps: "How you doin', you know, my name is Cornell Clark, you know. You know, how you doin', you know." I liked him already.

He kept going. "I'm into managing artists," he said. "I know that I can help you too, with your nutrition, choreography, and dance steps. I can make sure you're a whole person. I make sure that my artists are really being taken care of, to the best of, to the best of my ability."

I looked at Jay and Jay looked at me—and we busted out laughing. Cornell rolled his eyes but kept on talking. Every time he opened his mouth, we laughed. But he was serious with his stuff, and he wound up being one of the best friends I ever had.

It was Cornell who convinced me to hang out on the set of a movie they were making about rap called *Krush Groove*. He

said, "Just go down there and let them feel your presence. They will have to use you. They need you."

He was right. If you watch the movie, you will see me in a whole bunch of different shots. In one, I'm pushing crates back and forth. In another I'm walking by while two people are talking. I'm mopping up in another scene. I'm in a shot where I'm dancing with a group of people offstage. I was on the set so much, every day, begging to get on camera, that I became an extra to the fifth power.

Russell and Rick finally convinced George Jackson and Doug McHenry (who wrote and directed *Krush Groove*) to give me a cameo doing "Radio." Ironically, I was supposed to do a video of the song that same week, but I overslept. Def Jam lost $50,000 on the deal. Russell called me and went off:

"What?! Are you crazy? You overslept? The crew was waiting. It cost us fifty thousand dollars!"

To this day, I still have a problem getting up early in the morning. I schedule most of my meetings for late afternoon, early evening, so I can sleep for 16 hours at a time with no problem. I guess I got that from my mother. When she's sleeping, there's no waking her up. I'm the same way.

So my *Krush Groove* cameo ended up being my video for "Radio," my second single. It was perfect, because it exposed me to a much wider audience than I would have had with just the video. At that time MTV wasn't really kicking rap (*Yo!MTV Raps* was years away).

In less than six months, "Radio" was a hit and I began to realize my dream of making it. But before the success were pitfalls. First, my grandfather died. I came home from a performance and my mother told me. All I could say was "Oh." It was the single most painful event in my life. I couldn't even go to the funeral. And again Roscoe was there, making it worse. He was smoking a joint in the basement after the funeral, blow-

ing the smoke out of the window and laughing. I was so numb I didn't even react.

My grandfather was the only man in my life who had never disappointed me. And his death hurt me to the core. I really turned off a lot of things after that. I stopped listening to my mother and grandmother. I really shut down. I was very angry, yet focused on my career at the same time. For a time, I would ride around the city on buses with guns in my pockets, just for the hell of it. But then I'd go to the studio and knock out another cut for my album, *Radio*. It was crazy.

I was 16 years old and thought I was grown, but I was a very troubled young man. I was also in a beef with my grandmother over school. She didn't give a damn about rap, if it meant I might give up school. She wanted me to finish, and that was that. And she was on me every day about it. I was doing shows on the weekend and I was too exhausted to get up on Mondays and go to school.

I also didn't want to go to school because of the jealousy I had to face. Every day I had guys in my school who wanted to fight me, just because. And yeah, I was down to fight, but after a while I just got tired of fighting for no reason. I also felt that I wasn't learning anything there. School was too slow for me. So, I made up my mind that I was just going to make music and make money.

I had money in my pocket, a VCR, TV. I figured I was doing better without school. But I was wrong. And my grandmother was on point, as usual. She knew that no matter what happened in my music career, having a diploma was important. I wish I had listened to her.

She felt that I was not making enough money in the music industry, and she did not want me to give up on myself. I only had one record at the time, but I thought that was all I needed. I was thinking, If my grandfather were alive, he'd understand.

He wouldn't be on my back like this. He probably would have been, though, looking back.

My grandmother was just fed up with me, fed up with the fighting. So she gave me an ultimatum—either make school my priority or get out. Well, I left. I stuffed all my things into a big green Hefty bag—my clothes, sneakers, hats (of course), and some peanut butter and jelly that I took out of her kitchen cabinet.

Ironically, even with a record and an upcoming album, I had no one to turn to. I hadn't gotten my advance yet and my moms was sticking by her mother's decision. So I was literally homeless. What did I do? I slept on the trains for two weeks. I would hang out all night and at about noon I would hop on the E line at Hillside Avenue, riding back and forth from Queens to Manhattan and napping until rush hour. It was the same routine every day. I hardly bathed, brushed my teeth, or anything. If I stopped by a friend's house I would ask to use the bathroom and try to brush my teeth with a wash cloth and throw on some deodorant over the funk. I was just nasty. And so were the trains. You never know how nasty the trains are until you have to sleep on them. But I was so full of venom, pain, and just full of myself—full of pride—that I didn't care.

I would go to Russell's office, looking crazy, with my Hefty bag. Cornell finally saw me and was like, "What the hell is going on with you?" I told him. And he offered me a spot in his basement. He didn't ask for any money or anything.

Cornell was from uptown, Harlem, but he lived in a small house in Ozone Park, Queens. I chilled in his basement and listened to New Edition records to see if I could pick which would be their next hot single. I stayed with him for a few months. And it was there in his dusty basement that I finished all of the writing for my first album. Cornell saved me.

He gave me a lot more than an alternative to the subways, too. I always wanted to go out to eat. McDonald's was one of

my favorite spots. Later, when I first started touring abroad, the first thing I would do would be to check if there was a McDonald's. Even today I might pop into a McDonald's for a Big Mac, a Coke, and an apple pie.

Back then, I was in there every day. Cornell would say to me, "Why are you wasting your money like that? You'd be better off if you got some ground beef from the supermarket. For the same money you're spending in McDonald's in one day, you can have hamburgers for a week."

My man didn't just tell me, he showed me. Cornell made the best greasy, sloppy hamburgers around.

He also taught me little tricks of the trade, like stage presence—how to command an audience. He taught me how to project my voice and keep it strong. He taught me how to breathe. Cornell also taught me karate and how to stretch. He had danced with the Alvin Ailey troop back when, and he knew a lot of techniques. He also taught me that when I'm performing and I really get out of breath to just smile real hard and breathe through my teeth.

What I learned most from Cornell, though, was sincerity and true friendship. I learned about unconditional love. People don't know how to be sincere when you have money. They only know how to be sincere when you are both broke. It's that simple: if you have any money, nobody is your friend. It's unfortunate and it's sad, but it's true. Cornell was different.

SNAKES, BUREAUCRACY, AND BULLS***

Russell and Rick handed me my first check for signing with Def Jam. It was an advance on my sales for $50,000. Yo, fifty *thousand* dollars! For rapping? All they wanted me to do was produce an entire album. Hell, I had been writing forever, I had suitcases and drawers full of raps, good raps. I had enough material to do five albums. And they were willing to pay me. And pay me that much? It bugged me out.

All I knew was it sure beat the only other job I ever had—as a delivery boy for the *New York Post*. That was the worst. For something like two dollars and fifty cents a day, I had to put up with a whole lot of aggravation. I couldn't make out half the addresses on those tiny-a** labels, in the dark at whatever time in the morning I was supposed to get up. People were rude and nasty. One time, I was selling papers on the street, and this guy stopped at a light. I gave him his paper, and as the light was turning green, he just took off. He jerked me for a quarter! I couldn't believe it. You can guess how long that job lasted. One day I just got fed up and threw all the papers I had in the sewer.

But this rap thing was something else. I couldn't believe they were paying me so much money to do something I really loved doing, something I would do for free. I remember holding that first check for $50,000 and thinking I had hit the lottery.

> *LL I'm bad, other rappers know*
> *When I enter the center, they say, "Yo, yo, there he go!"*
> *My paycheck's large, Mr. Bogart in charge*
> *Not a punter or hunter from a raccoon lodge*

I had never seen that many zeroes before. I started thinking of all the things I wanted to buy. I bought my moms a Mercury Cougar. I got myself some gold chains. And, of course, I bought plenty of Kangols. I spent a lot of time in Revel Knox Hats on the Ave. (Jamaica Ave., Queens). My look had to be right. And that started with the hat.

Calling all cars, calling all cars . . .
Be on the lookout for a tall light-skinned brother with dimples
Wearing a black Kangol, sweat suit, gold chain, and sneakers
Last seen on Farmer's Boulevard headed east
Alias LL Cool J
He's bad . . .

I used to get up every day and begin my ritual. Before I went outside, I got dressed, combed my hair, and looked in the mirror, and then put on my hat—which was a process in and of itself. I would hold it over my head and slide it on real slow, just right. And I would look in the mirror and be like, "Yeah, now I'm Superman!" Mentally, I wasn't right until I had on my hat. As hats started getting played out, I would be right up in Revel Knox looking for the latest style. I changed with the times. Basically, I was doing with my hats what Busta Rhymes is doing now with his clothes—I was making a statement. And the more people wondered and questioned me about why I wore hats, the more pleasure I got out of wearing them. I used to bug people out.

One time, I was in the Dominican Republic at Lyor Cohen's wedding. He's the current president of Def Jam and he was like a senior vice president back in the day. So I'm swimming in the ocean, body surfing, and this humongous wave comes and takes me under and my Kangol comes off. Yo, it was like everybody who worked at Def Jam ran out of the hotel, stopped sunbathing, came back from the golf course, to gather on the beach to see if I would emerge from the ocean without my hat.

Sorry, folks. I would have drowned before I came out of that water without my hat on. While I held my breath underwater, I searched with my hand for my Kangol. I found it and pulled it down tight and swam to shore. I just walked to the hotel, which was right off the beach, with this dripping wet Kangol. Everybody was cracking up. But I was still Superman.

> *MCs can't win, I make 'em rust like tin*
> *They call me Jaws, my hat is like a shark's fin*

In addition to buying hats, I had to make sure my gear was correct. Even before I made a record, I dressed the part—Sergio Valente or colored Lee jeans, the shell-top Adidas or Pumas, Le Tigre jackets, and, of course, the Kangols. I even had a pair of fake Gazelles. Remember them joints? By the time I got money to afford the real ones, they were played out. But I wasn't. I was looking good all the time.

Within a few months, I got another check for $50,000 for royalties from "I Need a Beat." The dough was rolling in. But with the bait comes sharks: advisors, managers, accountants came and went, all there to help me with my newfound wealth. And some of these homeboys definitely have too much fun with the money.

Early on, I'm sitting across the table from one advisor and he's saying, "Whatever you want, you can have."

I said, "I want a Mercedes." That was the car that said, "Yo, I'm the man!" And I wanted one. But really I couldn't afford it, not after taxes.

This man said, "You'll get your Mercedes."

What he should have said is: "Son, I know you're making a lot of money now, but there are no guarantees in this business. Why don't you put half of this in the bank and make sure your taxes are taken care of? Get yourself a nice, moderately priced car. The Mercedes can wait until the next album—take care of your future first."

About the only smart thing I did with my money during those early years was bank some of my first advance. I had also made about $8,000 doing shows. I gave that money to my mother. I don't know what happened to the second $50,000. It was just gone. I should have been advised on how to spend it. Of all that money, only the $8,000 I gave my moms to watch survived.

People have a tendency to look at young athletes and young entertainers who make a whole lot of money and then lose it all as stupid. But when you're an 18- or 19-year-old kid hooked up to middle-aged, sophisticated businessmen who have been through myriad scenarios involving money, you don't have a chance. And I saw crooked lawyers and crooked accountants early in my career. There are always people just hanging around trying to skim some of the cream you are making.

Some of those accountants and business managers can plan some pretty devious ways to get to your money. The young, up-and-coming star is defenseless. They play games with royalties and expenses, get kickbacks on your deals, over-charge you in ways you can never imagine. And they're smooth—they do this for a living.

But back then I didn't know anything about these games. Nor did I care as long as I was able to get my Mercedes—convertible, no less.

The vocalization techniques I employ
The voice of my shadow could take a toy boy
The injection of bells into this beat
The result—enough energy to amputate your feet
Greater insulator microphone dominator
My name is Cool J, manipulator innovator
Connoisseur, I'm sure my percussion will excite
These bells are gonna rock all night
Rock the bells

The albums kept selling and the money kept rolling in. "Rock the Bells," another hit off *Radio*, blew up like the World Trade. I mean, this record debuted at number five on Billboard's top R&B singles chart, which for a rap single was unheard of. Billboard wasn't even charting rap back then. By the way, Grandma helped me with the hook to this one, too. "It needs more bells and drums," she said. Platinum.

It took just a few months for it to go gold. And in less than a year, "Rock the Bells" went platinum. One million copies. Mo' money.

That song is still making money for me. Foxy Brown, a female rapper on Def Jam, features a remake of "Rock the Bells" on her last album, *Ill Nana*. A lot of people think it's a tribute to me, by the way. (Even *she* thought she was honoring me.) But it isn't. *I* was supposed to record that version for my *Greatest Hits* album that came out in 1996. But all this was going on during renegotiations of my contract with Def Jam. And they ended up giving it to Foxy to give me a little wake-up call. I mean, they own part of the publishing rights to it.

I'm not mad at them for it—both sides were playing hardball at the time, and that's the way it goes in business. But if I had known to hold onto my publishing rights back in the day, it never would have happened. No hard feelings.

Back then, though, I didn't care about publishing and points because all I was seeing was the pesos, the moola, the cream. I was spending like crazy. I bought a red Audi 5000. That was one of my favorite cars. In fact, I coined the phrase "Audi 5000," which means, "I'm out." It's amazing to me the expression is still used today—I hear it all the time. And that car still sits in my grandmother's backyard, almost like a plaque or trophy or something.

I was feeling big one day and bought my grandmother a mink coat. I bought myself one too. I had the biggest gold chains a neck could hold. I had started working out around this

time, so my neck could hold a few pounds. I would drive around Manhattan in a limousine with my boys just for the hell of it, drinking expensive champagne like Moët and Cristal. (Yes, I was 18 and that was the legal drinking age then.) And the women. Yo, I didn't even have to open my mouth and they were flocking. Hell, even the guys who hung out with me would get mad play, lots of ladies.

No sooner had the riches and the fame from *Radio* dwindled than I set a new mark. In August, 1987, "I Need Love" dropped and put me in a whole other category as far as rappers were concerned. It was the very first rap ballad, which was different from the bravado and hard, rough style many rappers had adopted. LL Cool J moved from "hard as hell" to a bona fide ladies' man. That was a real risk for me then. I could have come off as soft. But obviously the listeners didn't think so— the record sales and money started rolling in.

Ironically, the inspiration for that record was real. Before I wrote it, I think I really did need love. Around this time I was feeling a lot of emptiness. I mean there were always people around, groupies, and my crew. But I was empty inside. I had this tune in my head for days. I hummed it for Bobcat and the engineer. They made a track for it. Some guy came in the studio and said, "Ugh! It sounds like Christmas music!" We argued back and forth on whether or not I should do it. But I needed to do this song. There was never a rap song that sounded like that, and I went home, sat in my room, and wrote it.

> *When I'm alone in my room, sometimes I stare at the wall*
> *And in the back of my mind, I hear my conscience call*
> *Tellin' me I need a girl who's as sweet as a dove*
> *For the first time in my life, I see I need love.*

That was real personal. Know what I mean?

Think about it, giggling about the games
That I had played with many hearts and I ain't saying no
names . . .

That song came from the heart. I was only in the rap game a couple of years, but I had already made the circuit of groupies and was getting a little out of control. I felt like the ladies only wanted to be with LL Cool J. Nobody was really feeling Todd. I wasn't sure if even I was.

I met her Easter Sunday, 1987. I was 19 and full of myself, but she treated me like, "So what." She was one of the first women to do that, and I liked it. (I still do!) She was this tiny girl, wearing a lemon-colored sweater set with a long skirt. And she had on these alligator pumps. I remembered looking at her and thinking, She dresses like a grown woman.

She was spending Easter Sunday with her aunt, who lived around the way. My man Jerry was there too. I hung out with Jerry, writing rhymes and stuff. When my mother asked me to go to the store for her after dinner, I stopped by to check Jerry on the way. And there was Simone. He introduced me to her and Simone's cousin Dina, who is now engaged to marry Karl Kani, one of the top hip hop clothing makers in the country. (Simone wanted me to wear Karl's clothes back in the day, but I had my own style then, with the Kangols and the tight sweatpants. I wasn't feeling that baggy jean look then.)

So Simone was standing in the driveway and Dina says, "Who's that?" pointing to me. But I only made eye contact with Simone. I thought she was cute. Real cute. She was a little lighter than me, and she had these tiny features. But it's funny, even before I thought she was cute on the outside, I saw her inside first, if that makes any sense. I connected with her, inside before outside. She looked up, and I looked in her eyes, and we communicated without speaking. Then when I took a step back and saw the outside, I thought, Damn, she *is* cute.

But what got me was her voice. As little as she was, she had a voice like a trucker—all deep and raspy. I thought it was sexy. All I knew was that I had never felt that way before and I was curious. So I told her, "Yo, you should come around some-time." She said, *"You* come around!" She was sassy too. I loved it.

She asked me if I had a number and we exchanged numbers as she walked me back to my mother's Cougar. I didn't call her right away. Maybe I thought I was being cool making her wait. When I did call her, I thought I had a wrong number. She said, "Hello?" and out comes this deep, heavy voice. I was like, "Is that you? Yo, you got a deep voice." We just joked about it and started talking and seemed to stay on the phone for hours.

I was already hooked. It was so different for me. It was like plugging in spiritually. I can't define that as love at first sight, because love is strange. The word *love* has even taken on a different meaning to me. People have the tendency to love things that are bad for them. Is addiction love? You love the feeling, the addiction, the lust, but is that love? I think love is a chemical reaction caused by the brain. I think that it's like strobe lights dancing around in your brain, creating this eu-phoric feeling inside. It's a trick that mother nature uses to get men and women to reproduce.

I do think, though, that true feelings and true connections are real. So I think a word like *bonded* is a better description of what I felt when I got to know Simone. *Bonded* says some-thing more than *love*. Every woman wants to hear those three magic words. But I think "I'm bonded with you" is more pow-erful. I hear people say, "I love my car." But if you hear some-one say, "I'm bonded with my car," you'd look at them a little funny. Sure, I now tell my kids and my wife "I love you" be-cause there is a general understanding of what that means and people expect it. But what I mean is, "I'm bonded to you."

I was bonded to Simone from the jump. Around her, all my

insecurities left me. She was the first woman who I took my hat off in front of. (Not for a while, though.) Can you believe that I never even took my hat off with a woman? But Simone made me feel good about myself. She was the first woman to tell me my lips were sexy, and she liked the way I licked them. My mother used to get on me all the time about licking my lips. "Todd, stop licking your lips. That looks so nasty." But I think I got the habit from her—my mother licked her lips the same way. So I was a little self-conscious about licking my lips before Simone. When she said it was sexy and it looked good when I did it, I started doing it more. And when I took the mike on stage, the first thing I would do is look out at the audience and lick my lips. The girls would go *wild*.

She was also the one who told me I had a nice butt. And I started wearing tight sweatpants to show it off. She understood me. We spoke the same language. We connected. We still do.

Simone was going through her own thing when I met her. She was dealing with her mother, who was addicted to heroin. That situation bonded us even more. I had my demons that I was trying to deal with and she had hers. So it wasn't as much, "I like you," and "You like me." It was more like, "I can really relate to your pain," and "You can relate to mine."

Her pain was really in sync with mine. Hers was current and physical. My pain was in the past and mental. My pain had left scars, emotional scars that I was trying to suppress, and she had emotional scabs that were constantly being reopened.

I could tell she was embarrassed the first time I went over to her house. It was scene she had been avoiding. She and I went on a double date with my ex–best friend Brian Latture and her first cousin, Sloan Pyle. We went in Brian's brown 98, which we called the "brown mo-bile." Simone and I sat in the back. We got Chinese food and a bottle of Riunite wine. Yeah, I know, cheap, right? I suggested we go back to Simone's house to eat.

As soon as we got in the front door, her mother came down the stairs in a tattered bathrobe, looking strung out. My man Brian looked at her like she was crazy. I could tell Simone was embarrassed. But I was like, "Whatever." It didn't faze me a bit. I shook her hand and said hello, and we went on about our business.

Afterwards, I guess Simone expected me to say something about her mother. I never did. I loved her mother. I mean, I could relate. So it was Simone who finally brought up the subject. We were sitting in my mother's Cougar chillin' when she told me her mother was a heroin addict.

I said, "So what. We all got problems with our families. We all got problems." After that I told her about my father shooting my moms and grandfather and how Roscoe used to beat me.

I could never condemn somebody for having an addiction, for being an addict. I can definitely relate. I was in no position to judge. I had my own addictions, which I'll tell you about later. I'm sure people will be tempted to judge me for them, too. But I hope not. I can't be judgmental. I don't laugh at people who have one leg. I don't park in handicap spots. And I don't judge drug addicts.

When I see a prostitute, I see a human being who might just be caught up. I don't see a piece of garbage. When I see a drug dealer, I see a guy who might just be trying to get by. You have some drug dealers who hustle because they want to have it all—they want the cars and the girls. And you have other drug dealers who hustle because they have kids to feed and they need the money, or they want their mothers to have steak for dinner once a week. There are a lot of reasons why people do certain things. I try not to judge anyone.

When Simone shared her feelings that day I only grew closer to her. I saw vulnerability through her toughness, and that made her even more cool to me. It's like you know some-

body's tough and you can't walk all over them, but then you see that there is something tender also about them and you like that too.

Simone eventually became my first steady girlfriend. She even came with me on the first leg of the *Walking with a Panther* tour. I brought her out on stage in Miami when I did "I Need Love." (Man, did all the girls in the front row look mad.) But when I first met her, I was still doing my own thing.

Walking with a Panther was a huge success. The tour was sold out everywhere and the album went triple platinum. Only Run-D.M.C. and the Beastie Boys were doing sales like that. At the same time, Public Enemy had burst onto the scene and created a movement within rap—social consciousness. Before them, Grandmaster Flash was portraying street life in their raps like "The Message." But PE and KRS-One were talking about taking action. "Fight the Power" and "911 Is a Joke" flew right in the face of government and racism. Their rap spoke to blacks across the country who were feeling oppressed, and it gave them more than "This is where you are." PE was saying, "This is how you get out." That whole movement talked about the black man educating himself and uplifting himself—both messages I was with totally.

I even had a couple of songs on my album like that, but people were just not into my vibe. I tried, but the songs that hit were talking about how many women I could do, how many gold chains I had, and how bad I was. I was rapping about champagne, silk shirts, cars, jewelry, girls. I had become the anti-Christ of rap. I was selfish, I was egocentric. People felt like I was not being honorable and that I didn't represent where the black community should be heading.

It's funny, the very thing I was catching flak for then is the exact same thing that many in rap are embracing now—champagne, designer clothes, cars, sex. So we've come full circle. And despite all the controversy, *Walking with a Panther* sold millions.

SPIRITUAL BLACKOUT

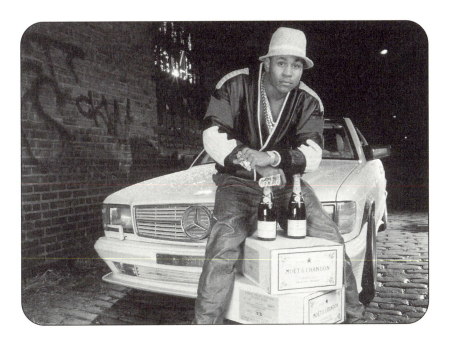

**That's me with my white Mercedes, my Moët, and my Cool J ring, from the
Walking with a Panther *shoot. And I was living the hype.***

(© Ricardo Betancourt/courtesy Def Jam Records)

EIGHT

BELIEVING MY OWN HYPE

I'm in a stretch limousine, gliding through Times Square. I'm wearing a black mink coat and have an iced bottle of Moët in my hand. I'm coming from the American Music Awards at Radio City where I had just performed—one of the first rap acts to perform at one of the most famous concert halls in the country, if not the world. I guess you could say I had made it.

I had back-to-back platinum albums, was working on a third, and I had a million dollars in the bank. And I had a $15,000 ring that spelled out my name across four fingers in diamonds. It was phat. Can you believe that? That was so much money I couldn't even wrap my brains around that figure to fully comprehend it. "Damn, I got a million dollars in the bank," I kept saying over and over to myself.

But it wasn't the money that I was bugging over. It was the power that comes with the money. I never rapped for the money, I rapped for the power. It was the power to walk into any car dealership in America and buy a car—cash—on the spot. Yo, what a rush!

Cars were one of my vices back in the day. I bought cars like most people buy shoes. I had one to fit every occasion. I went into a Porsche dealership on Long Island on a whim and bought a black 911, $72,000. I just called my accountant and had him wire the money. In Maryland, on tour during *Bigger and Deffer*, I went into a BMW dealership, saw a charcoal gray M3 that I liked, and bought it on the spot. I drove it back to New York.

When the tour stopped in Los Angeles, I bought a $100,000-plus white Mercedes convertible. It was custom made, the only one of its kind. I had gotten the top cut special. It had the white leather seats, white piping, black piping, white on white chrome rims, gold grill. It had the ill system. You know the sound system had to be straight in my car. It was nothing for me to spend $10–12,000 on a system. Back then, I needed to feel my music. And so did everybody else.

I loved that car. Right after I bought it, I wanted to show it off. So I took Simone out to Fat Burgers in it. After we ate, I came out, ready to put the top down and look fly. I slid the key into the ignition and turned. Nothing happened. The car wouldn't start. Ain't that something? But I deserved that.

At one time, I had like 12 cars spread out at like five different locations—my moms', my grandmother's, my house in Long Island, my condo in Jamaica Estates. And I wasn't just buying cars for myself. I eventually gave my man Brian Latture the Mercedes convertible. He was my manager and best friend back in the day. I bought my dad a Jeep Cherokee. I bought my moms another car.

I just had car after car. Yo, the attention and just being able to drive a fly European sports car were just incredible for me. The money I spent was about bravado and feeling like the man. I had the super big-screen TVs, a sound system in my house with speakers hooked up in every room—even the bathroom.

I was living.

But I was living a lie. It looked like I was on top of the world, but all the money in the world means nothing if you don't have control over your life. And I didn't have control over anything. I had all these things, but I was pissing away my soul in the process.

My success became overwhelming, not just for me, but for my family. My moms, who had been trying to keep track of things, didn't know the ins and outs of the record business. So

she broke down and called my father, who had once run his own business and was supposed to be very good with money, despite his obvious shortcomings.

I know that must have been a really tough call for her, considering their past. She had made a similar call before I went to Florida because I was wilding and getting into all kinds of trouble. Why should she suffer through it by herself? It was only fair that my father should share some of the responsibility and some of the pain.

She must have felt that I needed not just a man but my father in my life. And I was feeling that way, too. I think most kids who grow up without their fathers feel that way sooner or later. It doesn't matter how rotten or how much of a lowlife a child's father is, a kid wants to point to a man and say, "That's my daddy." It's a feeling that you belong to somebody, that you have an origin, that you exist. I felt I needed my father, despite the bad things he had done to my family. All I could remember was the time he bought me a puppy and all the backyard barbecues.

The first time my mother had tried to send me to stay with him in Los Angeles for the summer, he said he was too busy to take me in. He told her to send me to stay with his brother in Tampa instead. But this time I was stacking some cash. And there he was—all smiles, ready to be a daddy. He wasn't too busy to become my manager.

In the beginning, he was very helpful. He was looking out and teaching me a lot of things I didn't know. He was telling me how people were ripping me off. He taught me that rap was a business. "It's called show business for a reason," he said. "Look at the word *business* compared to the word *show*. It's much longer, right? That's for a reason. There's a lot more business than show in show business. And don't forget it."

My father started touring with me after *Walking with a Panther* dropped. It was also about the time that I was becom-

ing more and more depraved and doing some really wild things. Simone had given birth to our son, Najee, and I was running away from my responsibility and bugging out.

My father didn't help. He told me things like, "Simone is just trying to trap you." And I listened. He was still off the hook. He liked to smoke weed, get into fights, and curse people out. I thought it was fun. Hell, I just wanted to have a relationship with my father and I really didn't care. I wanted to love him and have him love me and take care of me. When I was around him, I became that little boy with the puppy all over again.

He used to get us in all kinds of trouble on tour with his temper. That was something I definitely inherited from him. One time we were in Miami, and he and I got into a fight in our hotel room over something so stupid, I don't even remember what it was. We ended up fistfighting each other. But afterwards, we went downstairs to hang out with my boys, as if nothing had happened. We would be fighting one minute, friends the next.

When something went down, though, no matter what we were feeling toward each other, we had each other's back. During one of the wildest fights I was ever involved in, my pops was right there.

We're walking through the lobby of a hotel with Roberto, a Cuban guy from Miami who was showing us around, and my man Chuck. And near the front desk, there's this South African wrestler standing at the phone booth in the lobby, talking. When he saw us, he said into the phone, "I gotta hang up. A couple of niggers just walked in."

Roberto said, "Did you hear what he just said?"

And I just looked at the guy and said, "What?"

He looked at me and then Roberto and said, "You don't want to mess with me!" He was about seven feet tall and weighed well over 300 pounds, pushing 400. I'm looking at

him, sizing him up. (I was always ready for a challenge.) And my pops, who was six two, about 250 pounds, and usually down for whatever, looked at this guy and warned me not to mess with him.

But the wrestler thought my pops had said something to him, so he rushed my pops, jacking him up against the elevator. Then the elevator doors opened and my pops fell into the elevator with the wrestler on top of him. My pops started yelling: "Man, get this motherf***** off of me so I can kill him."

My pops was mad and seeing red and didn't care that a seven-foot monster was on top of him. I ran over and started kicking the wrestler in the back and the butt. I tried to kick him in the nuts from the back. I finally struck gold, and he stopped choking my pops. Then he turned to me with this sinister grin and laughs.

He started chasing me. I ran through the hotel lobby around this big palm tree and stuck my foot out just as the guy came around the corner. Blam! He went down. But he got right up and continued chasing me.

I ran down a hallway past the elevators, and my Kangol flew off. You know I'm mad now. My hat is off in public? I hadn't had a haircut in a while and I had this big Afro underneath. I was embarrassed with all this wild hair hanging out.

While this is going on, my man Chuck was just watching and laughing. It must have been pretty hilarious. Then Roberto got into the flow and started chasing the guy. My pops, who was waiting for the guy to come around the corner again, grabbed one of those little ramps they used for handicapped people to get up the stairs. And when homeboy came around the bend, my pops slammed him with it.

The guy was dazed and bewildered but didn't go down. In two seconds he shook it off and it was on again. I stopped and did the trip move again, and he fell down again. My pops picked up a rock from the little garden area and started beating the

guy in the head. But homeboy was unbelievable, like my pops was a fly on an elephant. It didn't faze him a bit. While my pops was still hitting him, the wrestler takes him to the ground and starts jacking him up.

I jumped on the guy's back and I started punching him in the head to get him off my pops, but he was handling both of us. Roberto jumped in—and this dude took care of Roberto, too. Chuck was still standing there, laughing. Homeboy shook us off like fleas, and when we ran, he started chasing us again, past the glass front doors. I pick up a rock, and I'm ready to throw it, but I see those glass doors there. My father yells, "Don't just stand there, throw the s***!" So I threw it. Glass shattered all around the guy. And he shook that off, too! He was bleeding and laughing and out of breath.

"It took three of yous. Yeah, it took three of yous," he said.

My grandfather used to tell me that the wrestling on television wasn't real. He should have been down in Miami that day. Finally, hotel security, who were watching the whole show, came out. The cops showed up too. They shot a gun in the air to chill us out.

Meanwhile, during the commotion, homeboy disappeared upstairs and brought back three other wrestlers—Jimmy "Superfly" Snooka, Jigsaw Haystacks, and another guy—to do all of us in. Lucky the cops had shown up, I guess.

My father got arrested and the cops let homeboy go. Pops was in handcuffs, battered and disgusted, his shirt ripped up. Chuck, who hadn't bothered to get involved, had somehow lost his bracelet during the ruckus after the fight and was looking for it. The cops kept telling him to get back, but he was determined to find it. So they handcuffed and arrested him too. We had to bail them out a couple of hours later. But nothing came of it after that.

Yeah, my pops and I did some crazy things together. I was known for my practical jokes, especially on tour. And he'd be

right there laughing—except when the joke was on him. One time he was sleeping on the bus with his mouth open. I took a straw and filled it with hot sauce and slipped it in his mouth and ran away. He woke up coughing and cursing. It was hilarious.

I got Brian Latture good one time when he was sleeping. I took a boom box, tuned it to this heavy metal rock station, waited for the precise moment when he was looking angelic in the middle of sleep—and blasted it to peak volume in his ear. He must have jumped about 15 feet in the air.

I was bananas. I'd hit people working with us with buckets of water when they were coming out of their hotel rooms, getting ready to go out. They got me back once or twice. One time they left me on the tour bus by myself. I was asleep—and nobody can wake me up when I'm in a good sleep. They shut off the bus.

We were down south somewhere, maybe Louisiana. It was summertime, at least 100 degrees. The bus was one of those hydraulic buses, so nothing worked when it was shut off. In other words, the air-conditioning stopped working and you couldn't open the windows. And I'm in this bus, cooking. The only reason I woke up was because I couldn't breathe. I had sweated all the way through my clothes, even my hat.

I stormed to the hotel. Everyone was in a room playing cards. When they saw me, they all broke into a laugh. My pops, who was smoking a joint, looked up from his card game and said, "You rested?"

Another time, we had this bus with sleeping compartments. It was fly. But someone put itching powder in my bunk before I went to bed that night. I was scratching everywhere for about 11 hours. That was a good one.

The one person who never could take a joke was my man Cut Creator. Jay will pretend like he can take it, but that brother gets mad quick if you even try something on him. If you start snapping on him, he'll get upset, especially if you talk

about the crunch on the back of his neck. (Just kidding, Jay—I love you, baby!) So for the most part, we didn't bother Jay. Plus, he was too damn big to get him mad.

Cornell was the most fun to tour with just because he was so funny to look at, plus he always had something smart to say. But Cornell really meant well, that's why he was my man. He was a true friend.

My pops, on the other hand, was constantly burning bridges and getting into beefs with people wherever we went. Conflict was his middle name. Back then, I thought that was funny; he was my role model. But being around him taught me you have to be your own role model and that being a father is about more than supplying the sperm. You have to be there for your kids. You have to share positive things and nurture them. He didn't do that often enough for me.

The one time he tried to act like a father, even that was ironic. I was performing in Virginia with some local acts and Roscoe showed up, out of the blue, to see me. After the show, he apparently came backstage looking for me. And he ran right into my pops.

The two men who called themselves my father are standing face to face. I can look back and see my pops as an angry man. But I don't view him the same way I view Roscoe. I do remember the good times with him. Despite the craziness, I don't see him as a monster. He was a good small businessman. I just think he got in a little over his head with my business. And perhaps family shouldn't ever work so close together.

Roscoe was a different story. He was lazy and didn't work much at all. Where I can see strength in my father, I only see weakness in Roscoe. He was like a weasel, a get-over artist, looking to take advantage wherever he could.

So they're standing face-to-face backstage, my pops looks Roscoe up and down, and says, "What do you want?"

Roscoe says, "How you doin'? I'm LL's father."

These two had never met before, and I don't even know if my father knew Roscoe existed, but all he said back was, "Get the f*** out of here!" And he literally picked Roscoe up and tossed him out the backstage door.

Pops told me this story with pride. And, at the time, I was loving him for that. But I have to be real with myself now. Our relationship was all business, and not very good business at that. What I didn't know then was that while he was busy keeping people away from me, warning me about this one ripping me off, that one stealing, and this accountant not paying my taxes, he wasn't taking care of my business properly. He wasn't making sure my taxes got paid. He was ringing up personal stuff on corporate credit cards. And he wasn't looking out for my money as others around were stealing from me.

I was so into my own world and acting ill that I didn't realize just how out of control everything was. It seemed like I had all the money I needed. My career seemed to be doing well. I was making platinum albums. My tours were sold out. I had just found out that I would have a role in the movie *Toys* with Robin Williams and Joan Cusack, and directed by Barry Levinson.

But it was the sunshine before the storm. With all the fame, the good times, the money, the jewelry, the life I had craved for so long, I thought I was flying high. But I was really drowning.

EVIL CHEMISTRY

Inside my head, my voice sounded like Alvin from the chipmunks. Everything around me was racing at like 10,000 miles an hour. And so was I. I was wired. Sweat poured from my body like a rain shower and I couldn't remember my lyrics. I was on tour for *Bigger and Deffer* somewhere in Los Angeles, and all I could think about was getting offstage as fast as I could.

When Cut Creator did his final scratch, I rushed backstage and just threw up all over the floor. I had dropped some mescaline right before my performance, and I was sick as a dog. It was the first and last time I ever performed high.

Drugs are prevalent in entertainment. It seems to go with the lifestyle—the money, the fast cars, the jewelry, and the women. There are even some who feel they can't perform without some weed or a hit of cocaine. That wasn't me. But I did enough in my day to know that drugs are not the answer. I didn't get into a deep dark drug world, as you can see. But I did try things. I experimented with cocaine, angel dust, even mescaline.

My first introduction to drugs was around when I started getting into rap. I experimented with drugs the way kids in the movie *Porky's* or *Animal House* experimented with drugs. I started off smoking a little weed with my peeps from around the way. Yeah, yeah, I even inhaled a couple of times. It was something everybody was doing. And I guess not much has changed. Kids are still smoking weed around the way. We used to get the El Producto cigars, the real cheap ones, from the

corner store and make blunts. I never bought the stuff myself, but somebody always had a nickel bag. Around my way you could get it as easy as buying a pack of gum.

When I got older, we would sometimes spice up the blunts with coke or angel dust. I wasn't into sniffing coke, probably because I was afraid of dying. But I would smoke just about anything. One time, I was hanging out with my boys and we smoked some dust inside a movie theater somewhere in Jamaica, Queens. We were just sitting there throughout the whole movie, punching each other in the face and laughing. I don't even know what was playing, because we didn't really look at the movie. I would punch my man next to me and he would laugh. "Haha, you hit me!" Then he would swing a left hook and land on my jaw. And I'd bust out laughing. Back and forth this went down the row. That's the kind of stupid s*** drugs make you do.

The next day, I'm walking around with a swollen face and a cut lip. I wasn't laughing then. I was just looking stupid with lumps all over on my face and poison in my system.

Drugs are funny like that. While you're doing them, you think you're cool. Afterward you feel like an a**—you look in the mirror and see your face is all lumped up and greasy and realize it's not so fun. Maybe that's why some people stay high, so they never stop feeling cool, so they never have to see the lumps.

To this day, I can't understand why I tried drugs. I had such a negative reaction to them from living with Roscoe. On any given day, I would come home from school and walk in the kitchen, and there would be a pile of cocaine on a mirror on the table. Or I'd be in my room and he'd come in smoking a joint. And then he'd beat me after he finished. So I associated drugs with bad things and bad behavior. But, like most kids, I had to find out for myself, firsthand. I'm just glad I was able to walk away from it.

I can relate to kids getting caught up in peer pressure. I never wanted to feel out of place. I always wanted to be cool. And smoking weed was cool back then. For a lot of people, it still is. Unfortunately.

This is not an easy subject for me to talk about, because I did some things I'm not very proud of. Now I travel around to schools telling kids to stay in school and stay away from negative influences like drugs. I mean every word. But I can't lie and say, "I didn't do drugs." Because I did do drugs. But that definitely doesn't make it right. And I do believe kids should stay away from them. I'm just thankful that I didn't get hooked. And I didn't die, by the grace of God.

So I hope you all know I'm being straight up when I tell you to stay away from drugs. Because you may not be so fortunate.

There was even a time when I thought seriously about getting involved in the drug game. Growing up in Queens, there were guys in the neighborhood who were large.

There was Fat Cat, Supreme, and Tommy Montana. He owned an entire block in Queens, with a grocery store, a little nightclub, and a fly sneaker store. He drove around in a black 560 Mercedes Benz with gold trim. When he got tired of driving, he was driven around in a Rolls Royce that had a Nintendo set in the back. He had a phat house in Dix Hills, Long Island, where mostly well-to-do white people lived. It was more of a mansion than a house, with a swimming pool, servants, and a high-tech security system. He had gold fronts (teeth, that is) with diamond studs that spelled out his initials. And he was only 21. Tommy was a drug dealer, but to every kid in Queens, he was a hero. All the dealers from around the way had status. They represented everything poor people didn't have and wanted so much: Money, clothes, cars, property. They were living the African American dream, workin' the BMW, the black man's wish.

You know what I mean?

I used to roll with a guy from uptown, Big B. He was Mount Vernon's answer to Tommy Montana and the others. He had the jewelry and the cars and the women, and I wanted to be down. I would hang around him and sometimes he would let me weigh his stuff. I even cut his coke for him a few times. He would yell at me, "You're putting too much in!" I couldn't have been more than 16 at the time, and to me he was the pinnacle. All I could think was, "Wow, he's doing his thing and he's getting *paid.*"

Drug dealing is negative and destructive. But at the same time it fulfills some people's dreams, and unfortunately, it's very attractive to a lot of poor black and Latino kids. All they see is the jewelry, the cars, the women, the good times. They see the results, but they don't see the paranoia, the spiritual death, the violence, the betrayal, and the danger that goes hand in hand with drug dealing. You can ask any drug dealer and he will tell you that he would give up all that money to get half that amount legally. All the ones I've ever known wish they didn't have to do it. But back then, I was blinded by the so-called wealth.

Right before *Radio* dropped, I really, really wanted to get some of that money Big B was making. I didn't think rap was going to bring me the same type of dollars as fast.

All the time, I used to tell Big B, "Yo, I'm gonna give you five thousand dollars." And I was serious. I thought five grand would be enough to get me into the game. He would take my money, buy drugs and flip it, and probably come back with $10,000 in a couple of days. And we'd keep doing it, $20,000, $40,000, $80,000, $160,000. I could see all that easy money just rolling in.

Before I was able to give him that first $5,000, though, he got busted and was sent to jail. I'm not glad he went to jail, because I hate to see any man in lockdown. But I am glad I

never got the chance to become a part of that drug scene. God must have been really looking out for me.

If Big B's arrest wasn't a strong enough warning, one of my closest friends and rap partners at the time, Cal-ski, gave up rap to become a full-time drug dealer. About a year later he was arrested and sentenced to over 20 years in prison. I still have love for Cal-ski, and hopefully he will get out soon and have a real chance to start his life over again positively.

I know that some people sit around in their comfortable homes without feeling much sympathy for drug dealers. I know they think a person who makes that kind of lifestyle choice deserves whatever tragedy comes their way. Well, it's true that dealing is a terrible lifestyle, but for some kids, there's not always much of a choice. When I was out there on the edge, I had to get out of my family situation, and I needed the fastest escape route possible. I wanted cash. That cash represented power. And there was a lot of it moving through my man Big B's hand. It would have been real easy to start running errands for him for a few dollars—you know, keep an eye open for the cops, or run this paper bag up the block. And once you're in that scene, you don't get out. 'Cause once you've committed a crime for someone, no matter how small, they've got a hook in you for life. They can work you any way they want. The dealer's life has many entrances. But the only two exits are prison and death.

Remember that.

It's funny, there are a lot of corollaries between the drug game and the rap game. In both cases young people are looking for power and a voice in a powerless situation. The life of a rap artist coming up at first is similar to that of a dealer or even a wiseguy, a Mafioso. You got the knot of cash in your pocket, the cars, the money, the jewelry, the walk.

When I did start making some money in the rap game, it was Big B and some of the other big-time dealers from around

my way who put me down with the best known jeweler in the city—Manny's, in Manhattan's diamond district, the real deal. It was nothing for me to drop $20,000 on a chain or a ring—just like the big-time dealers. Before then, I bought my gold on Jamaica Ave.

And with the wiseguy money and lifestyle could come real wiseguy-style danger, too. If a rapper's not living right, he is subject to the same violence that is such a major part of the underworld. You can get caught up in the same culture. Even if you change as a person and start to move away from that lifestyle, sometimes that culture follows you. The people around you don't change and you can end up killing yourself through your lifestyle.

Of all my tours, the one for *Walking with a Panther* was the most off the hook for me. At the time, it seemed like the most fun I ever had. In hindsight, though, I was at my lowest and my most destructive. My father was my manager then, and he and Cornell used to get high together all the time right in front of me. They used to argue like an old married couple, because Cornell used to always return the joint to my father all wet with slobber.

"Damn, Cornell! Can't you smoke a joint without getting spit all over it?"

"Shut the hell up, Jimmy. I'm a grown man. Don't be telling me how to smoke a joint."

They were hilarious to me then. But they were pretty lousy role models. Every tour seemed like the same story—drugs and women.

I could go into great detail, dime people out, dime myself out. For what? The only thing anyone needs to know, the only thing I learned experimenting with drugs is that drugs ain't s***. Drugs aren't the answer. I didn't find any answers in weed, coke, mescaline, or dust. No answers, just a question: Why?

Why was it that when I smoked coke, everybody in the room was my friend. I mean, did all of these jerks suddenly turn into great people? I don't think so, but the drugs could make you believe anything.

Know what I mean?

At a point in time, I even began to do drugs with Cornell. He and I would smoke weed or coke together. And I know he was a real friend. But he did give out stupid advice sometimes. He would say, "Look, stop walking around the goddamn party, sniffing out of everybody's dollar bill. Just go get yourself an eighth and do it by yourself."

Now what kind of advice was that? It was warped. But he thought he was making us sophisticated. He meant well in his own zany way.

If you hang with me today, you'll see that I surround myself with people who don't do drugs. This is a drug-free camp. The most you'll see is allergy medicine. I don't even want beer or any alcohol around. You can tell by my life that it's clean, because I'm not getting into trouble anymore. I'm not getting high, getting drunk, and having women all over the place. I don't bring it into my camp. And I don't allow anyone else to. The atmosphere around me now keeps me focused. And I think it's easier for my troops to respect me when they see me conduct myself in a manner that is worthy of respect.

I think that's important, because it used to be a free-for-all. Everybody was a clown, and so was I. That's why it was so easy for people to rob me or play me out. I was too busy getting high and having girls and drinking my little Cristal and my Moët and my Alizé to notice what was going on around me. In fact, I was drinking so much Alizé I was going to name my son Alizé. No joke. Good thing Simone wasn't having it. I'm sure Najee's glad too.

It wasn't easy to get back in control. Somehow I overcame the drugs and the alcohol. But I needed help. I needed strength.

I had to dig deep down inside myself and find who I really was, and force myself to understand what I saw. Lots of people struggle with drugs and various addictions and don't think they can get out. It's not easy. I didn't come through my trials and tribulations without a scratch either. I have scars, and I've left a few scars on others. Roscoe had turned me into a person I couldn't even say was human. Because I knew nothing but pain. I was inflicting pain and receiving pain.

There is a powerful saying in the hip hop community that is like the hip hop motto: Keepin' it real. You ain't nothing, ain't true to the game unless you keep it real. For some, keepin' it real is just being you—no matter how negative that is. But I totally disagree with that. I'm sure glad I grew up and became real. A real man doesn't behave like a savage.

I grew up surrounded by people who didn't keep it real. My father, who tried to blast my grandfather and mother into eternity with a shotgun, didn't keep it real. Roscoe, who beat me with vacuum cleaner attachments, threw me down stairs, and blew reefer in my face didn't keep it real.

But keepin' it real ain't about carrying a gun or smoking blunts. It's about being true to yourself and those around you, taking care of your family and showing respect for others, being considerate. Men and women who diss and try to kill one another and who abuse drugs and sex ain't keepin' it real.

You know what I'm saying?

Keepin' it real, for me, is about staying tight spiritually. You've got to keep it real with God. You have to keep it real with your internal self, your essence, with that which makes you a human being. With that subconscious power that keeps your blood flowing, that makes you blink when you don't even know it, that makes you breathe without having to think about it. That's what you have to keep it real with—righteousness.

No, I didn't keep it very real the early part of my career. And I now know that there's a price to pay for not keepin' it

real. You think it's okay, that you can get away with that kind of behavior. But it eventually catches up to you. I learned that lesson the hard way.

But not right away.

EXCESS XXX

Note: *I just want to let everyone who is reading this know that I am not proud of anything that's in this chapter and I wouldn't advise any person to do any of the things that I did. Period. I know some of the acts I committed were sick and disgusting. I'm merely coming clean to prove the point that anyone can overcome the most heinous of sins, the most deviant behavior, and turn their life around for the better.*

This chapter contains explicit material. An edition of this book that is suitable for all audiences is available. Check with your local book retailer.

The lights are down real low. There's a rumble from the crowd—waiting, anticipating. Cut Creator takes his place on the stage and starts scratching. The bass from "Rock the Bells" is pumping, rocking the huge speakers on either side of the stage. (Can you feel it?) I'm leaning up against the speaker at stage right. Neither the audience nor the crew can see me. And it's a good thing. My eyes are closed and I'm just feeling it. A beautiful young lady, the kind of woman who's supposed to be onstage hanging onto a superstar, is on her sweet knees in front of me. And she's doin' it and doin' it and doin' it well, if you know what I mean.

It's Madison Square Garden, where I'm opening for Run-D.M.C. Cut Creator gives me my cue to come . . . out. And I do.

I take my time zipping up my jeans, trying to seem apprecia-tive. I drop a smile on the lady, run out onstage like a man possessed, and grab the mike.

Aaaaaaaaaaaaah yeah!
Throw your hands in the air!
Everybody, throw your hands in the air!

It was my first tour. I was 17 years old, and I was thinking, If this is the way it's going to be, I'm definitely going to love being a rapper.

The groupies—big ones, small ones, tall ones, sexy ones, soft ones—were as plentiful as the grains of sand on Jones Beach. And being with them was as easy as pouring out a hand-ful of candy and tossing it in my mouth. Women waiting, stalk-ing, wanting to do whatever it took to get a piece of me. To some of them having sex with a rapper was like collecting base-ball cards. They wanted to collect one from every player. It was wild.

I did one show during the *Panther* tour, in Atlanta. After the first set, there were so many girls waiting backstage, you wouldn't believe me if I told you. I mean mad honeys—leather miniskirts, fishnet stockings, lace-up corsets everywhere. Hoo-chie central. One girl caught my eye. She was wearing this short black skirt, showing off those long legs, and her cleavage was spilling out like melons at a fruit stand. I pointed to her and gestured for her to follow me.

I sneaked her upstairs, slipping through the entourage and the security (my boys were just smilin'), and we went into the bathroom of the dressing room. "All I've ever wanted was to make love to you," she said breathlessly. "I love you."

"Um hum," I said, unzipping her skirt.

I didn't even know her, let alone believe her. All of that was nice, but I was just thinking about one thing—knocking it out.

We didn't waste any time. We didn't even take all our clothes off. I just bent her over the sink, pulled down her little lace panties, and went to work from behind. That was probably the best way because she was pregnant—and showing it.

I had just met her that night. And in a lot of ways, that was one of the sickest things I ever did. It was also the day I realized I was out of control.

I know you're making faces right now, but you wanted it real and I'm giving it to you real. I was having sex for the sake of sex, no love, no respect, just quick, sweaty sex. It took me a while to break the habit.

In this business, sex is like candy—plentiful and cheap. Every artist who performs in front of a lot of people and goes on tour knows what I'm talking about: crazy experiences and sex with wild women and sex groupies, mad parties, which almost turn into orgies. Sometimes you have multiple couples going at it in the same room. And nobody blinks an eye. They say it comes with the territory, that it's a part of that culture. But just because everybody's doing, it doesn't make it right. I knew I wasn't right.

I was wild, bananas, off the hook. And so were my tours. I now realize that's not how it has to be. I can dictate whether or not my tours will be wild, wet, and woolly. Sure, all kinds of women will always be there as long as I'm doing my thing right, but whether or not I partake in their activities is another story. When I was wild, touring was almost like whoring. But today, my tours—behind the scenes and in the hotels—are tame, sometimes even boring. I don't even want the people around me to drink. It's all business.

My wild behavior, the sexual athletics, was a little sick. No healthy normal person would behave like that. Then again, how many 17-year-olds do you know who would pass up a blow job while all pumped up onstage before a performance—especially with a young lady dressed in her best and ready Freddy with

her sweet-smelling body? Let's be real. All the same, I wasn't living right.

After that episode with the pregnant groupie, I really began to face my demons. I began to realize that I was addicted to being destructive.

Some of my behavior was because I was just nasty, just the dog in me. But I know that a lot of it had to do with the beatings, the neglect, and the abuse I received as a kid. It definitely warped my perspective on love and relationships. It was like Roscoe had started me down a path, and I kept on walking.

The man was a pervert, straight up. Our house was full of pornographic magazines. And it wasn't just the usual stuff—there was sadomasochism, orgies, you name it.

One time, when I was eight years old, I was alone in the house with Roscoe. I had gone to the bathroom and as I was heading back to my room I passed Roscoe asleep in the bedroom. Magazines were spread out all over the bed. I went to check out the situation. I was a kid, so I was naturally curious. Then I picked one of them up, and my eyes bugged out—nothing but naked women.

Roscoe suddenly woke and barked out, "What are you doing?" I dropped the magazine and turned to run, but before I could get out of the room, he grabbed my arm. I almost peed myself.

"Look at it," he said. "Go ahead. Look at it all!"

He made me stay there and look at each magazine. Every page, every woman. I was sweating hard. Here I was, an eight-year-old kid, practically in tears, being force-fed pornography. For an adult to do what he did was cruel and evil, really f***ed up.

Another time, I came home and went upstairs after school. The bathroom door was cracked, and I accidentally saw Roscoe standing over the toilet, masturbating. I didn't know exactly what he was doing. But I knew it had something to do with sex,

and I figured that must be where he got his power. In my little kid's mind, I began to associate masturbation and sex with power. Here was a man who had complete control over me, who beat me, belittled me, terrified me, and ran my mother. I must have subconsciously thought he got that power over us through sex—through dominating women. I wanted it too.

I can admit it now: I was addicted to porn. Aside from it always being in the house, it represented power and escape. I would look at the pictures and get hard, and even though I didn't know exactly what was what, I knew it felt good. And I knew it took me to a pleasurable world where no one bothered me and where women were beautiful. It was an escape from the other bulls***.

Later, when I finally started having sex, I tried not to carry a lot of that filth with me.

The first time I had real sex, I was 13. My aunt let me have some friends over and we camped out in the backyard. There were a couple of girls too. We were in the backyard bugging out in a tent. And I noticed that Sheila (not her real name) was giving me the vibes—the ones that say, "I want to mess around." I was feeling her, and when I made my move, she was with it. She was older, 15, and we got busy right in that tent while her girl was asleep right next to her. It was exciting because at any moment we could have gotten busted so we had to be quick. And I was. But just before I was about to climax, I pulled out because I was so scared. I had never felt that feeling before—like I was literally going to explode. I was just staring at my penis in amazement. She asked me if I was all right. (She must have been through this a few times.) I was a little shell-shocked, but I lied and said, "Yeah."

When I was 16, I had a little girlfriend I used to mess with. She was about 15 and while she liked to mess—kissing and touching and rubbing and sucking—she didn't want to go all the way. She liked me doing things to her, but she didn't want

to do anything to me. And I was never the type to push up on a girl and try to force the issue, so I went with her program, hoping that one day she would say yes. Every other day I would go to her house, hoping. And each time I would end up leaving there in pain with blue balls.

On my way home, I'd go crazy. I'd be sitting on the bus back home to Hollis, horny as hell. One time, I just got off the bus right on Jamaica Ave., one of the main strips in Queens, found a corner, and jerked off. I just couldn't take it anymore, she drove me nuts—literally. It was two in the morning and my hormones were raging, the wind was howling, and I'm hunched over in a corner on Jamaica Ave., not caring who could see me, beating my meat like some pervert.

Once I started touring, though, none of the girls were making me wait. Nobody said no. It was like it wasn't in the vocabulary backstage. On my first minitour for *Radio*, we stopped in Boston, a 15,000-seat arena. It sure wasn't the Manhattan Center High School auditorium, capacity 250. This was the big time. I was the opening act for Run-D.M.C., but as far as I was concerned, I was the main attraction. And the crowd, especially the ladies, seemed to agree. I slept with two girls there in one day. I was like, "Bring it on!"

After Boston, we headed to Maine. The audience was mixed, black and white, like in Boston. I had never seen that many white people so into rap. But it wasn't just performing that had me juiced. It was the aftershow show, the ladies. I was a kid in a candy shop of sex.

When the show was over, a half-dozen women, maybe more, were waiting for us at the backstage door. One girl—big and fat—gave me that look. The sly smirk, which says, "You can do whatever you want, when you want, however you want, wherever you want for as long as you want." She had "freak" written all over her. Me and my man, E-Love, both got down with her right there on the staircase between the stage and the

exit from the arena. Yo, after that every time we'd see groupies, we'd yell out, "Maine!" That was our code for "freak."

Groupies were waiting at every stop. They'd be everywhere—in the hallway, in the lobby, on the street. They'd be at the hotel before we even got there. I don't know how they found out where we'd be staying. But in every city, town, or village, they would be waiting and ready. And I was like a lion picking out slow gazelles. After a while, I would just take a quick look and know who to go after.

But it was also a yin and yang thing. They were on the hunt, too. Some of them wanted to be loved. Some wanted to feel special. Some of them wanted careers, wanted to be actresses, singers. Some of them just wanted to get a man with money to take care of them. Some just wanted to get to the money. And yes, some just wanted good sex. The women were all different, but in a lot of ways, the same. It wasn't always negative or always positive. It didn't really matter—I didn't care about anything but getting my freak on.

I was 17 and always thinking the same thing: "She's pretty or she looks like a freak, and I'm going to take her in my room and knock it out. We'll deal with the rest later." It wasn't particularly wise to be that way. I wasn't particularly careful. But I was lucky.

I said, "How you doin', my name's Big L
Don't ask me how I'm livin', 'cause, yo, I'm living swell
But then again I'm livin' kind of foul
'Cause my girl don't know that I'm out on the prowl."
To make a long story short, I got the digits
Calls her on my car phone and paid her a visit
I was spankin' her and thankin' her, chewin' her and doin' her
Layin' like a king on sheets of satin
That's what time it is, you know what's happenin'
She had a big ole booty, I was doin' my duty

I saw her in the audience at a concert in Baltimore. She was standing up front looking hot. I winked at her and motioned for her to meet me backstage after the show. Yeah, I did all of that while onstage. I was off the hook. Her name was Phoenix (not her real name). She was beautiful, about my complexion, and she had freckles. And she was a virgin.

I brought her back to the hotel room, and we started getting romantic. But we couldn't really complete the act because I was so inexperienced. My total thing was hitting it and moving on. Back then I had one speed: fast. There wasn't a whole lot of variety in my repertoire, but it seemed to work well anyway. This time, however, I was out of my league. I had never been with a virgin and I didn't know how to make the girl feel at ease. It took us two and a half hours of hugging and kissing, rubbing and prodding, and still nothing was happening. It was frustrating and at the same time comical. So I finally gave up. I just held her for the rest of the evening and we fell asleep.

While my sole purpose at that time was sex, some women had other motives. Some used sex for selfish reasons, to get what they could get. Others denied sex for the same reason. At 17 and 18, I definitely wasn't checking for that. I met one young lady while touring in Philly, and we hung out and had a good time. We were in my suite and I was trying to convince her to have sex with me, but nothing was happening. I got up and went into the bedroom for a while, hoping she'd change her mind.

She was in the living room watching TV when there was a knock on the bedroom door. I looked through the peephole and saw another girl I'd met at the concert. I had given her my room number. Good thing, I thought.

She was standing in the hallway with that "do me" smirk on her face. I let her in and she didn't waste any time. It started with slow, warm kisses and soft touches, her easing down the zipper of her top. Then it just turned wild. She was ripping off

my clothes and pushing me onto the floor. Before I know it, I'm on my hands and knees and she's behind me licking my star-fish. Then I look up, and there's the girl from the next room standing there staring. All I could do was laugh. The girl who was doing me didn't stop, though, and neither did I.

Sometimes I can't believe how wild I was. I know being that way wasn't healthy. But I escaped pretty much unscathed. Physically, anyway.

I didn't have any fatal attractions, and nothing real crazy happened to me. My encounters with the ladies were very calm, cool, and relaxed. There wasn't a lot of drama. I didn't force myself on them. If someone didn't want to do it, I didn't push. It was about having fun. It was, "Yo, let's get busy, the whole nine."

I was so caught up in myself, I would tell girls, "Don't fall in love with me." But plenty of them got attached anyway. There was always a point where they were telling me they loved me. And that bugged me out.

One time, though, the script got flipped and I thought I was in love.

I'm going back to Cali
Rising, surprising
Advising, realizing she's sizin' me up
Her bikini small, heels tall
She said she liked the ocean
She showed me a beach
Gave me a peach
And pulled out the suntan lotion

It was my first time out in California. And from the moment I stepped off that plane, I was loving Cali—the weather, the palm trees, and of course, the ladies. I wrote "Going Back to Cali," in tribute to my love for the place.

I was booked to do *Soul Train* right after *Radio* dropped.

I was so excited, just like a little kid. I grew up watching *Soul Train* and now I was on it. During my performance, I noticed this girl in the audience, dancing. She wasn't a professional dancer, one of their regulars; she was just there dancing. She was unreal, slim with smooth skin. And she was black but had that Latin look. Curly hair and slightly bow-legged. After the show, homegirl came up to me, all sassy, gave me that smirk, and said, "Come here and give me a kiss." Did I? Yeah.

I took her back to the hotel. She had a small rip in the crotch of her pants. I made a bigger rip. And it was over. Gina (not her real name) was my introduction to Cali sex, and I thought it was off the hook. It was my first time getting a chick on the humble like that and I got really caught up. In fact, she became my first regular sexual partner. I hadn't thought about being with a girl on a regular basis before her. Not that she was my girl, because she wasn't the only one I was dealing with— and I damn sure wasn't the only one for her. Cheating wasn't the word for what she was doing. She was about 17 or 18 and from Cali and had been around. But I wanted her—a lot. She was wild and had me open, and I couldn't get enough.

I used to be so into the sex, and she would scratch my back up and yell for me to keep going. With her, it was totally about sex. It didn't matter what was going on mentally, because physically it was just so good. There was conversation, but it was the fit, the wetness, the tightness, it was the everything that you love. It was ripe, plus she had a mound of Venus—a real fly trap. She had complete control over her muscles. It was crazy for me at 16. I couldn't handle it back then. It was definitely handling me.

I was pretty much in control of the ladies until her. But I had never really chased women. I wasn't one of those smooth brothers who had a rap. I was very shy. To some women it might have seemed like I was too into myself or like I thought I was all that. But it was just the opposite. I was petrified of

being rejected. So I rarely tried. I mean you gotta check a kid who starts wearing a hat at a very early age and never takes it off. That ain't someone who thinks they're all that.

But rap fame brought the women to me. All I had to do was pick and choose. There was no guessing game about whether or not I was going to get it. There was no question. I was. It was mine.

As I got more and more successful and famous, there were more and more women, and the selection only got better. There was a new world full of groupies and I was the Christopher Columbus of hip hop.

But I definitely wasn't experienced enough to handle Gina. I was whipped by her sex, which was incredible. And she played me like a little puppy dog. She started only giving it to me when she wanted, like she was training me. I was so sprung, I believed everything she told me. I even found out that she had gotten pregnant (by God knows who, because it wasn't me). Instead of admitting it, she had told me that something was wrong with her stomach, that she had gone to the doctor and had some kind of condition. And I believed her. Now tell me I wasn't caught up.

One time, I flew all the way from New York to be with her, and when I got to her place she told me to go away. She wouldn't even open the door. And I knew she had someone else inside. I couldn't believe it. This girl definitely had game. And I had none.

After that, I decided not to mess with her anymore and left her alone. But she really messed me up. For the longest time, I was going through women like rocks through windows.

It seemed like the more I f∗∗∗ed, the hotter my records got.

I said to the girl, "Them young boys ain't nothin'
You want to get freaky, let me kiss your belly button."
I circled it and teased it and made her squeal

Grabbed a pack of bullets and pulled out the steel.
When I was through, I wiped the sweat from my eyes
Went to the kitchen and got some sweet potato pies.
Tina busted in my house while I was eatin'
You know what I said,
"Too bad you caught me cheatin', but . . .
Brenda got a big ole butt."

My next album, *Bigger and Deffer*, had dropped and I was working on my third when I saw Gina next. It was at the Black Radio Exclusive, a convention at a big hotel in Cali. I walked in with my mink coat and my entourage. She saw me from across the room and yelled out, "Hey! Come here."

I said, "Yeah, yeah. I'll be back in a minute."

I went upstairs to a room, grabbed a couple of groupies, and knocked it out. And I never got with Gina again. Was it revenge? Hell, yeah.

With each passing episode, I became more and more out of control. That porn mentality from way back was growing, lurking under the surface. And while I rarely crossed the line, I often thought about it. Sometimes the line became so blurry I couldn't tell if I was crossing it or not. If a girl was down to do something a little freaky, I was right there with her. My favorite was taking a shower curtain, spreading it smooth side up on the bed, and pouring a bottle of baby oil on it. That made for some crazy, slippery, bugged-out sex. Sometimes I'd get a girl to fill her mouth with warm water and give me a blow job. And they say oil and water don't mix!

Ironically, none of my porn mentality seeped into my stage performances. I know I take off my shirt a lot and all that, but I don't get off on that. I really take off my shirt because it's hot in those lights onstage. And the times I brought the couch onstage during my "I Need Love" days, it was completely choreographed—every move. And there ain't nothing wicked about that, believe me. Onstage, the sexy things I do are all business.

I toured following the release of *Bigger and Deffer* with a group of prominent rap artists. This was another wild tour. There were so many people doing drugs at our hotel, you could walk down the hall and see them snorting cocaine right in the open. It was like that. And the groupies. Unbelievable.

One time I was chilling in the hotel and this rapper, who was a lot bigger than I was at the time (and who will remain nameless), pulls me to the side. He tells me to go into his room and hide in the closet. I didn't know exactly what he was up to, but I knew it would be off the hook.

In walks the rapper. He has this fly-a** hottie with him. I leave a crack in the closet door so I can see what's going on. I feel like I'm in junior high school again, getting busted looking into the girls' bathroom. Except this is much more interesting.

The rapper is sitting on the edge of the bed, and the hottie is on her knees. She pulls out his joint and starts giving him a blow job. I mean honey was working it. She was doing him lovely. After a while I just couldn't take it anymore. So I busted out of the closet and said, "Will you do me next?" She looked at me all disgusted and said, "No!" Homeboy just looked at me and started laughing. That was messed up.

I've been propositioned by women in long-term relationships, even a lot of married and professional women. When you're what they consider a celebrity, people think if they have sex with you it will somehow rub off on them or something. With some people, it's like they're on crack. They can't control themselves. I can't explain it. That was never my mindset even before I became a celebrity.

But I was getting my fix, feeding my sex habit. Sex, with a healthy helping of pornography thrown in, made me feel I had control of my emotions, my feelings. But I really didn't. It was controlling me. I was so off the hook.

I used to buy prostitutes for my boys. Buying hookers for my friends was exciting for me. It was part of the hype, the

power trip, the myth of livin' large. We used to go up to this hotel on Jamaica Ave. on the spur of the moment and I would get a room and get like three or four hookers for my friends. I would just peel off the cash and give it to them, telling them to have a ball.

I also used to go down to Forty-second Street in Manhattan to the peep shows. That little shot in my video "Doin' It," where I'm in the peep booth and there's a sexy lady dancing while I'm eating an apple, was really tame compared to the real thing. I mean, girls behind the glass, doing all kinds of freaky things. And me there watching.

It's funny, even then, in the back of my mind, I'd be sitting in these places thinking how nasty, sad, and seedy they were. I was looking around at the filth and death. And there I was, sitting right in the middle of it.

When I was home in Queens, I used to take young ladies to this motel in Kew Gardens, Queens, which was not too far from LaGuardia Airport. It was freak central, my headquarters. A lot of times I would go to the restaurant downstairs and just sit there and watch, like it was my own personal peep show. It was hilarious, watching the couples come and go.

Sometimes I went there just to chill. I was pretty well known and it was one place where people rarely recognized me. These were everyday people. Hundreds of couples every day, doing the same things I was doing—getting busy. Or thinking about it. Or looking at pictures and movies of it. Isn't it funny? They say the pornography industry takes in hundreds of millions of dollars a year. But no one *ever* talks about it.

I accumulated porn tapes too. I would be driving late at night, and someone would be selling them near the Queensboro Bridge. Or a tape would be left on the tour bus and I would just claim it. Or I would rent them and never return them. I had stacks of them. I was into a lot of well-known porn stars

like Vanessa Del Rio and Seka. I even slipped Ron Jeremy into one of my raps, "Clap Your Hands," on *Panther*:

LL Cool J and the J is for Jeremy, so do me!

I even heard a couple of my songs, like "Big Ole Butt" and, later, "Jingling Baby," as background music on a few porn flicks. That bugged me out.

I was a pornography addict on my way to becoming a sex junkie. If sex and pornography left tracks, I would have had needle marks from head to toe. And being a rap artist on tour just made it worse. It was like giving a junkie an unlimited supply of heroin. And overdosing on sex, like overdosing on dope, is lethal.

My collection of XXX-rated tapes was growing. Sex was running my life. I was illing, juggling all of these ladies and not respecting any of them—or myself. So one day I got fed up. I gathered up all my porno tapes—about 20—grabbed my pile of magazines, and threw them in a big green trash bag. It was 3 A.M. I went out and found a Dumpster and threw the bag in it. I quit, cold turkey. Thank God.

I've done some stupid things sexually. The dumbest was having unprotected sex. I mean I was wilding. Recently, I had to take an AIDS test for an insurance policy, and I was going through a living hell for two weeks. I was waking up in cold sweats with nightmares of all the wild things I had done in my past. I knew I could have easily been caught out there. While waiting for the results, all I did was pray and think about the devastation a positive test would have meant to my wife and children, to my life now. Something I did back in the day could have come back to haunt me. It really gave me something to think about.

The test came back negative, thank God. I was clean, but not because I took care of myself and was responsible. Proba-

bly the few times I did use a condom saved my life. Now I tell everyone I know: Whatever you do, no matter what the circumstances, do it safely.

I had met Simone right in the middle of this wild period in my life. And for a hot second, she was responsible for chilling me out. For the first time in my life, I met a woman whom I just liked for herself. Looking back on all of that, I must have been really crazy to be such a dog, because to me Simone is like 400 billion times better-looking than all of those girls. Her beauty is the kind you don't see every day.

The hottest and most pleasurable moments for me now are when I'm with my wife. It's not just physical. I get the most pleasure out of really feeling her inside without even touching her. She's beautiful and talented and smart as well.

When you share sex with someone you're truly connected with, it's special. The movements are the same, but the subtext is different. I am aware of what she's feeling and giving her what she needs. It's not all about me.

It's funny, some brothers feel that if their lady is screaming and hollering, they're really getting the job done. If she's walking funny afterward, they want to slap pounds with their boys. I've learned that that ain't cool. Yo, if she's walking funny, it hurt her. And just because she's yelling and screaming doesn't mean it's feeling good. You have to be in tune with your woman and know that she may not tell you all the time what she wants. You have to be there with her. Or ask, if you don't know.

I feel really blessed that Simone waited for me to grow up. I'm glad she endured and stuck by me during the rough times. Don't get me wrong, she didn't go out like a sucker. She let me know how foul I was. And for a little while she even saw another man. But her heart was always with me. She's the one woman who knows me at my core—especially after this book (ha ha!). And she knew that I would eventually become the kind of man I needed to be.

There's definitely a reason why she's the mother of my children and there's definitely a reason why she's my wife. A relationship—any relationship—only works when two people are growing together. Simone and I are growing together.

I'm really fortunate that I came out of my dark period of sexuality. There are people in their thirties and forties who still live like I did. On the outside it seems fun, but underneath there's a lot of pain. It took me a few years to figure that out. And like many junkies, I even had relapses.

I think I'm all right now, though. As Simone says, "You'd better be!"

ELEVEN

SLEEPING WITH THE ENEMY

I met Lisette in 1988 while rehearsing for my *Walking with a Panther* tour in a midtown rehearsal studio called SIR. The album had just dropped, and it was doing pretty well. And Dapper Dan, this big-time clothier from uptown who supplied us with a lot of our gear, brought her, her twin sister, and one of her girlfriends to meet me.

There was no attraction. In fact, she had a smart mouth. When she met me she was like, "That's your car out there?" with all this attitude like she couldn't believe it was my car. I had just bought the white custom-made convertible 560 Mercedes in Cali.

"Yep," I said.

Lisette was like, "Yeah, right. That ain't your car."

So I said, "Let's go for a ride then." I took her and her little girlfriends for a spin, just playing with them, showing off. And we built a friendship from there.

It started out very innocently at a time when I was heavily involved with Simone. Lisette was my little hip hop consultant. I needed to keep plugged in to the younger people, and I really was vibing with her like that.

But after Simone had our first child, Najee, I started bugging out. I was scared of the responsibility at that point. I wanted my freedom, and being tied down to a woman and a child was not my idea of freedom. So I ran. And when I did, Lisette was right there waiting.

She was part of another world—Harlem. There is a differ-

ence between living in Queens and going uptown. People from uptown, from Harlem, act differently from people in Queens. People uptown are a little more aware of clothes, they're a little more stylish. Harlem is where the Cotton Club is. That's where Cab Calloway, Duke Ellington were. That's where the Apollo is. That's flavor, the capital of black New York, no question about it. And it's more than a borough away from Queens in attitude.

I was already going uptown a lot buying jewelry, going to clubs, and just hanging out. But Lisette introduced me to a part of Harlem that I hadn't seen. She was part Trinidadian and part Dominican, lived in Spanish Harlem, and spoke Spanish. That tripped me out. It was a whole new environment for me. And, little by little, we became closer friends and started hanging out a lot.

Our friendship didn't make any sense. Not to me, not to anyone around me, and definitely not to Simone. I had almost completely abandoned Simone, but I made sure she was living okay. She had a condo in Jamaica Estates. And we had our second child, conceived during a rough period for us. I know Simone didn't want to have another baby for me, with the way I was acting. But, despite my fear of responsibility, I did. It was like a great accomplishment. But what I didn't realize then (and I definitely do now) is that if you aren't there to make sure the seed you planted is properly nourished, watered, and taken care of, it may not grow right. Thank God for Simone's character. She did a helluva job with our kids when I wasn't there. And she put up with a lot of stuff from me, too.

One time Simone and Lisette had this crazy confrontation in front of my condo in Jamaica Estates. (It was my first home away from my grandparents' house.) I was just coming home and Simone must have been waiting for me. While I was gone, I had told Lisette not to answer the phone. But Simone called and Lisette answered. I don't know exactly what transpired, but Simone came over after that. And when I pulled up, Lisette

was out on the terrace of my apartment and Simone was on the sidewalk below. And the two of them are going at it, shouting back and forth. It was crazy.

I'm sitting in my Mercedes with this kid I'll call Rat, who used to hang around me and steal from me. I knew he was no good, but that's how I was living then. He stole jewelry, money, clothes, everything. He had that kind of access to my stuff. One time he stole some guns from me and I just got fed up, and me and my boys took Rat to a garage and beat him down. I know. Why didn't I just tell him to step off after the first time he stole from me? I don't know. Why did I have the guns anyway? I don't know. That's just how I was living. It was sick. It was a tortured existence.

So Simone and Lisette are having this really loud argument in the middle of the night on a quiet street in Jamaica Estates. And I'm just sitting in the car watching with my man. Simone comes walking over and says, "Todd, tell this girl to get out of your house." She's looking at me like she knows I'm going to set things straight. But I just sat there in the car and didn't say anything to either one of them. Just like an a**.

I knew something wasn't right. But I wanted to have my cake and eat it too. I wanted to have the best of all worlds. It was like I was under a spell.

I really do believe Lisette tried to put a spell on me, by the way. She was into voodoo, and even though I never really believed in that stuff before, I knew whatever she was doing was real. I started finding little mojos around the house, and she would bring me little things she wanted me to wear. I wouldn't wear them, though, and she would get mad at me. One time she brought me a little clay face that her grandmother had made and said, "Wear this, this is nice."

I said, "Nah, I don't want to wear that."

She sucked her teeth and had an attitude for the rest of the night.

I was friends with Lisette for close to a year before I realized something wasn't right. But back then I couldn't see clearly because I wasn't spiritually evolved. That impotent demon was all over me again. I was so busy running around that I gave up a family, the chance to raise my son in his early years, the chance to see my daughter's early years and the opportunity to have a woman on my side who was really on my side. I gave up the opportunity to be a real man and take care of my responsibilities. I gave up the opportunity to show God that I was truly grateful for what he gave me by making sure that my children had the best of everything.

I traded all of that in for nothing. Almost nothing could have stopped me from doing it—only a bullet could have stopped me from going down that track. A bullet or God, of course. But sometimes God puts us in situations so we can learn. He says, "Hey, I'll close your eyes and make it so you can't see the right way, just so you will learn something valuable by feeling your way in the dark." That's what happened to me.

In the beginning, I was enjoying the hell out of my supposed freedom. Toward the end it was hell. And it seemed like everything around me was going there with me—my money, my friends, my career. I owned a house in Long Island—a house I had promised Simone we would live in together—but I had Lisette hanging out there a lot instead. I was so foul. And now I realize it and I'm very sorry for that.

My next album, *Mama Said Knock You Out*, took me to another level musically, but my lifestyle only got worse. The year before I did that album, gangsta rap had become huge. Ice T was out there, and N.W.A. was blowing up the spot with "Straight Outta Compton." Too Short was selling millions underground—you couldn't play his stuff on the radio, it was so

off the hook. They took the reality Public Enemy and KRS-One were talking about to the extreme. They were talking about finding power in drive-bys and killing police, and they were really speaking to a whole generation of disillusioned and angry youth.

My style had been getting a little tired, and I knew I wasn't feeling the people anymore. The backlash I got from *Panther* had shaken my confidence. A lot of rappers were dissing me on their records. Kool Moe Dee, MC Shan, Steady B, and even Ice T were saying that my style was played out and whack. (I must have been doing okay, though, for them to take those shots at me.) I dissed them back. It was like any kind of competition, like what the Chicago Bulls and the Utah Jazz do in the NBA championships. It's all about the game and winning. And I was in it to win it.

I had to regroup. So I went back to the beginning, to Grandma's. One night, I left the studio early and just went to the house where it all began, into the basement so I could think and get connected. My grandmother knew something was up. She came down and asked me what was the matter.

"Grandma, I don't know if I have it anymore," I said. "I feel like all these other guys are getting over."

She didn't understand.

"It's changed so much," I said. "I can't do it the way they do it. What's selling now is something totally different."

She said, "Oh, baby, just knock them out!" And she went back upstairs.

Knock them out? I thought. Yeah, I'll knock them out. I rolled the idea over and over again in my brain. And that night I started writing.

> **Don't call it a comeback**
> **I've been here for years,**
> **Rocking my peers, puttin' suckers in fear. . . .**
>
> **I'm gonna knock you out! Mama said knock you out!**

Platinum. Again.

I knew I had to do something bigger and different with this one, so I came out hard. Not gangsta, just hard. Real raw. And I knew I needed help to achieve that. On *Panther*, I had done a lot of it myself—the writing and mixing. While doing promotional work for it, though, I frequently popped up on local radio stations. One time I did a gig at WBLS-FM in Manhattan on the air with deejay Marley Marl. After the show, he talked to me about doing remixes on my upcoming album and I said, "All right." So on *Mama* he remixed "Jingling Baby." It blew up. It seemed like every song on that album was a hit. And I was really enjoying the fruits.

I remember sitting in the audience of Madison Square Garden, wearing nothing but a leather vest, matching pants, and a leather Kangol-style hat. Chest out, arms out, buffed. I had really put in a lot of work for this entire album, down to perfecting my body. And it paid off. So I was sitting in the audience, waiting for them to call my name for a Grammy. And they did. Yo! A Grammy! That moment was one of the sweetest. It was like everyone who ever said I couldn't do something was proved wrong that day.

It was just like when I was up for a *Soul Train* Music Award for "I Need Love," back in 1987. It was a record that people had laughed at in the beginning. They were saying it was too soft for rap and it wouldn't sell. It blew up. When they told me I won that time, all I could hear was the playa haters saying, "You ain't nothing. You suck. You can't do it. Just give up."

Ha! When they called my name, I literally bugged out. Everybody was talking about how wild me and my crew—Bobcat and the LA posse—were acting. Like we had never won anything before. (We hadn't.) But I felt vindicated.

It's funny, that seems to be a constant theme in my life. From learning how to ride a bike, to my first performance in a church basement at 13, when this girl came up to me afterward

and said simply, "You suck," I have always had something to prove. When I was trying to get a record deal, no one believed in me except my family. And I went out and did it.

Another time, just after I had cut my first record, I did a block party around my way. After I finished my set I told the crowd to look out for my new single in the stores. The MC grabbed the mike from me and yelled, "Stop lying!" And the whole crowd started laughing. I was standing there like a sucker. A few years and two platinum albums later, though, I saw that guy again at a clothing store. He looked at me and nodded his head in recognition of how wrong he had been.

After *Panther*, which went platinum, people said I was finished, washed up because of the negative backlash I got for my "selfish" lyrics. And I came back with *Mama Said Knock You Out*. With a Grammy, another platinum hit, more cars, and more women, I thought I was back on top.

I was also feeling good about the movie *Toys*, which was in the works. I was working with acting giants and a great director. What I had thought was a bit part was turning out to be a great role. And we were having fun on the set.

Robin Williams was real nice to me. He was no prima donna caught up in that big Hollywood star syndrome. In fact, at times he was a little *too* real. He would show up to the set all funky, smelling like a wild boar, like a truckload of hot garbage. And I was thinking, Damn, this guy is really regular.

He was so entertaining, though, that I didn't mind. On the set, he was hilarious, constantly in character and making jokes and carrying on. And I really learned a lot about acting from him.

So on the surface, everything seemed perfect. But I couldn't have been more wrong. Everything was definitely *not* perfect.

While I was out collecting my spoils, Simone was sitting at home, taking care of our two kids, enduring a whole lot of bull

from me. My kids were living day to day in a small two-bedroom condo, while I was a millionaire, three or four times over. And, at one point in time, some other man was there, taking them places, eating dinner out with them.

And I was paying for that spiritually, with Lisette. Fortunately, there was another voice in my other ear, saying, "Homeboy, you ain't living right." It started getting louder and louder.

That voice was Charles Fisher's. He had been there at the very beginning of my career, this obscure, strange guy I didn't pay much attention to. Over the years, he kept popping up here and there, like a constant reminder. But this last time, he was armed with the word. I couldn't run from that.

Charles had worked with Russell in the early 1980s, and at one point he even ran my fan club. The first time we met was in 1985, when I was finishing *Radio*. We just happened to be leaving Russell's office at the same time and he offered me a ride to the studio. We walked a couple of blocks from Broadway to Third Avenue, where he said his car was parked. But it wasn't there. It had been towed or stolen. I didn't stick around to find out, because I had to jet to the studio.

When I met him again in 1991, in a nightclub in Queens, he said he had some spiritual and cultural literature that he wanted me to read. This was during the *Mama* years, when I was supposedly at the pinnacle of my career. I had a full entourage, plenty of champagne, and I was draped in women. But underneath the gold chains and the glitter was this foul stench. And I guess Charles smelled it. He told me what was on those pages would give me spiritual power and wealth.

I'm thinking, I already have that.

But he was insistent about my reading the material he had. So I had him send it over, and I took it on tour with me. What the hell, I thought, it couldn't hurt. Somewhere along the way, though, I lost the material before I could finish reading it.

A few months later, I ran into Charles again at the Christmas party for Video Music Box, which was a big event at the time. He asked me what I thought of the stuff he had sent me, and I confessed that I had lost it on the tour bus. But I told him that what I had read was exciting, and I asked him for another copy of what he called "The Power of the Prophets."

He handed me his business card, looked me in the eye, and said, "If you're serious about acquiring real power, prove it and give me a call."

Two days later, New Year's Day, I took Charles up on his challenge. I had decided to start my life fresh and clean, and my New Year's resolution was self-improvement. It seemed like the perfect opportunity to walk the talk.

When I called his house, Charles couldn't believe it was me calling him on New Year's Day. But he told me he would give me another copy of the information if I would commit to being the honorary Chairman of his youth program, Youth Enterprises, for one year. I agreed. Hours later, I was knocking at his door to get the information that would change my life.

I read everything Charles gave me. It was like water in the desert, filling in all the missing parts, not just in my education, but in my soul. Things I already knew, but couldn't prove, were answered for me. Things about the origin of man and what God really expects from us. Charles had me reading everything from the Bible to the Koran. And I was drinking it up like I had been on the Sahara for ten years without a drop.

I would come to his house at two in the morning, tapping on his window for another book. Charles would come to the door in his baggy drawers and those stick-figure legs with a book in his hand for me. I was like a junkie needing a fix, and he had the drug—knowledge. If school taught stuff like that, I would have graduated summa cum laude.

Just about every day, we studied either in person or by phone. And I began to realize that even though I thought I was

rich and successful, there were still a lot of things that I did not know. In order for me to get to the next level in life, I needed to discover my true purpose on this planet, and how to use my success for the benefit of those who were less fortunate.

Charles was like my personal spiritual tutor, like Yoda. He even taught me about meditation. And, little by little, I started to see what was going on around me. My eyes, my mind's eyes, began to open.

What I saw frightened me. I began to see Lisette for who she really was. And it wasn't good. I realized she was doing some foul stuff to stay my friend. And I was following like a zombie, under a spell. I was crazy.

While we were hanging out, strange things had been happening. Her grandmother was so upset with her for dealing with me that she took a Bible, burned it, put it in her shoes, and mailed it to her. Yo, I still don't know what that was all about. I don't know if her grandmother was mad because she didn't want her dealing with me, or mad about the things she knew Lisette was doing in terms of the voodoo. Either way, it was ill.

During the time I spent with Lisette, my grandmother even went to fortune tellers to find out what was wrong with me, why I was such a zombie. Why I was just cutting off everybody in my life—my family, all my people—just to be Lisette's friend. It was like me and her against righteousness. And I was bound to lose.

I also began to realize that my so-called friends were betraying me. Brian Latture, my co-manager, was supposed to be managing my career—but he was spending too much time managing Nas. (Ask Nas how he liked that.) I began to feel like he was playing me out. I was also starting to think something wasn't right between me and my father.

I should have known something was really wrong in my life when my father started encouraging me to marry Lisette. What

was that all about? I don't know. But Simone, to her credit, never gave up on me. She kept trying to snap me out of it. She had moved on with her life and she was seeing another guy during this time, but the bond between us was too strong for her to let me fall. I always knew she was there, and I'm forever grateful.

I was very disrespectful during this time and I'm very sorry for that. I was disrespectful to my family, disrespectful to my future wife and the mother of my children. And I finally began to see *myself* for what I was. So I made a decision to change. It wasn't easy. But looking back on it, it seems like the only possible solution.

Charles taught me to erect spiritual mirrors by living righteous. If I cultivated my spiritual strength, he said, anyone trying to throw evil my way would have it come right back on them. I didn't waste any time. I started studying more and trying to apply those principles to my life. And I started struggling with those mirrors. Strangely, Lisette died from leukemia within two months of this. She was 17.

After her death, I was lying in the bed in the basement of my grandmother's. I was feeling the need to be connected so I went back to my grandmother's house. That's where I do most of my writing for my albums and most of my heavy thinking. In that house I was always looked out for and loved.

Conflict was constant in my life. I was battling the pull to act wild versus the need to be righteous. And it was difficult. So I was lying in the bed, not sleeping, just staring at the ceiling in the dark. Everything had happened so fast.

So I'm lying there, and all of a sudden I feel this force. Some people may think this is crazy, but it's real. This force—a demon—was in the room, hovering over me. It pinned me to the bed. I couldn't move. I could barely breathe. It had my arms pinned to the bed, and I felt this presence around my face. It was like the forces of darkness had come to life in my room. I

could feel the breath on my face. It said, "You can be where you want to be. You can have everything you want. But you have to say yes now."

At the time I was feeling like I had nothing—no kids, no wife, no friends, no home, no career, nothing. I had the reverse Midas touch—everything I touched was turning to s∗∗∗. But I knew if I said yes, I would be selling my soul.

It said to me again, "Say yes. Just say yes, and it's yours."

I was fighting, trying to break loose. I screamed, "No!" And as I said no, I felt snakes crawling through me up my rectum, out of my mouth and ears, and then wrapping around my neck, choking me. I heard women giggling all around me. And then—silence. Everything was gone.

I was left lying there sweating, my wrists aching. Even today, sometimes my wrists will ache for no apparent reason. I think it's a reminder that evil is just waiting for me, waiting to give me everything I think I want, but really wanting only to take everything I need. I know I have to be strong, strong enough to say no, and patient enough to wait for the real goodness.

RIGHTEOUS REVELATION

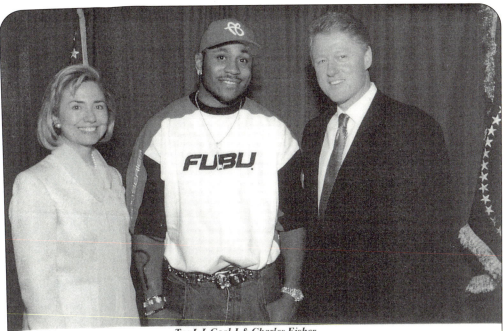

To: L L Cool J & Charles Fisher
Thanks for supporting the
President's Summit for America's Future
Wishing the both of you much Success

Hillary Rodham Clinton *Bill Clinton*

THE WHITE HOUSE
WASHINGTON

June 19, 1997

Dear LL Cool J:

I'm glad you could join me at the Presidents' Summit for America's Future. I was impressed by the outpouring of support generated by the Summit, and your involvement helped make that possible.

By bringing people together from all across the nation to kick off this effort, we have taken a major step toward reinvigorating America's commitment to citizen service. In the months and years ahead, we want to instill a new sense of duty and determination in Americans to carry the ethic of service into our daily lives. I look forward to working with you to build upon the foundation of community activism we established in Philadelphia.

Hillary joins me in sending best wishes.

Sincerely,

Bill Clinton

THE WHITE HOUSE
WASHINGTON

July 3, 1997

Dear LL Cool J:

I'm glad that you could join me in Denver for the Summit of the Eight. The entertainment was one of the highlights of the gathering, and your performance helped make the Summit a great success.

I am pleased that we could give our international partners a sense of the natural beauty and character of our country -- and that we could also demonstrate our frontier spirit, our common commitment to the future, and our ability to blend and recognize the strengths of our many cultures. You truly helped us showcase the rich variety of America's unique and inspiring musical genres.

Thanks again. Hillary joins me in sending best wishes.

Sincerely,

Bill Clinton

TWELVE

CROSSROADS

I was standing in the shower naked—both inside and out. I let the water flow all over my body. The tears washed down my face along with the water. I hadn't really cried since I was a kid. But on this day, I made up for it. I was crying for a woman I had treated like a dog, crying for the children I had abandoned, crying for my life, which I was just throwing away. And crying because I felt like I had been betrayed on every level. I had a broken heart.

I had fooled myself into believing that I had won some kind of major spiritual battle. But you can't fool yourself forever. My life had gone from hell to *Hell*. I was pouring my soul into my next album, *14 Shots to the Dome*. Lyrically, it was the deepest thing I had ever done. But my spirit was disturbed throughout the recording and mixing and remixing, throughout the whole process. And it sold fewer than 800,000 copies. For most artists that would be good, real good. But for LL Cool J, coming off four straight platinum hits and a Grammy, it was a setback. Maybe the end. I had set a high standard for myself. And a lot of people who had put me out front by buying my music were now saying I didn't have it anymore. It looked like my career was finished.

We had high hopes for my latest film, *Out of Sync*, my first real starring role. But it bombed at the box office. They spent like a million dollars to make it—and it made only $9,000. It was in and out of the theaters so fast it should have gone straight to video. I thought it would do well, because for the

first time I had nothing on my head, for all to see. (You're holding the second time.) And besides, it was directed by Debbie Allen, who I thought was great. She did a fantastic job on the budget she had. But my acting sucked. I should have paid them for the movie. So I cried about that, too.

I was alone in the shower, in my empty apartment in California. After about half an hour, I came out. My body was clean, and my soul had also gotten a thorough rinsing.

I realized I had been driving in a car with dirty windows. When your windows are dirty, you don't have a clear view of what's around you. You might think your house and yard, like your life, are nice and well maintained. And then someone comes along and cleans your windshield. Suddenly, instead of flowers and nicely trimmed hedges, you realize you've got all sorts of weeds in your yard. You see the chipped paint, the broken stairs, the cracked sidewalk. You see that your house is not in order.

That shower cleaned my windshield. I realized the people around me were like weeds, choking the life out of me. But I was the one who had planted the seeds. Charles had warned me, but I was stubborn. I had to witness the destruction first-hand, to reach the bottom of the pit before I could get up and climb out.

Terrified
you feel the fire blaze.
The ground can't hold your weight.
You reach out to grab the pearly gates.
*Who clocked this f****
not from space.
Never again
will you see the human race.
19 angels leadin' the devil straight to hell!
Torment!
Pain!

What you're seein' here
you can't explain.
All your life
some men
we played the game.
Never realize that there's a flame.

I had been badly burned. My best friend—my son's godfa-
ther and my manager—had betrayed me. I felt like my own
father was stabbing me in the back. But I was my own worst
enemy. I had thrown away a solid relationship with a woman I
loved and lost the chance to see my kids grow up. I was creat-
ing the scenario so they would have a painful childhood like
mine: walking out of their lives so they could be raised by an-
other man who wasn't their father and might mistreat them
because they weren't his children.

It had taken me nearly seven years to get to the so-called
top. (Now I know better than to *ever* think I'm on top.) And it
took less than a year to lose everything.

I was surrounded by people who only cared about what
they could get from me and what I represented to them. I was
only LL Cool J, the big-spending, Grammy-winning, platinum-
selling rapper. LL the commodity. Nobody was seeing Todd.

I concluded that the deal my pops had renegotiated with
Def Jam was smart for them, but not so smart for me. The deal
basically locked me into the new contract for what seemed like
life. I found out that I owed more than two million dollars in
back taxes. I almost lost my house. One of the main things my
father used to complain about—accountants not making sure
my taxes were paid—was the very thing he let happen. I don't
know if he was in over his head, or what, but he was also misus-
ing the company credit cards. Plus, movie offers had been com-
ing in left and right that I was never told about.

I had taken what I thought was a bit part in *Toys*, and it

turned out to be the best role of my life. But I had never really capitalized on it. Today I see Will Smith in blockbuster films, having become a box office superstar, and I respect how he parlayed his rap career into a big-time film career.

Eventually that will be me. But back then, my management didn't encourage me to hone my acting skills, and they didn't push me into the right roles.

For *Toys* to be my first flick out the box (*Krush Groove* doesn't count, since it was really a cameo), I should have been on my way. Besides having fun, I got rave reviews for my part. After *Toys* I played a detective in a movie with Michael J. Fox and James Woods. It was cool, but it wasn't really a step up or a stretch for me. And *Out of Sync* hadn't been a success as we'd all hoped. My film career had no momentum.

Besides the general mismanagement, I think one of my father's biggest failures was making bad career choices for me, particularly with films. But some of it was my fault, too. He wouldn't have made so many bad decisions if I didn't let him. You can't just hand over the reins to your manager and say, "Here's my career. Do what you want." Because ultimately it is your career, and every decision made, no matter by whom, directly affects you. Today, I'm aware of every role, every offer, every deal, and every dime that comes through my camp. I'm involved with every decision, even down to the covers of my albums. Even the cover of this book. That's the way it should have been from Day One.

Real trust is a rare attribute in show business. I trusted my father. I wanted to believe he was looking out for me. He wasn't.

And Brian hurt me just as much. I thought he was my best friend. He was my son's godfather and was there from the beginning. But what he did to me, what he did to Cornell, made me realize the type of person he must have been all along. I had been blind, deaf, and dumb.

The wind is howlin'
the rain pours down
eyes are bloodshot
heartbeat pounds.
Lights go out
the whole world's in darkness
the ground is tremblin'
dogs are barkless.
In the sky there appears a great light
burnin' all the flesh off the creatures of the night.

Cornell lay in a bed in Manhattan, in a raggedy hospital gown. He had no clothes or shoes of his own. He had lost his hair and only weighed about 70 pounds. He was dying, and I wasn't there. He had been sick for a while and I never knew. I was out in Los Angeles filming *Out of Sync* and we had gotten out of touch. But Gene Anthony Ray (from *Fame*) was working on the film with me and he told me Cornell was sick.

I called him in the hospital and he didn't sound good. I asked him how he was doing. He broke down and cried. He told me he had AIDS. My first reaction was, "How'd you catch that, man?!" But then I realized it really didn't matter. All I knew was that he was one of the best friends I ever had. And he was on his deathbed with no clothes, no shoes, and no money.

I asked Brian to take care of him. I told him to give him a few thousand dollars so that he could buy some clothes and shoes, so he could live his last days with some dignity. If I was in the hospital and dying, I would at least want to have a robe and some decent clothes so I could talk to my visitors without being self-conscious.

Instead Brian went around telling everyone that Cornell was on crack and that he was pretending he was sick so he could squeeze some money out of me. Brian didn't give him a dime. All along, he kept telling me that he had taken care of Cornell. It wasn't until Cornell died that I found out the truth. I

can never forgive Brian for what he did (or rather, what he didn't do).

All those years, Cornell had known he was dying and never told anyone. He was too proud to ask me for anything. When he finally broke down and called me, the people I trusted to handle my business let him down, and let me down. There are no words to describe how disgusted I was and still am.

I did my best to make it up at his funeral. His family couldn't afford to bury him in New York. They were going to have a modest service and bury him somewhere in Jersey. But I knew Cornell wouldn't want to be buried anywhere but in New York City. He was so proud to be from Harlem, proud to be from New York. He used to walk around singing "New York, New York" all the time.

I got him a good casket, a real nice suit, and a tombstone, and buried him in Woodlawn Cemetery in Queens, not too far from where he used to live and not too far from my grandmother's house. It ain't Harlem, but at least he's buried in New York. I try to visit his grave sometimes when I come home.

I played "The Player's Ball" by Outkast over and over again in my limo behind the hearse. It was a big funeral, with lots of flowers and lots of limousines and lots of people. Cornell, my man and my teacher, would have loved it—the spotlight and all the people loving him. It's a shame he had to die to get it.

I took a lot of flak over the years for my relationship with Cornell. There had always been rumors about his sexuality. His dying from AIDS just added to the speculation. But I didn't care because he was my man. He died of AIDS, so what. The worst thing was that he died.

I used to wonder if he was gay or not myself. But it didn't matter to me if he was, because I wasn't getting to that part of it with him. He had embraced me, took me in, and looked out for me. He showed me the right way. What I learned from Cornell was sincerity and true friendship, unconditional love. I

learned some funny things too—like how to give a courtesy flush, and what to do if anybody ever kicked me in the nuts (jump up and down on my heels real hard). Even his death taught me something. It taught me how to start acting in my own life like the friend Cornell was to me.

It's hard to find sincere people when you have money. They only know how to be sincere when you are broke. If you have money, nobody is your friend. People like Brian, my father, and my growing entourage taught me an important lesson—that most people only want what they can get from you. It's one of the saddest aspects of being successful.

I had given Brian his own record company, made sure he always had money, a car, everything. Then he turned around and let me down. He allowed my main man to die in a hospital with no clothes or shoes because he didn't like him and was probably jealous of our relationship.

You have to look at what people bring into your life. If they bring bad vibes and turmoil, then they're bad for you. If they are always around conflict or in conflict, they're bad for you. That's something I learned from Cornell. The things he did for me, for the most part, changed my life for the better. Cornell was special. He was so cool.

One time I told him, "Yo, Cornell, we look alike."

He said, "Get the hell outta here."

"No, I'm telling you we look alike. Look at our faces, the shape." I was seeing beyond the exterior and looking inside Cornell, looking at the structure of his soul. I never saw him with a man or anything. But anybody who would turn down an opportunity to have a true friend because of their sexual preference, race, or religion ain't real. If you have just one real friend, you are lucky. Do you know how many people don't have any friends at all? There is a song about that, about how the luckiest thing in the world is to find a friend along the way. It's completely true.

Losing Cornell gave me the courage to clean house, something I had needed to do for years. I severed my business relationship with Brian in a gentlemanly fashion and we went our separate ways.

I then went to the bank to freeze what little money I had left. While I was there, ironically, my father called to find out how much money was in the account that he could sign on. I froze that too.

I had to sever my relationship with him too. Weeks later, he was calling me, saying, "You're not better off without me!" I looked at the phone like he was crazy. Not only was I better off, I was free. My own father had let me down. He broke my heart. And for the first time in almost ten years I was alone. I was forced to make my own decisions and be a man.

Ring! Ring!

"Who's this?!" I screamed into the phone.

I was in my empty house in Long Island, and Lisette had been getting a lot of crank calls while she was hanging out at my crib. I thought it might have been another one. But it wasn't.

"Hi, is LL Cool J home?" said this soft voice on the other line. "This is Kidada. Kidada Jones, Quincy's daughter."

She said she got my number from Russell Simmons and had been trying to hook up with me for weeks. She kept calling me, like every other day, and finally we decided to go out on a date. I met her in Manhattan where she was staying with a friend and we went out to eat. It was fun, so we started hanging out on the regular and eventually we became romantic.

The first time I brought her home, my grandmother was so excited because she was Quincy Jones' daughter. I didn't care about all of that. I just thought she was cool.

I respected Kidada. We might have stayed together, but I

guess fate and God had other plans for me. Kidada studied a form of yoga. She would go to an ashram, consult a guru, and pray to statues. No disrespect to any religion, but I can't pray to statues. That's something I knew long before I read about idolatry with Charles. I can only pray to God. Even when I went to Catholic church, I used to ask the priest why we had to pray to a statue of Jesus. I didn't understand why we couldn't just talk to God. The priest said something about it being easier to communicate through another. I wasn't buying that.

Before my album *14 Shots to the Dome* dropped, Kidada told me she threw some kind of stick into the eternal fire for my album. I was like, "Yo, why did you do that? I didn't ask you to do that!" That joint flopped crazily.

"Oh, well, I'm sorry I cared!" she said. I had hurt her feelings, but she had hurt me too.

I know she meant well, but I just couldn't get with that. She took me to her guru once and I remember kneeling before this strange young woman who was touching us with feathers. I said to myself, "You know what? I'm like Solomon right now." I was being led to praise things other than what I should be praising—God. And that freaked me out—it shook me back to reality. Here I was again, trying to go with someone else's flow, sacrificing my soul in the process.

I knew then I couldn't be with her. I thought she was a really nice girl, and we even talked about getting married (I bought a ring and everything). But I knew God didn't bring me all that way for me to turn my back on Him and go out like that. It boiled down to the fact that we just didn't believe the same things. No harm, no foul.

It was not about disrespecting Kidada, it was more about me respecting and connecting with God on a level where I felt comfortable. We weren't on the same wavelength, not just spiritually. I was from Queens, she was from Bel Air. I know what it's like to be hungry and live on the subway, all she's ever

known is being rich. She has a rich, successful, talented father. My father was mostly absent. She praised a guru and statues, and I praise God, straight up. We were just different. So we went our separate ways.

Some people have accused me of using our relationship to get next to her father. If that were the case, I would have just stayed with her. But I couldn't do that. I wasn't going to take advantage of someone's daughter for personal gain, because I can imagine how I'd feel if someone tried to do that to Tally or Samaria down the line, to get next to me. In fact, when I eventually started doing the television show with Mr. Jones, he told me Kidada asked him why he had to do a show with *me*.

This period of my life was about soul searching, and I am grateful for the experiences that I went through. Through that seeking I found myself and many of the answers I was looking for.

Some of them were right there in front of me all along.

THIRTEEN

G.E.D. (GENERAL EDUCATION ON DECENCY)

I sat in a cramped classroom in Hempstead, New York. There were about 15 students and me—with four platinum albums, a Grammy, and millions of dollars. And not one of the people in that classroom paid any attention to the Grammy, to the millions, to the fame. They were there for a purpose and so was I.

I enrolled in this program to work on my G.E.D. But more important, I needed to work on me. I had just severed my relationship with my management team and I knew that one reason I kept them on so long was because I was insecure about my abilities to handle my own finances. I was insecure about my lack of education. So I went back to school to build my confidence and fill in some of the blanks I had from dropping out.

It's one of the smartest things I ever did. I might be the only one to become successful out of a million kids who drop out of school. But even with the wealth, the fame, and the success, if I had it to do over again, I would finish school. Not having that education left me vulnerable to a business that literally eats people alive. Going back to school got me back on track.

I was studying with Charles every night. But that was more spiritual knowledge. I also needed to brush up on my math skills so I could be more involved with my career and make better decisions. And I started looking for new management.

I hooked up with Sean "Puff Daddy" Combs for a hot minute. He was the production mastermind behind Mary J. Blige

and Jodeci while he was an A&R man at Uptown Records. And he had parlayed his platinum-hit abilities into his own label. He had a new act, the late Notorious B.I.G. (may he rest in peace), who was looking like he was going to be major. I wanted to work with someone who I thought had insight and the ability to take it to the next level.

But Puffy was on the rise and very busy, and I had a lot of financial difficulties. We couldn't agree on what the budget would be because financially I wasn't in as good a position as I would have liked. And he wasn't at a point where he was ready to compromise. He wanted $500,000, which was not outrageous. I just couldn't do it on my budget. So we went our separate ways. (No hard feelings—Puffy and I are currently working on new projects together and hopefully will be making some hits.)

Norm Nixon, former Los Angeles Lakers basketball player and Debbie Allen's husband, also managed me for a little while. I met him while doing *Out of Sync*, which was directed by Debbie. Norm was a very smart man who had a lot of connections with agents through his athletics, and he knew a lot of people in Hollywood. He helped me renegotiate my deal with Def Jam for the *Mr. Smith* album and he did a good job. But I still wasn't feeling like I was totally taking care of business. I decided to back up for a minute and really figure out what I wanted to do instead of jumping right into another management situation.

When I backed up, I bumped right into my new management team—a guy who had been staring me in the mirror for more than 25 years. Me. I had more than a decade under my belt in the business, and no one knew the ins and outs of my career and what I needed better than me. I was feeling more and more confident, and I felt ready to take responsibility for my career.

I also knew I needed someone to handle the day-to-day

stuff. And there was someone who had been around me for a while, one of the only people who was giving more than he was taking—Charles. We studied and talked about spirituality together and it just made sense to continue along that path in my business life as well.

He had also done some managing himself. He discovered R Kelly and the Public Announcement in Chicago, and helped Kelly get his first contract with Jive Records. And he was someone who showed me the way spiritually. So I decided to give him a shot. Hell, he couldn't do any worse than the last management teams I had. And besides, this time, I would be involved in every single decision.

My next album was *Mr. Smith*. I had already written it, but it was during the time when I was going through all the turmoil, getting rid of my prior management, and going through my thing. And it reflected all of that—the album was a mess.

I talked with Lyor Cohen, president of Def Jam, about my album, and he suggested I meet Chris Lighty. Chris ran Violator at Def Jam, in the A&R division. I had seen him at different industry parties. We were always friendly but we had never really had a conversation.

We talked about redoing the album together. The first thing I expressed to him was that I had no problem with taking advice or being guided. I was in a G.E.D. program, I was a spiritual student, I was learning to manage myself, and I was ready to do whatever I needed to do to make a good album. I didn't want to be the guy of old, who wasn't focused, or the guy who had all the answers. I just wanted to be humble. I was thankful, ambitious, and ready to make something good.

This has been my philosophy ever since. And I'm going to stick with it because it really doesn't pay to be cocky. Look where I ended up. We kept two songs off the original *Mr. Smith* album, the title cut and "No Airplay," but we basically started from scratch.

This was to be my coming-of-age album, something like Janet Jackson's *Control*. For the first time I was making my own decisions and making my own rules. But doing it in a spiritual way—allowing others to help.

Chris wanted to get a lot of people involved. He introduced me to Trackmasters, who did most of my beats. They put together "I Shot Ya," a cut featuring several rappers. Back in the day I never would have done a record like that. In fact, Chris had to convince me to do that one. I didn't feel comfortable rapping on a song with so many other rappers, especially some of the new ones. I didn't know if my style would work with theirs or if I would sound up to par. But I did it and it worked.

When I heard the first sample cut I was feeling it. I also noticed they had sneaked a young lady on the back end. It was

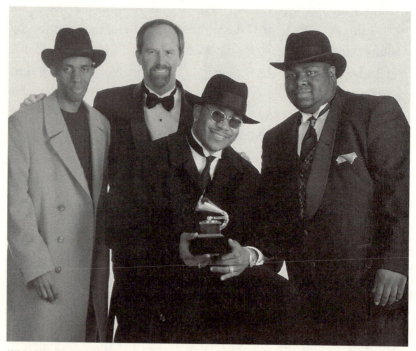

With Charles Fisher, Ralph Roundtree, and Michael Greene, President and CEO of the National Academy of Recording Arts and Sciences, right after I won my second Grammy.
(Jim McHugh/NARAS/39th Annual Grammy Awards)

Foxy Brown. She sounded good, so I didn't tell them to take her off.

I had written another song, "Hey Lover," with strong vocals to go with the rap. Chris' assistant Mona contacted Boyz II Men's management. The next week, we all jumped in Chris's car—me, Chris, and Trackmasters—and headed to Philly where they were recording. They listened to the track, but didn't know if they could sing on it because they were on Motown. I reminded them that Def Jam and Motown are both distributed by Polygram—no more obstacles. And you know how that one turned out—Platinum!

I now really enjoy working with other artists. I love feeling their energy and their vibes and putting things together, then watching how it turns out. Imagine if Michelangelo and Picasso could paint a painting together. That's what it's like for me to work with artists like Boyz II Men. I learn things from other artists, too, all the time. I'll always be a student of hip hop.

I hooked up with Hype Williams to do most of the videos for *Mr. Smith*. He did "Hey Lover," "I Shot Ya," and "Doin' It," which was really off the hook. He wanted to do all sorts of crazy things with that one. In one scene he painted me silver. I let Wesley Snipes talk me into that one. He was on the set while we were filming, and I was hesitating on the silver thing. Wesley says, "Go ahead and do it, man, it'll look good." I figured here's a man that dressed up like a woman. If he could do that, I can get painted silver.

Not many of those shots ended up in the video. I was a little overweight, about eight pounds, and the paint seemed to magnify the extra weight around my middle. And the paint looked funny with the hair on my chest and stomach. But it was a creative idea, and I liked that. My main thing is being creative and making good music. I don't head trip off of my records anymore. I don't let this business drive me crazy. Look at Michael Jordan in the fourth quarter when the Bulls are down by

six. He's not panicking. I'm sure he is hoping he can drop a couple of threes, but he knows panicking ain't going to help him do it.

Now I just do the best I can during the time I have. I used to put everything on hold until my album was done—family, fun, life. Not anymore. When I'm not doing the album, I'm not thinking about the album. I make time for everything else. I keep a nice balance. Only when you're balanced do things work properly. Another valuable life lesson.

Before *Mr. Smith* dropped I got a real break. Quincy Jones offered me a television show. I had been at my lowest point when he first called—I had no management, no money, and I was in renegotiations with Def Jam, so even my music was uncertain. He and his partner, David Salzman, who I had met several times hanging out with Mr. Jones, had an idea for a show. I was definitely all ears—they were the team behind *Fresh Prince of Bel Air*, which was still in the top 30 when it went off the air in 1995. And they had also made hits with *The Jenny Jones Show* and *Vibe* magazine.

They wanted to team me with Debbie Allen, who directed me in *Out of Sync*. (Ain't that wild: a film that made only $9,000 led me to my TV show.) The role sounded perfect. They wanted me to play a character, a former athlete, who was trying to get back on the gridiron but, ironically enough, was strapped for cash. So he takes in this family and kind of becomes nanny, friend, and confidant.

What really convinced me to do the show was that the character had a holistic approach to life—no drinking, no wild women, no drugs. Just the way my life had become. It wouldn't be a hard role to play at all, plus I would be teaching by example. I signed up.

I was also able to be a positive force when I toured for *Mr. Smith*. On the Down Low Tour, with R Kelly, Escape, and Solo,

I made a point of doing community work in every city we hit. We visited hospitals, schools, churches, everything.

I remember one little boy I met in a children's hospital whose parents, I was told, had locked him in a closet and then set the house on fire. He had burns all over his body—even his eyelids were burned. It was indescribable, and it was a very moving experience meeting him. We were all there crying in the hospital, and I realized not only that this boy was someone I wanted to look out for, but that there are millions of kids out there, and they're all special. He helped me realize how important it is to be involved and do what I can—and how thankful I am to be where I am.

When I won a Grammy for one of the songs on *Mr. Smith*, it was like the final confirmation that my decision to leave the negative energy behind and live in a positive manner was absolutely, 100 percent right. I had made the right choices about how to conduct myself, and what kind of people to surround myself with. And the feeling of winning that Grammy—it was like regaining the heavyweight championship of the world.

So my career was back on track. But I still wasn't complete. I had one loose end in my life to tie up.

I had decided I wanted to spend more time with my kids, so I would drop by Simone's condo in Jamaica Estates more often. We were staying on friendly terms for the kids' sake, and we started talking again. Ironically, even during our breakups, Simone was still a part of the family. She and the kids would often drop by my moms or go to my grandmother's for Sunday dinner. But we had to get to know each other again.

Before long, I realized that the love I was seeking was there all along. It had been there for more than eight years. It was always there in my best friend, Simone.

We were driving down the Southern State Parkway heading to the house in Long Island in the spring of 1994. We had had

a great time and were laughing about something and it just hit me. I wanted this every day.

At the same time, I kept hearing my uncle Waldo's voice in my head. He was my grandfather's younger brother, and he would constantly call me and say, "You need to settle down and get married. You have a family, and you need to do what's right." He had a good point. He helped me realize what I needed to do through his wisdom.

I had been mulling it over for three or four weeks, and it came together. I was driving along the highway with the radio blasting as usual. Strangely enough, it was the same highway where my mother had rolled out of the car, pregnant with me, more than 25 years before. I turned the music down, looked at Simone, and said, "You wanna do this?"

I know it's not romantic. I didn't get down on one knee with a big ring and a poem. But what I said, I meant from my heart. All of those elements were wrapped into that simple question. I may have said, "You wanna do this?" But what I meant was, "I want to spend the rest of my life with you. I've learned my lessons, and I'm sorry for putting you through so much. I'm bonded to you. You are my soulmate."

And Simone knew it. She has always been my around the way girl.

FOURTEEN

MY AROUND THE WAY GIRL

I need a girl with extensions in her hair
Bamboo earrings at least two pair
A Fendi bag and a bad attitude. . . .

Simone walked down the aisle in a beautiful cream-colored lace dress, and it seemed as though everybody witnessing this in the backyard of our Merrick, Long Island, home was in tears. My grandmother, my mother, her grandmother, her uncle, even her cousin Sloan, who was the maid of honor, couldn't help but cry. They had all been there from the beginning, and they watched us go through our thing. To finally be here on this day, getting married, was like a miracle.

We had a down-home wedding—like us, no frills. It was not a big catered affair. Simone's grandfather baked a big ham and made collard greens. My cousin Vern made my favorite seven-layer salad. There was fried chicken, candied yams, macaroni and cheese, roast beef, biscuits, rolls, pies, and cakes. Everybody brought a different dish. We did it in the backyard with only immediate family and friends.

It was August, 1995. I was dressed in a pair of tan pants, a tan patterned vest, and a matching hat. And when Rev. Floyd Flake, a U.S. Congressman from New York, said, "You can kiss the bride," I did. I gave her a kiss I had been saving for eight years. It's the kiss she should have felt from the beginning. It was the kiss she deserved. That kiss sealed us as a family.

Our son, Najee, was the ring bearer and our daughter,

Italia, was a flower girl. And my wife, Simone, was carrying our third child, Samaria, in her belly. She was eight months pregnant. Simone wanted to wait until after the baby was born, but once we knew we were getting married, I refused to bring another child into this world out of wedlock. (Not that bringing my other two children into the world was a mistake, because it wasn't.) That was too important to me. I didn't care about anything else once I made that decision. There were already too many wasted moments in our life, and I wasn't about to waste any more.

When Simone said yes, it was a new beginning with the woman I was bonded to. I had put her through so much and it was such a relief to make our family a family.

I wasn't as nice a guy as I should have been all the time. And the worst thing I did was leaving her with the kids. And I don't have any excuses for that. I do have an explanation, though—fear and ignorance.

I was there when Najee was born, but it happened at a time when I didn't even know who I was, let alone what it meant to be a father. It was a hectic time in my life. I was with Simone, though, in the delivery room. She was tossing and turning, screaming and yelling. And I'm standing there watching this chaos, getting scared. At one point, she screamed, "I can't do it!" I yelled back, "What do you mean you can't do it, you got to do it!" I didn't realize that she didn't have any say in the matter. Najee was going to come out regardless of what Simone or I wanted.

I was supposed to be holding her head, calming her down during the delivery. I was her coach, who was supposed to help her with her breathing. But as soon as the doctor said, "I see the head," I dropped Simone's head on the table and ran to the front. And there was Najee. His head came out, long and funny-looking. It was molded to the shape of the birth canal. I was thinking, "Yo! He looks like E.T.!"

I was looking at him and I remember him blinking both his eyes and looking back at me. The next thing I did was check the family jewels. I think all men, when they have a son, check out the penis and the testicles, especially the testicles. And it's wild because the baby is so little and his testicles are so large for his size. There's a certain powerful feeling you get that you created that. It's like a real trip. There's something spiritual in it that goes beyond vanity. You think, That's where life comes from—those testicles. It's like point A. Sperm, which grows in the testicles, decide whether a baby will be a boy or a girl. It's the origin of life. I was looking at my newborn, which originated in my testicles, and someday life will originate in those testicles. It was an incredible feeling.

I watched Najee get circumcised and I laughed. They were cutting the skin off his little penis and he was crying. He looked upset and it made me chuckle. I knew I would be upset too if they were doing that to me. After they cleaned him up, I took him and I held him up to God because I was extremely thankful.

But when Simone brought Najee home, I realized there was another side to it—4 A.M. feedings, crying, diapers, time. My youth and freedom, I thought, were gone.

I know that's a reason why so many fathers leave. That fear is overwhelming. When you have children, you lose that sense of freedom. For me, it was like someone had come up to me and said, "You can no longer live life for yourself. You have to live life for someone else now." It was almost like the time I got put on punishment for the summer. It was like I couldn't go outside to play.

I was 21, and I had no concept of responsibility. I was totally and completely petrified by the responsibility. And I ran. I went out like a sucker. Simone knew what was happening, but she was only 19, going through her own thing, dealing with her own emotions about becoming a mother. She didn't know how to make me feel comfortable about being a father. If we were

both more mature, we would have known how to handle the situation better.

I had never dealt with anything like fatherhood and I didn't understand what it was all about. All I wanted to do was drive around in my convertible Mercedes with my gold chains and with a girl in the passenger's seat. I wanted to be free. I didn't want to feel like I was handcuffed—and that's what fatherhood felt like at that point.

I didn't realize that Simone had just performed a magnificent miracle by giving me a child. She had given me something precious that some couples strive 20 years to achieve. Fertility clinics and drugs, sperm donors, surrogate mothers, and then a mountain of emotional trauma after finding out they can't reproduce. I didn't realize what God had done for me. I was too wild and selfish. I had no respect for her or for our child. And although I would have disagreed at that point, when I look back on it now I was disrespecting myself. The only thing I respected was my freedom.

But not more than a year later, we were right back in the hospital again with another child—our daughter, Italia. As crazy as it sounds, even though I was afraid of the responsibility, I did want to have children. But again I ran. This time faster and farther.

It makes me even more thankful to have them in my life now. And God willing, my children will never have the insecurity of not having their father around. Because I am ready now. I have grown up and become a man. I realized that it wasn't enough to give money and make sure my kids had clothes and food and things. I had to be a father.

Yeah, it took a while, but I'm here. I can look in the mirror and honestly say that I am a good role model to my kids, a teacher to my family. Finally, I am the type of father I always wanted to have.

Every week that I'm home, we all go to their favorite restau-

rant, Benihana, where they cook the food in front of you. Yo, my kids love that place. We go there in Los Angeles *and* in New York. They would eat there every night if we let them.

On days when I'm not working, I like to take my kids places, expose them to different things and prepare them for their future. We do the usual amusement parks, of course, although it's getting harder and harder with the autograph seekers. I also took my kids on a trip to the New York Stock Exchange recently. We went behind the scenes, where they took us from A to Z on how the exchange works. I know it was a little over my kids' heads, but I want them to understand how this country works, and the stock market is a great place to start. I want them to understand money at a young age. I want them to have a foundation and be able to handle their money—and whatever I leave them—and make it grow in the future. They may not have understood everything they said and did at the stock exchange, but I know they'll remember the experience. And we'll definitely go back.

Najee's eyes lit up when he saw all those men running around down on the floor and the numbers changing rapid-fire. He's the oldest and he's starting to understand what it all means. Every other Saturday I try to take him to the barber shop with me, and we have our little teacher/student classes. One time I brought some money from Ethiopia with us to the barber shop. After Najee finished getting a haircut, we went to a Chinese restaurant and I explained to him that there are countries where they have black faces on money. I wanted him to know that and see it.

Najee's full name is Najee Laurent Todd Eugene Smith. Yeah, I have a lot of hope for him, huh? Actually I'm terrible at naming kids. Simone does that. If it were up to me, my kids would have names like Compassion and Strength. I think of the positive attributes of those words and they sound like good

names to me. That's why Simone's in charge of that. But I help out on the middle names.

Najee means success in Arabic. Laurent just sounds nice; it's poetic, it's creative. Todd, well that's me, and Eugene is my grandfather—the first real man I ever had in my life. I want Najee to carry on all of the legacies of those names. And I try to spend a lot of time with him because that will help ensure that his foundation is sound. He's the first-born and the only boy in the family right now, and he's going to need a little extra from me to make it in this world as an African American.

Najee's real sensitive. He's a lot like me, and very creative. He recently had a crush on this little girl in his school named Rachel. She has ponytails down to her elbows, and she's really cute. So he found some plastic flowers in the house, sprayed some of Simone's perfume on them, and wrote a note, "From Najee to Rachel." Yo, this kid is eight years old and already has style. I think it's great that he's not afraid to share his feelings. And Najee has an interesting depth to him that even I can't quite understand.

My daughter, Tally, is very independent and very focused. She's only seven, but Tally already knows what she wants and she knows how to get it. She has me wrapped around her finger. I'll ask her for a kiss and she'll say, "No," playing hard to get. I have to keep begging her before she finally comes over to me, and I tickle her and she cracks up. We play this game all the time. She's going to be a strong young lady. She already is.

Tally's full name is Italia Anita Maria. Simone's grandmother was Italian, and her name was Anita Maria. And the Roman Centurion who was kind to Jesus and tried to keep Jesus from being crucified was Italian, so there's a lot of strength there. Tally is a mama's girl. You can always find her in the kitchen helping Simone cook. That's her thing right now.

Simone calls our youngest daughter, Samaria, a terror. But I don't see her that way. I just think she's aggressive and com-

manding. One time Najee and Tally were bothering her, and they took one of her toys away from her. The next thing we know, Najee is coming out of his room crying. Samaria had picked up one of his toy cars and hit him in the face with it. Now mind you, she's only two years old. She may be two, but Samaria Leah Wisdom (I wanted her to be wise) is more like 12 in her understanding of life. She's definitely living up to her name. That kid is very advanced. Maybe having an older brother and sister dragging her around everywhere, talking to her, and messing with her all the time has made her much older than her actual years.

I'm really enjoying my kids. Fellas, if you leave your family, you really don't know the blessing you're missing out on. It's something you will never be able to get back, because once your kids are grown, it's too late. I never wanted any regrets. And right now, I just regret I didn't come to my senses sooner.

I'm also enjoying my wife and being married. I never thought I'd be saying that, but it's really true. It's really cool to come home and know that there's somebody there who understands me. I can talk to Simone about anything, and I do. When I'm on the road, I call her after every show. If I go out, I call to tell her where I am, and I always try to call her before I go to bed. I like to make sure everything is okay at home. That's the righteous manner in which a man should conduct himself—he should take care of home even when he isn't there.

FIFTEEN

FROM THOSE TO WHOM MUCH IS GIVEN, MUCH WILL BE REQUIRED

I'm sitting in a stall at this nightclub, the Mirage, in Manhattan. I don't normally go to the bathroom in public rest rooms, but I really, really have to go. So I'm sitting there . . . thinking. And I see this hand come from underneath the stall door with a napkin and a pen in it. On the other side of the door I hear, "Yo, LL, you think you can sign this for my babe? She's a big fan of yours."

I'm saying to myself, "You've got be kidding." But I sign it and give it back to him like I had nothing else better to do. This ain't unusual for me. Wherever I go, I am bombarded with autograph seekers. And it's strange, because I've been a rapper for what, 13 years? But it wasn't until the television show, *In the House*, that people have started really going bananas.

I'm thankful, though. I have to give my supporters the utmost respect and love, because if it weren't for them, I wouldn't be in a position to support my family the way I do. I realize that if I'm going to have the success, the fame, and the wealth, I must give back. That comes with the territory.

Some celebrities get hostile when people approach them when they're out. I cannot. Because I know that from those to whom much is given, much will be required. If I can't accept that, then I don't deserve all of the things God has given me.

But I do wish people would be a little more considerate sometimes. When a brother's in the bathroom, I wish they would just wait until he gets out and washes his hands before

they ask for an autograph. Or if I'm out with my family, I wish they would understand that it's my family's time.

My older daughter, Italia—the sassy one in the family—has started addressing my fans herself. If someone comes up to me and I'm with her, she'll stop them and say, ''He's not giving out autographs today!'' And she's serious. I'll always sign it anyway. But I see that being a public figure definitely takes its toll on my kids.

Once I was holding my baby girl, Samaria, in my arms and people were asking me for autographs. I didn't have anyplace to put the baby. But they didn't care. I wonder sometimes what people are thinking when they invade your space like that. I am human—just as human as anyone else, and sometimes it gets very hectic. I accept the responsibility of being a celebrity. But when it comes to my kids, I have to make an exception.

The times I spend with Najee are really rewarding. I see how much boys need their fathers. After our father-son barber shop outings, I take him sometimes to lunch at Mr. Chow's in L.A. That's my favorite Chinese restaurant in the world. I love their peppered lobster, the shrimp with the shells on deep fried, with rice and mango chutney they have. Mmm, mmm. I leave there feeling banged out. It's almost better than my grandmother's corned beef and cabbage. It's almost better than sleep. Almost.

While we were there one time, a young lady comes up and asks me for my autograph. Then she asks my son for his, too. He's seven years old and he was thrilled. After he signed it, the young lady started talking to me about how he wrote better than her little sister, who is the same age. That made Najee's day.

But many times it's not like that. A simple ordinary thing like going to a ball game or going shopping becomes a fiasco. I was in Roosevelt Fields, a mall on Long Island, recently. I was just shopping, and I ended up spending more time signing

autographs than buying my kids clothes. A young lady wearing a brown trench coat asked me for my autograph and I said no. I was tired. She just looked at me and walked away with a sad expression. I felt really bad. I thought to myself that I might have lost a fan, a supporter. But I hope she understood. And I apologize to her. It hurts me to tell one person no, because I really appreciate what it takes to ask someone for their autograph, what it must feel like.

I've even asked for an autograph or two myself. I can remember getting Bob Hope's autograph while doing a sports benefit a few years ago. It wasn't really for me; I thought my grandmother would like it because she was a fan. He signed a baseball mitt, and she still has that glove.

The first time I ever wanted an autograph for myself, I was 13 years old. The Treacherous 3 were playing at the Olympia Palace in Queens. After the show, I saw L.A. Sunshine standing near the stage. I thought he was really cool so I went up to him and asked, "Are you L.A. Sunshine?"

And he said, "In the flesh, my brother."

And I thought to myself, What the hell was that all about, "In the flesh, my brother"? That just didn't feel right to me.

People like that make me appreciate the humility you need to have to be a celebrity. Lou Rawls asked *me* for an autograph a few years back. I was perplexed. I mean, Lou Rawls asking *me* for an autograph? I was looking at him, getting ready to sign it, and I'm like, This is Lou Rawls! It really freaked me out. That to me was humbling—I was thinking, Who am I? I should be asking *him* for an autograph. But that says a lot about Lou Rawls. I think he's really cool.

So I really understand how people feel when they come to me. And I accept my responsibility. It's easy when I remember fans like that lady in the brown trench coat in Roosevelt Fields. So, now instead of saying no, I just don't go to places where I know I'll be mobbed. If I really want to see a game or go get

something to eat, I'll travel with my security, who make it easier for me.

I take them with me if I want to go to a Knicks game or go to a club in peace. Yes, I still like to go to clubs to hear what's hot, and because I like to dance, hang out, and vibe, just like everybody else. I don't have security because I fear for my life. Granted there's enough violence out there to warrant the fear, but I don't live like that anymore—thank God. I deal in karma.

Being in the public eye, I try to be understanding and am willing to extend my hand. One time, I was at Red Lobster on Long Island, and this young lady came up to my table and asked my security if she could get an autograph. I was busy eating and not really paying attention. She told them it was her birthday, and one of my guys said, "Yeah, that's what they all say." And it's true, some people will do anything to get an autograph. But she looked hurt and started to walk away, so I promised her when I was finished I would stop by. I did—and her mother starting telling me how I shouldn't be so rude to my fans, and how I should be nice and appreciate them.

She told me she was a corrections officer on Rikers Island. I asked her if she was always kind and patient with the inmates she encounters every day. She said no.

"Why not?" I asked.

"They don't act right all the time or they don't listen, so we have to get a little rough," she said.

"Were you always like that?" I asked. She said no. When she first started she was nice because it was all new and exciting.

I just looked at her and a lightbulb went on over her head. She got it. In her job, which requires patience, she still doesn't respond the way she should. I deal with 100 times more people than she does and I still try to be gracious and nice. And while that first autograph at Manhattan Center still sticks out as one of the sweetest moments in my life, I cannot dismiss the mil-

lionth autograph I signed yesterday. It's just as important. Be-
cause to that person they *are* the first—they don't see the 100
million before them. And they shouldn't have to. So I try to
treat each one as if it were the first.

I recognize that I have to fight every day to make each one
special. But I do understand people like that corrections offi-
cer, who work in an environment dealing with people every
day. I understand why they develop a certain lack of apprecia-
tion for the people around them. It's natural to become discon-
nected to the things that would have charmed you in the
beginning. Those people are allowed to change, but I cannot.
That's the price I pay for fame. But I'll take that every day of
the week. It comes with the territory.

I was on the other end of being an annoying fan recently,
and it really hurt me. I was at the Riga Royal Hotel, getting
ready for the Essence Awards, and Muhammad Ali comes out
of the elevator where I was standing with a couple of my peo-
ple. Everybody was so excited, and my people start pushing
me to take a picture with him. I could see in his face that the
champ really didn't want to take a picture. He was probably
tired. And I realized that he was bothered the same way I would
have been bothered by fans. But he took the time out to take a
picture with me anyway. I guess there is a price to pay if you
want to be the greatest. Ali taught me that lesson.

I've learned even more about being gracious and being a
servant to my fans through my associations in recent years with
people like Quincy Jones. Mr. Jones took me under his wing
and introduced me to a new world. Through him I met Oprah
Winfrey, Bill Cosby, Barbra Streisand, Michael Milken, Michael
Jackson, Donna Karan, Prince, so many people I can't even
name. He showed me to an arena that was previously closed
shut to rappers, because in entertainment, rap has always been
like the bastard child. That's changing a lot now, though—
mostly because of people like Mr. Jones who have embraced

rappers, featured rap on CDs, and brought it into the main-stream. It *should* be in the mainstream; it's art just like jazz, classical, and soul.

When I first met Mr. Jones, years ago, he was throwing a birthday party for his son, QD III (I call him Snoop). At that party, I asked Mr. Jones what he thought about rap. Rap was just starting to take off—I had just done my first album—and there was a lot of criticism within the music industry surrounding it. I wanted to know what the master musician thought.

He told me, ''Hey, man, we love it. Don't worry. We love it.''

We clicked. I learned how to be a class act from him. (Although it obviously took a while for that lesson to sink in.) No matter where Mr. Jones goes, he brings class with him. Through him I learned how to listen to people and be gracious. I learned how to think big. Everything he does is big. He's a man who is 60 but looks 40, and everything he does blows up. I also learned from him how in the midst of fame and suc-cess you can still be real. Because Mr. Jones surrounds himself with real, down-to-earth people. Even his celebrity friends are real.

Mr. Jones took me with him to Bill Cosby's house one night for dinner in New York. I came into the house, but had to run back out to the car to get something. As I was coming back in, Mr. Cosby was standing in the foyer waiting for me. I don't know if Mr. Jones told him about me or what, but Mr. Cosby immediately said to me, ''What are you doing in my house with your hat on?''

''You talkin' to me?'' I said, looking around in shock. I really didn't believe he was talking to me.

''Are you standing in my house?'' he said.

I said, ''Yes, sir.''

''Then, take your hat off!''

Now everyone knows I hate taking my hat off. And back

then I never did my hair because I was always wearing a hat. (I don't hate it that much these days because I keep my head shaved, but back then I never ever took my hat off. Never.) But I was standing there face to face with *Bill Cosby*, and he wanted me to take my hat off. There was no way I was going to disrespect Bill Cosby in his own house.

So I took the hat off. I sat down at the dining room table with the other guests with my hat in my hand. My hair was looking crazy—I had it shaved around the edges and stubble was growing in. It wasn't combed on the top. And everybody was just looking at me and trying to hold in the laughter.

Mr. Jones leaned over, looked at me, and said, "Yep, that's about how I pictured you without your hat." And he busted out laughing.

Finally, Mr. Cosby, seeing my torture, said, "Boy, put your hat back on." Then he started laughing and everybody else started laughing too. That was bugged.

I feel grateful to have known some of these people. It has made me realize how easy I have it. Yeah, I get a lot of people wanting my autograph, but I can still lounge around my way, or play ball in the yard without really being bothered.

People like Michael Jordan, Michael Jackson, Bill Cosby, and Mr. Jones are celebrities to the fifth power who are literally mobbed. One time I was at an NBA All-Star Game in Cleveland, hanging out with Michael Jordan and Grant Hill. We were in the lobby of the hotel talking, and all these kids bum rush them. I kind of slip out of the pack unnoticed and I'm standing near the elevators in the back. Mike looks up and sees me and he points. "Hey, kids, there's LL Cool J." They turn and run for me and he gets away.

When I'm in Los Angeles, I run into Jack Nicholson a lot. I call him Cool Jack because, well, I think he's cool. I stopped him at a party once and said, "Just how cool are you, Jack?" He said in that "Here's Johnny!" voice, "I'm so cool that

wherever I stand, there's a draft!" Then he walked away. I just stood there cracking up.

Oprah gets mobbed too. At the recent President's Summit in Philly, I was asked by MTV to be a roving reporter. One of my assignments was to interview Oprah Winfrey. I had met Ms. Winfrey through Mr. Jones at Barbra Streisand's birthday party about four years ago. She is a nice lady who seems to be trying her best to remain human. But it's hard. That's something I struggle with every day, too. And I'm just a blip on the celebrity screen compared to her, so this time I was on the B side of the coin.

She is surrounded by people whose job it is to protect her and shield her from the outside. And it's hard sometimes just to be regular. I imagine with the life she's living, the amount of money she's acquired (she is the wealthiest African American in this country. Go, Oprah!), and the fame she has, that it must be harder and harder for her just to be Oprah. But I can see that she's trying. In fact, her book club was one of the things that inspired me to do this book. She showed books are a great way to reach people and get them talking about things.

So MTV was trying to set up this interview and her people said Ms. Winfrey would not be doing any interviews. (I didn't find out about this until much later.) So, we're all at this gala and I'm doing my reporting thing and someone tells Ms. Winfrey that I want to speak to her. They don't, however, tell her it's an interview. So she's like, okay. I walk over to her thinking she has okayed an interview. And she's waiting, thinking she's agreed to just talk with me, LL, on a casual tip. I walk up to her with the cameras behind me and I shove this mike in her face. And she's standing there looking at me like I'm crazy.

I said to her, "Didn't you know about this?"

She said, "No."

Now she's caught out there on camera and I felt like a dirty journalist. I felt played out and she felt played out and that

wasn't cool. I know what that feels like. That's violating some-one's human rights, their right to privacy, their right to say no. I told her afterwards, ''Ms. Winfrey, I apologize for that. I had no idea you didn't know.'' And I really didn't know. I felt stupid and I felt like I had injured my relationship with her. I hope I didn't because I really respect her.

There are a lot of artists and entertainers who really handle success well. I also admire people like Howard Stern, who has changed his style and taken more responsibility for the things he does. He's still outrageous, but he knows now that he can tone it down and still be just as funny, witty, and entertaining— without being so negative. (He is off the hook, though.)

I did his show last year and I was really nervous. I thought I was going to be a slow gazelle in a lion's jaws. I thought he was going to tear me up. But he didn't. He was actually very nice. The wildest thing he asked me was when I lost my virgin-ity. Then I told him I was 13. Then I asked him when he lost his—and he quickly changed the subject! The show ended up being a lot of fun for me.

There's another radio disc jockey in New York, though, named Wendy Williams, who's not as funny. I think she abuses her privileges.

She's a young lady who did well and somewhere along the way just sold herself for her position. She must have decided she wasn't going to care about anything but the ratings of her show (which happens to be the number-one afternoon drive show in the city). I bet she would destroy her own family mem-bers to stay there. I feel like every African American in enter-tainment (and for that matter, every human being) is family— we're all generating a certain amount of money and we're all working toward taking care of ourselves and our children. It's a tight group.

There are already a lot of forces against us hoping that we'll fail. To have one of our own out there trying to damage the

integrity of another artist just to get ratings is sad. I think it's selfish and dangerous. What Wendy Williams does is not about privacy or journalism. A journalist can report something about a person publicly without degrading that person. Criticism can be public too. But it's not like Wendy is on her show giving constructive criticism. I feel she's manipulating the minds of 14-, 15-, and 16-year-old girls. Her example shows that it's really cool to gossip and talk about other people. But I feel it's dangerous, especially in this violent society.

A little girl who thinks she wants to be like Wendy Williams and goes and gossips in her school can't hide behind the ivory towers of a radio station. She could be in a world of trouble if she talks about someone who is dangerous or hangs with dangerous people. She could get confronted. Or worse.

I'm more concerned with the fact that Wendy Williams is not a positive role model for the kids than I am about the fact that she gossips. And not only does it seem as though she makes it okay for kids to gossip about and degrade each other, but I also feel she promotes self-hatred. Like when she gets on her show talking about her weave and her liposuction. I don't think little girls growing up in the ghetto need to hear that or feel like they should hate themselves and hate the way they look. They shouldn't hate themselves for having hips, or for being heavyset, or for not being 115 pounds. A lot of them can't afford liposuction like Wendy Williams. And many of them really don't need it. Maybe Wendy didn't need it either.

I'm not going to down someone for having plastic surgery. To each his own—what you do with your body is your choice. But don't promote it to young girls.

I don't really care what she says about me. I do care about the way things she says affect kids. And I'm sure by me saying this in my book, I've only increased her audience and added fuel to the fire. But I really do hope she understands where I'm

coming from. It's nothing personal. The reality is that negativity is not the way to go.

There is a lot of responsibility that goes along with being in the public eye. You can't do and say things that you might normally do. And, thank God, I have changed to the point where I really don't even want to say or do negative things. I have children who I respect enough to be a good role model, and I have fans who deserve my best.

I try to give it.

SIXTEEN

MR. SMITH

I was walking around the set of *In the House*, and I noticed people were being very friendly. Not that they weren't usually friendly, because they were. But this was different. People were smiling and even chuckling as they passed me. At first I was thinking, Yeah, I'm cool. But I turned around a couple of times and caught a few of them pointing. And I thought, Yo! What's up? Finally I felt my back and there was this big sign that said "Wild Thing" on my back.

It was all good, though. Just the day before we had played a similar practical joke on Alphonso Ribiero's dad. Alphonso, who plays Max, the nerdy doctor on *In the House*, is off the hook crazy. He races cars and motorcycles and stuff, and he loves practical jokes. His father, who comes by the set often, also loves a good joke, so he was fair game. Someone (and I'm not naming any names) put a Stage Dad sign on his back. That was definitely funny.

Practical jokes run rampant on the set of *In the House*. We do some really stupid things to pass the day. For a while there was a clothespin craze. We'd try to see how many clothespins we could get on someone without them knowing.

These pranks break the tension and make it easier to do our thing. And we have enough jokesters between me, Kim Wayans, and Alphonso to really make the set loose. Besides, last season we taped on the same set as *The Wayans Brothers*, Kim's real-life siblings. When they came over to visit it was really off the hook. They are some real cats who helped me get through the season.

Working at UPN, where the show airs, is a far cry from my days when *In the House* was on NBC. Everything seemed real good in the beginning. But there was always this underlying feeling that they didn't want us there.

The show, which came at one of my lowest points in my career, became a training ground for me. It gave me discipline. I had to get up early every morning—and anyone who knows me knows that is a real struggle. When I'm making music I don't go to bed until 6 or 7 a.m., so I usually sleep all day. And when I sleep, I really sleep. Sometimes, I've been on the road, and they have had to send hotel management to make sure I was all right because I didn't answer the phone or the door. I've even been awakened by the police and the fire department. It's like I'm in a coma. When I'm home and have an early appointment, my man Roundtree (we call him Round) has to wake me up. My grandmother will let him in, but he has to wake me up. 'Cause I be out. (And I do mean *be!*) I can sleep for 18 hours straight with no problem when I've been working for a couple of nights.

But when I'm doing the show, I am supposed to be on the set by 11 a.m., sometimes 10. I have a ritual. I lie in bed a good half hour trying to convince myself to get up. I can't just jump out of bed, into the shower, and out the door. I have to meditate for a while before I can even get up.

I take my shower, of course, and put on something nice-smelling. I never leave the house without cologne. Fortunately, I don't have to labor much over what I'm going to wear, because I always wear FUBU. So I'll put on a pair of FUBU jeans, rolling up the left leg to expose my tattoos, a FUBU shirt or sweatshirt if it's cold, and a FUBU hat. And I just started a sneaker and boot company, Najee, so I'm covered from head to toe.

Simone will help me out by making me some salmon and grits or cheese eggs, or my favorite: a fried bologna and Ameri-

can cheese sandwich. I don't care how much money you make or how successful you become, some things never change.

Once I'm out, I go to the set to rehearse, do wardrobe, and blocking, which is where you go over where you're going to stand and what you're going to say in every scene. Instead of making my music and having complete control, I have to listen to people tell me what to do, where to go, and how to do it. At first it was a real stretch for me.

Fortunately, Debbie Allen, who co-starred in the show with me, basically walked me through the ins and outs of the business. I was so grateful to her. She's a real pro. She hipped me to all the dos and don'ts in television—and there were more don'ts than I bargained for.

One of the biggest don'ts seems to be Don't tell the truth. Now for me that was just out of the question. If you ask me something, I will tell you how it is. I never really mastered the art of bulls***. But in Hollywood, and especially in network television, bulls*** rules. No one ever tells you to your face that you stink, or that they don't like a particular scene or the way you said a line. They will beat around the bush, hem and haw, get someone else to tell you—anything to avoid the truth. I feel there would be so many better shows on television if there was more honesty in the business.

One time, while the show was still at NBC, I was expressing my concerns about the script. I was being honest about the image they wanted me to portray because it was wrong. They wanted me to come in and trip over something and fall and look really stupid. I mean, that's just not me. I'm not a slapstick sort of guy, and I felt that trying to make me into one would betray my character, the audience, and me. People who might watch the show for me want to get the me they know. It's important not to go completely off into left field with a character and change my entire image for one joke.

I knew the show wouldn't work if they totally changed my

image. But it wasn't the first time we had a battle over something like that and they were pretty much getting tired of me challenging the script. There was another scene where they wanted me to strip. And I was like, ''Nah! I don't get down like that.'' But it's funny, in the midst of my telling them what I didn't like, they never once had a harsh word to say to me. To my face.

One Christmas, though, I received a gift from someone at NBC. Hand-delivered by a black woman was a pair of sterling silver shackles on a key chain. Now, maybe they were looking for a nice way to say we were bonded for life. But sterling silver shackles? My first reaction was that someone was saying, ''Nigga behave!'' and Al Jolson was about to come around the corner, shuckin' and jivin' in blackface. I'm sure that's not what they meant, but I'm still wondering about that particular choice for a gift.

It would be nice to think those days are behind us for good, but certain things live on. One time I was at a birthday bash for Quincy Jones. It was a gala, black-tie affair, a sit-down dinner. I was at the table with Mr. Jones, Oprah Winfrey, Steadman Graham, and Sidney Poitier and his wife. During the night, they passed around a mike and people would wish Mr. Jones their best or say whatever they wanted. At one point, Don Rickles grabbed the mike and started roasting Mr. Jones. He was funny and started congratulating Mr. Jones on his success, his beautiful lady, the whole nine. ''But no matter how successful you are,'' he said, ''you're still a black man!''

Mr. Jones laughed it off and Mr. Poitier just shook his head and said, ''Tack-y. Very tack-y.'' That was putting it mildly. Hollywood can be a real racist town in lots of ways. So I'm grateful to NBC and the people there who gave me the opportunity to do a sitcom. Even though it didn't work out in the long run, I have to give them my props.

But my first full year of TV was very rough. We wanted to

make a lot of changes to the show, but the executive producers and the network could not agree on what exactly they should be. So Quincy Jones and David Salzman ended up moving the show to UPN, where they got a two-year deal.

UPN wanted to make me the anchor for their Monday night lineup, and they basically rolled out the red carpet. It was like night and day. UPN has shown me so much love, and I really enjoy doing the show now. I guess with them being a fledgling network—or as the folks there would say, "*The* network, baby!"—they have to work a little harder and be a little more open to artist input. Or perhaps they understand the wisdom of leaving open the road to creativity.

I really don't want to disrespect all of NBC. But there were signs from day one that it would not be a perfect marriage. While we were shooting the pilot, Warren Littlefield, one of the heads of NBC, dropped by the set. When he saw me, he told me to take off my hat. I told him, "I don't take off my hat, it's part of the image."

"Just take it off," he said. "We're paying for it."

"I don't take off my hat," I said again. "It's part of my music thing, my image. Think about it."

He said, "*You* think about it!"

I'm not trying to burn any bridges. In fact, Warren Little- field is one of the people who was willing to take a chance on me, and I appreciate it. But I have to be honest: if network television is going to produce the kinds of shows that will make a positive difference in this country, the heads of those net- works must be willing to keep it real with themselves and with the people who work for them, and be open to creative input.

It seems like quite a few of the TV actors who get ahead the most are the ones who play this game of skinning and grinning, bowing and scraping very well. In that world, if you don't kiss butt, you're not a team player. But that's wrong. I care about the success of *In the House* as much, if not more, than anyone

else on that show. And because I'm willing to put myself on the ledge and be honest, I should be respected. I want us to continue to grow and get better, and honesty and a willingness to be open is the only way for that to happen. Fortunately, for now, I've found a network that is willing to see that happen.

And I look forward to honing the show and my acting skills. I'm getting other TV work as well. I did a Gap commercial that I felt pretty good about, and it got a lot of airplay. I'm also getting ready to do a Coke commercial, which is exciting.

But my first love was music, and it's still very important to me. It released me from my own personal prison and it has taken me places I only dreamed of going. I want to make sure I give back just as much.

In 13 years, I have seen hip hop go a lot of places. But it's always had to be alternative to push the envelope. Every time there's a hip hop artist that has 10 million in sales, or a huge album, they've been alternative. Vanilla Ice and MC Hammer blew up by being alternative to what was happening. Even in the beginning it was that way, with the Beastie Boys and Run-D.M.C.

In 1996 and 1997 it was groups like the Fugees, who were more R&B than rap. They took hip hop in another direction, expanded its horizons. And after 13 years in the business, I think I can take hip hop to yet another level.

My new album, *Smithsonian,* is definitely innovative. It's going to tell the story of my life in rap—the first-ever sound-track to a book.

When I first talked to Lyor Cohen at Def Jam about the concept, he said, ''Hey, cross-promotion!'' But as the album evolved everyone realized that this was about more than marketing. It was about reaching people where they are in order to deliver a message. Every one of the tracks on that album came from the heart because they came from life.

I also have my own label now, Ilion Records. I'll be produc-

ing artists and there too I'll be trying to make music that no one else is making. Trying to take it to the next level.

My vision is to create the Motown of the new millennium—not just with hip hop and rap, either. I want in-house producers, writers, and an in-house staff. I'll find the most talented people in the industry and have them work with me. I'm looking for diamonds in the rough who want to be a part of a family, who want to be treated fairly and honestly. I want them to know there is an open-door policy to creativity. If they are willing to work, I am willing to work with them for as long as we're feeling each other.

I want to make music that's real and honest, that has integrity. I know I need to be careful when it comes to violence and negativity. As an entertainer, I recognize that I have so much power and influence over the kids; no matter what I do, it has to be positive all the way through, or there has to be a moral at the end. That's what I'm about.

There are rebels and there are innovators. I'm an innovator. But I can't condemn those rappers and entertainers who aren't always positive.

You can't expect someone to become a positive role model for all of mainstream America overnight. It takes time to realize the power your music has over people. It took me more than ten years. For a lot of artists, they never get that time. By the time they figure it out, they're finished.

Somebody who is on their first or second album—they don't know how powerful they are. They don't know how influential they are when it comes to children, so they say what they feel. But four, five, nine years down the road, after they've had a few albums and can see what statements they've made and how they've affected people—then it's time for them to live up to their responsibility and be a role model to a wider audience. You can't expect a kid who is fresh out of the proj- ects and going triple platinum to understand the complete

spectrum of his influence as an artist. When did he get an op-portunity to grow and learn about what that means?

Tupac had some very positive songs, like "Dear Mama" and "Keep Your Head Up." And Biggie (The Notorious B.I.G.) had a song, "Juicy," on his first album, which was a celebratory song of a young man's rise from the street. He was talking about having a better life. And it was cool. A lot of people iden-tify with what Biggie and Tupac were saying. But we will never know how they would have handled the responsibility of being a role model in the future. They were cut short too soon.

I left Los Angeles just two hours before Biggie was killed. I was at the same *Soul Train* Music Awards he attended. In fact, I hosted them. And I would have been at that party where he got shot, too, had I not promised Simone a vacation in Jamaica. Fate is funny. And I think that's what he and Tupac were vic-tims of—fate and the sorry violent state of this country. Rap music didn't kill either one of them.

I listen to politicians and activists blame rap for everything under the sun, from world violence to world hunger. But if you removed every rapper from the face of the earth, you'd still have violence and wars. In fact, if not for certain rappers, "mainstream" society would have no idea of what is going on in our communities, where real war is being waged every day. For many Americans, life is rough, and gangsta rap was born out of that misery, pain, and hunger. It didn't create it.

I met Biggie in a Manhattan studio right after he released his first album, *Ready to Die*. He was blowing up. We were working on Craig Mack's remix of "Flava in Your Ear." I thought he was a tremendous talent. And he was cool.

I asked him why he liked to smoke weed before he wrote his songs. He said the weed just made him feel like he was in the track. That was just his vibe. If that's his way of working, that was on him. I'm not telling anyone to break the law; weed

is illegal. But he was an adult and it was like, hey, do your thing.

Biggie seemed like he was in the process of making a transition away from that lifestyle, though. He was ready to move on and experience something else. It's a shame he never got that opportunity. Rest in peace, Big.

The same goes for Tupac.

Ironically, the last time I saw him was at the *Soul Train* Music Awards the year before. We never had much conversation and I never hung out with him, but if I'd see him I'd say, "What's up?"

On this night he was with Suge Knight, walking through the crowd in his camouflage gear and bulletproof vest, expressing himself in a Tupac-ish manner. He was upset because he had been slated to perform, but at the last minute it was canceled by the show's producers.

I was hosting and I could see all the commotion from the stage. The show had just ended as he came up to the stage and reached for the mike. "Yo, let me get that for a minute, L," he said. He wanted to talk to the people, but they were shutting down everything and the mike was off. So I took it back from him.

"You just had to take the mike back, didn't you?" he said.

"Yo, B, the joint ain't on," I told him.

He said, "Y'all don't show me no love."

"I show you a lot of love," I said. "I just gave you a shout-out on my record, 'Hip Hop' on *Mr. Smith*. Didn't you hear it?"

He was like, "Yeah, that's true."

"You're young and talented and you need to do your thing, B." And I was being honest. I thought he was really gifted.

I look at the death of him and Biggie and I wonder where I'd be if I hadn't calmed down when I did before the culture turned illmatic. The bottom line is we live in an incredibly vio-

lent society and hip hop didn't create that. Hip hop didn't make Timothy McVeigh blow up the federal building in Oklahoma City, it didn't make the Unabomber kill all those people through the mail. It didn't make Susan Smith kill her kids. It doesn't cause thousands of carjackings and drug-related murders each year.

Any politician who wants to use the deaths of Tupac and Biggie as an opportunity to try and snuff out the voices of the urban streets—or as an opportunity to get elected—really isn't living in this world, really isn't in touch with reality.

You know you live in a violent society when they have public service announcements and television programs devoted to teaching protection methods. I was watching this show on TV and the announcer said, ''When you go to a parking lot, always look around and lock your doors. Don't go home if you think you're being followed.'' There's a world out there where they have to educate people on how not to be victims. Isn't that wild? You grow up in an urban area and you already know to watch your back. It's second nature. So I can't listen to people who have to be educated on how to survive turn around and talk about people who just do naturally whatever they have to do to survive, every day.

Regardless of how many shows I do, or people I meet, I can relate to people who are trying to survive. I'm always going to try to bring something positive while still relating to those caught up in the struggle.

While many rappers keep it real, I try to take that notion to another level. I try to keep it positive because in doing so, maybe some little kid out there will latch on and run with it. That's part of my responsibility.

That's why I'm working with hip hop gospel singer Kirk Franklin and the Family on my new album as well. I have never used my music to really deliver a message before. But I think

I've evolved to the point where I have to. And that message is about the power of God. Because that's part of my life now.

I think it all became clear to me when I was onstage in Dallas doing "Doin' It," last year, on R Kelly's 12-play tour. I go to the edge of the stage like I normally do and reach down to touch the fans in the front. And right in the front row is a nun, in full habit, black dress, the whole nine. And she's really into the show. I sort of bug out a little, but I keep going. Sure enough, after the show, she's waiting backstage with the groupies, wanting my autograph.

It blew me away. I realized that what I do transcends music and rap. That I have the potential to reach people beyond kids around the way. A nun, a real nun, was my fan. Man, I have a responsibility, to be an example and a role model, not just to my fans, but before God.

FINALE

POWER OF GOD

His eyes were bright with power. It was the most fascinating thing I have ever seen in another person's eyes. I guess that's the mark of power. I'm standing there next to the President of the United States, taking a picture at the AmeriCorps signing in Washington, D.C., and I'm thinking, I have never seen real power until now.

There was a current that ran through him. I guess there is something about being spiritually picked to be one of the leaders of the world. Regardless of how you look at a president or a politician, those who are in power were picked spiritually for one reason or the other. And Bill Clinton was definitely chosen. But Bill and Hillary Clinton are also real people. I have supported them more than any president during my years as an artist and as a registered voter, partly because—like most Americans—they have real problems. And not only does the President keep it real, but crime and unemployment are down, the economy is booming, and the world is at peace. The man knows how to run a country.

And after reading Mrs. Clinton's book, *It Takes a Village* (which won a Grammy for its audio version the same night I did), I got a better understanding of the First Lady and her genuine concerns for our youth and family values. I agree with her—family values made America the greatest country on earth.

The President seemed cool as we stood there side by side for this photo opportunity. I'm sure from his point of view, I

was just another item on a long list of things to do that day. But from my point of view, it was interesting.

I've been involved in President Clinton's campaign since the beginning. I performed at his first inaugural ball, at the youth ball at his second inauguration. I performed at his fiftieth birthday party last year and I've been working with his America-corps program since its inception. I'm friends with Chelsea, and the President always treats me very cordially. Last time I saw him, he said, ''Good to see you again.''

I said, ''You know I've been with you since the beginning.''

''Yeah, I know,'' he said and shook my hand.

I met a number of presidents at the Presidents' Summit for America's Future in Philadelphia recently. (Because of the community service I've done, I was there as a guest of the White House and as a roving reporter for MTV.) I met George Bush, Jimmy Carter, and Colin Powell as well. And in meeting them, I couldn't help thinking that I might have an opportunity to make a difference. That I had a direct line to power in this country.

I asked them all directly for words of wisdom for America's youth. After getting their answers, I now know personally that they are completely and totally aware of the plight of our neigh-borhoods. And I walked away with mixed emotions. I was, of course, honored to be meeting people in positions of power. But on the other hand, I was hoping they would really, really, really stick to some of the promises they made. Or better yet, come up with some new things, be innovative about what they're trying to do and take care of our youth, our cities, and our communities. It's a funny feeling, like I hand-delivered a message. Now I'm just going to wait and see what they're going to do.

In the meantime, I'm trying to do my thing. Part of my so-cial mission is to reach kids like that, give them something to work for, get them to stay away from drugs and guns and in-

spire them to graduate from school. I have a sleep-away camp for inner-city kids, Camp Cool J. It started as a means to give kids a chance to see another world.

Today, along with our partner, the Vacamas Programs for Youth, I help send more than 100 kids each summer to Camp Cool J. It has lakes and cabins and boats and mountains and woods to hike through. But it also has programs that deal with issues like teen pregnancy, AIDS, and drugs. There are also leadership programs and opportunities for kids to learn about computers and other essentials. The camp's motto is, ''Preparing our youth for the future.''

And I make kids work to go to camp. They must be in good academic standing, have good attendance, and write an essay, called the Community Cool-Out Essay, about what they can do to improve their communities. I want them to think about their responsibility to make a difference in their neighborhoods. This year we will be expanding our camp into a year-round program.

I also try to get to kids in other ways. In my own neighborhood in Queens, I give talks from time to time at schools and churches. I'm the chair of an organization called Political Power for Youth, which helped Rock the Vote register more than 500,000 new voters in 1996.

I feel it's important to motivate kids to do well. I wish someone had motivated me like that. And when I go around to schools, that's the message that I send—not just stay in school, but get something out of it. Because there's always a reward at the end for achievement.

A lot of the so-called powerful people can't imagine what it must be like to have spiritual power. While I sought worldly power my entire life, the only power I seek today is the power of God.

I cried out to God for help; I cried out to God to hear me.
When I was in distress, I sought the Lord;

at night I stretched out untiring hands and my soul refused
to be comforted.
I remembered you, O God, and I groaned;
I mused, and my spirit grew faint.
You kept my eyes from closing; I was too troubled to speak.
I thought about the former days, the years of long ago;
I remembered my songs in the night.
My heart mused and my spirit inquired:
Will the Lord reject forever?
Will he never show his favor again?
Has his unfailing love vanished forever?
Has his promise failed for all time?
Has God forgotten to be merciful?
Has he in anger withheld his compassion?
Then I thought, ''To this I will appeal;
the years of the right hand of the Most High.''
I will remember the deeds of the Lord
yes, I will remember your miracles of long ago.
I will meditate on all your works
and consider all your mighty deeds.
Your ways, O God, are holy.
What god is so great as our God?
You are the God who performs miracles;
you display your power among the people.
With your mighty arm you redeemed your people, the
descendants of Jacob and Joseph.
The waters saw you, O God,
the waters saw you and writhed; the very depths were
convulsed.
The clouds poured down water, the skies resounded with
thunder;
your arrows flashed back and forth.
Your thunder was heard in the whirlwind,

*your lightning lit up the world; the earth trembled and
quaked.
Your path led through the sea, your way through the mighty
waters,
though your footprints were not seen.
You led your people like a flock by the hand of Moses and
Aaron.*

—*Psalm 77*

This passage is painted onto the door, on an ancient scroll, leading to my office on Ilion Avenue. Ironically, I wanted a different passage but the artist, Deka, misunderstood me and did this one. And when I saw it I thought, Yeah, this is exactly what I wanted. This is what I was feeling.

God's funny that way. He doesn't always give you what you want, but he gives you exactly what you need. When I look at that psalm, I think about all the crazy and sick things I've experienced. I think about the child abuse, dropping out of school, sleeping on the subways, carrying guns, using drugs, abusing sex. And I realize that only God could leave me standing where I am today. Through him all things are possible. I'm living proof.

I surround myself with messages like the 77th Psalm because I know how powerful words are. I make a living with words, and if you don't think each word and each phrase is carefully thought out, then you really don't understand rap. So I fill my environment with positive words and images to keep me on track.

My office in Queens, where the scripture is painted, is like my sanctuary. I have images of the pyramids, the stars, and these words:

Think,

plan,

envision,

dream,

manifest,

succeed,

conquer,

develop,

envelop.

Power brings peace, ignorance is a prison.

Those things are real to me. And I know that with a dream and a vision—and an opportunity—anything is possible.

Rap for me was an end in itself. My dream wasn't being famous or being rich, having a lot of women, cars, and things. My dream was simply having the freedom to express myself. Ain't that a trip? It's like Solomon asking for wisdom and gaining everything. I was focused on one thing—being heard. And I was.

People have to get beyond materialism. The toys, the cars, the clothes, and the jewelry get tired after a while. After they're gone, what do you have? You still have to look in the mirror every day. If you don't like what you see on the inside, all the money in the world won't make up for that.

Money doesn't make you happy. I was riding on a plane once coming back from a Las Vegas show with Michael Milken, Michael Jackson, and Quincy Jones. None of us were bouncing off the seats. I mean they are three of the most wealthy and powerful men in this country and they didn't look any happier than the guys hanging out on Farmer's. With wealth and success comes even more responsibility. And I accept that.

Happiness to me today is being with my family. And it feels good. There was a point when I couldn't focus on anything but my music. When I was doing an album, everything and every-body in my life suffered. Now I do what I can when I can, and I make time for my family. I don't juggle all the things in my life;

the music, the TV shows, the record label, the sneaker and boot business, the movie offers, the endorsement deals, the personal appearances, Camp Cool J, the charity events, and my family. I balance them. I make time for everything, but my family comes first. That's the natural order of things.

It may take me a while to plug back in after I've been away working. But in a couple of days, we're doing our routines—Benihana's, bedtimes stories, playing games, watching movies, lounging, the works. That's how I have fun now.

I've eliminated most of the toys that used to consume my life. I used to have 12 cars. Today I own only one, a Suburban. It's a family truck that I had customized with a television and VCR and stuff for the kids when we travel. I have three other cars, but they're leased. Instead of spending $80,000–$100,000 on a car, I can throw that money in an annuity for my kids. My mindset today is about looking out for my future and making better decisions about my life.

I just bought a house in the Carolinas, not too far from my cousin, Allison. I want to raise my kids in a calm environment, away from Hollywood and New York. I think the South has some of the values and the serenity, the peace that I need.

I'm always looking for peace nowadays. Some nights I like to unwind while taking a bubble bath and listening to Mozart or Bach. Or Simone and I will just talk quietly after the kids are asleep. I make time just for Simone. We try to take at least one vacation a year with just the two of us. Last year we rented a villa in Ocho Rios, Jamaica. We had practically a whole portion of the island to ourselves—with servants and the whole nine. On the way home, I rented a Lear jet so we could have some privacy. That was really relaxing.

I like to take some time for just me and God, too. I spend an hour before bed meditating and, of course, praying. And I also try to go to church on Sundays with my family. When I can't be there, I take spirituality with me on the road through

my reading and discussing different spiritual principles with my crew.

It's so funny when I think about church. By going to Catholic Mass most of my life, I felt so out of touch with that black church experience. Except for the one woman who used to catch the Holy Ghost at St. Bonaventure, I really had no connection to the Baptist church, or any of the other traditional black churches.

But Simone grew up as a Baptist, and she introduced me to it. The first time I went to a Baptist church in Los Angeles was a real culture shock for me. The tambourines, the singing, the shouting, the Holy Ghost was everywhere. My eyes just bugged out. Simone grew up in a church like that, but for me it was like, ''Whoa! What's happening here. This is church?'' Church was quiet, prayerful, and serene. Kneeling and praying and done in an hour. But then I started feeling it.

Since then, I've been to mosques, synagogues, and all kinds of other spiritual and religious institutions. And I've learned that God can be praised in so many ways. And it's all good.

Anyone who doesn't believe in God or his power only has to look around them and see God's work. There's a sun, there's a moon, there are stars. There's life. What is that? Make-believe? A dream?

Nah! It's the power of God.

A SNEAK PREVIEW

OF MY NEW ALBUM, PHENOMENON

FROM "FATHER"

I swear to tell the truth and nothing but the truth, so help me God

If your plane crashed in the water and everybody died
Would you drown on purpose or try to survive?
I was born handicapped, my arm wouldn't move
They called me a cripple, Pops caught a attitude.
Beat my moms, smoke "la," drove trucks
My moms had a miscarriage, he didn't give a f***
He sniffed some coke, come home
beat up on my moms 'cause she's talking on the phone
Come on.

All I ever wanted
all I ever needed
was a father
that's all

(repeat)

Moms got tired of the beatings, said, "Yo, we got to go."
Packed up the bags and we bounced out the do'
She ain't taking these whippings no more
I want to live to see my little Todd grow
I remember teardrops on my pop's face,
Lookin' down at me standing on the staircase.
Handsome brother with a smooth goatee,
Makes me wonder why he acts so ugly
You feelin' me?

All I ever wanted
all I ever needed
was a father
that's all

. . .

My head was spinning, I had never seen blood
Four years old, this don't feel like love
Anyway, pops disappeared
Grandpops and Moms healed up over the years
This therapist got up in her head
Led her to believe without him she'd be dead
You know, they fell in love with one another
Everything seemed right, that's word to Mother
Until I started getting beatings every day
Sometimes for going outside to play
Late at night, on my knees I pray
A young child, wishing the pain would go away
Dad, where was you when he made me strip
Beat me with belts like a slave, with a whip
Kicked me down steps, outside in the snow
Punched me in the chest, stomped me out on the floor
That's just the tip of the iceberg
Look, it's too long for a song, but perfect for a book

Word is bond. It's real baby!
(as above)

FROM "CANDY GIRL"

When you were 17 and I was 19
We fell deep in love, growing up in Queens
We didn't know a thing about love
We was innocent, sneaking on the doorstep to hug
Held you tightly and promised you the world
You gave me hickies and said you was my girl
When I think about it now, it makes me smile
'Cause I ain't felt these butterflies in a while
Funny, how you grow up and innocence fades
We used to live for love, but now we're afraid
Of the darkness and bitter memories
Lovers who crushed us through infidelity
I promised you I would love you to the end
Always and forever since way back when

You're like candy, the world's sweetest friend
you taste better now than you did back then
You'll be my candy girl forever
I'm down for whatever

. . .

When I'm alone in my room
Sometimes I stare at the wall
And in the back of my mind
I hear my memories call
For days when love was true, I slept and held you
I taste the brown sugar, let your climax melt you
Candy, you're occupying all of my thoughts
Turn my soul upside down with lessons you taught
I could feel you, even when you're far away, you're right
 here with me,
Sweet love strictly
And I'm a bend over backwards to keep you on my side
Take you for a mental and emotional ride
Make love to your soul, your heart, and your mind
In your hour of need, girl, I'll be there every time
And as long as you support my dreams
Stand right beside me as a part of my team
I'm a take you where the average man can only dream of
'Cause in a world so sour, I've got the sweetest love

You'll be my candy girl forever
I'm down for whatever
(repeat)

Sometimes, you gotta go back home. . . .

ACKNOWLEDGMENTS

First of all, I would like to thank the Creator.

Thanks to my editor, Greg Cohn, for his vision and for helping me articulate mine. Also to Karen Hunter, for helping me construct and formalize this book—you are, without a doubt, a sweetheart. As always, thank you, Charles Fisher, for helping me take it to the next level. Let's try to get there.

Special thanks to the folks at St. Martin's: John Sargent, Sally Richardson, Steve Cohen, John Cunningham, John Murphy, Jenny Dworkin, Steve Snider, Karen Gillis, Twisne Fan, Amelie Littell, Lisa Vecchione, Gretchen Achilles, Mike Curro, Kim Walker, the sales and rights folks, and everyone else who pulled out all the stops to help bring this to the world.

Thanks to Russell Simmons, Lyor Cohen, Rick Rubin, and all the people at Def Jam for putting LL Cool J on the rap map. Special thanks to Chris Lighty, Sean Combs, and all the producers who've worked with me on my albums over the years. Wait 'til we start on this label. To Mr. Quincy Jones for being my mentor and an example of how to conduct myself in this business, and also, along with David Salzman and Deborah Langford, for giving me an opportunity to have my own television show—and more. To UPN and NBC for having the courage to allow me to be me. To Daymond John and the FUBU crew for putting clothes on my back, and to Najee, my new sneaker and boot company, for putting shoes on my feet. To Jack Stahl, Greg Edwards, and the Coca-Cola staff, for believing in me. To Dr. Sebi and the Fig Tree staff for their health advice.

To the law firm of Jackson, Brown, Powel, St. George, the law firm of Rubin & Balin, Ortoli, Mayer, Baker & Fry, the law

firm of Davis & Gilbert, the law firm of Solovay Marshall &
Edlin, and the law firm of Hansen, Jacobson, Teller, Hoberman.

Thanks also to George Gilbert, Francois Mobasser, Lawrence
J. Studnicky III, David Benjamin, Ernest R. Booker, Jerry Adé
at Famous Artists, Phil Casey at ICM, and Jason Barrett.

Thanks to Jade Hill, Camp Vacamas and Mike Friedman, Con-
gressman Floyd Flake, Councilman Archie Spigner, Senator
Alton Waldon, Jr., Assemblyman Bill Scarsborough, Katherine
Wells and the N.Y. Board of Education. To Jamaica, August
Martin, and Andrew Jackson High Schools. To York College
and James Heyliger; to the Community Service Division of the
Department of Probation; to Richard Harris, Michael Leonard,
and Debra Grant-Wade; to Sandra Lewis Smith and D.O.C.; to
Victor Logan and the 103 Precinct; to Sony Publishing; to Leah
Wilcox, the NBA and the WNBA, Dr. Al Monsour, Al Osborne,
Luke Drual, G. William Hunter, Khemfoia T. Padu, D.C., Ph.D.,
HRH Prince Khalid, HRH Prince Alwaleed, President Chang,
and Bill McBride. To Lance Perry and Webadex; to Babyface,
Dr. Mark Johnson, Michael D. Casserly, Ted Mattox, and
Anthony Lee; to Eric Cronfeld, Alain Levy, and PDG. Thanks
to Frank Cooper, Mike Abbot, Sharon Nusbaum, Marianne
Romanno, Mike Hudson, Mwitu Ndugu, and Ermette Purce-
Williams.

Special thanks to Robert Meloni, Michael Hertz, Paul Mar-
shall, Bruce Jackson, and their respective teams, for their ad-
vice. Thanks also to Jeff Golenberg—keep it coming.

Thanks to all the radio programmers and deejays, music
video directors and programmers, MTV, BET, the Video Music
Box and all the local video channels. Thanks also to all the
publicists, booking agents, casting agents, and other people
who don't always get remembered.

Big thanks to all the folks at Ilion Books, Ilion Records,
Camp Cool J, and Starfish Management: Round, Chris, Dono-
van, Camara, KC, Aminah, Greg Fisher, Lisa St. Rose, Leland

Hardy, Kevin Glover, Tyoka Powell, Nicole Taylor, Kaymel Fisher, and Randolph Fisher.

To Cut Creator, for keeping it funky from day one. To the Farmer's Crew. To the entire hip hop nation, especially those who paved the way for me: Grandmaster Flash, Crash Crew, Treacherous 3, Afrika Bambaataa, the Sugar Hill Gang, Dynamic Breakers, Rock Steady Crew, Run-D.M.C., Fat Boys, Whodini, the Beastie Boys . . . and many more.

Most of all, I'd like to thank my family: my mother and grandmother, everyone who let me use their photos for this book, and especially, my wife, Simone, and my three children, Najee, Italia, and Samaria, for making sure home is always home.

And to Queens, U.S.A., and all the world: Love you all, baby!

—LL Cool J
New York
4/Ever

ABOUT THE AUTHORS

LL Cool J, born James Todd Smith, began rapping at the age of nine. He has won two Grammys and a host of other music awards for his recordings. Six of his albums have gone platinum or multiplatinum. His latest album, *Phenomenon,* is available on Def Jam Records.

An acclaimed actor with several movie credits, LL Cool J is also the star of *In the House,* a television sitcom on the UPN network that airs Monday nights at 8 p.m.

In addition, LL Cool J is a committed public servant who has been a spokesperson for Americorps, Rock the Vote, and numerous other charitable organizations. He is the founder of Camp Cool J, a youth leadership summer camp, and also the honorary chairman of Youth Enterprises.

In recent years, LL Cool J has been selected to represent such internationally known brands as Coca-Cola, FUBU, the Gap, and Major League Baseball.

A native of Queens, New York, LL Cool J divides his time between Los Angeles and New York. He lives with his wife, Simone, and his three children, Najee, Italia, and Samaria.

Karen Hunter, an award-winning journalist, is a member of the editorial board at the New York *Daily News,* where she covers education and writes an occasional pop culture column. She has interviewed many rap artists.

A resident of East Orange, New Jersey, Karen also teaches journalism at New York University.

**THE CAMP COOL J FOUNDATION AND
ILION BOOKS PRESENT:**

THE L FOR LITERACY ESSAY CONTEST

Win a $10,000 educational grant, a walk-on appearance on LL's TV show, or other valuable prizes!

To enter, all you have to do is write a one-page essay on why reading, writing, and graduating are important tools for success.

One winner will receive a $10,000 educational grant and a walk-on appearance on LL's television show, *In the House*. One second prize winner will receive a $1,000 educational grant. Ten runners-up will win LL Cool J's new album, *Phenomenon*, assorted FUBU and Najee apparel, and other prizes.

OFFICIAL CONTEST RULES:

1. No purchase necessary. To enter, you must be a full-time student, age 5 to 18 years, who is a U.S. resident. To enter, type or handwrite an original essay, no more than one page ($8^{1}/_{2}'' \times 11''$) in length, that describes "Why reading, writing, and graduating are important tools for success." On the essay, write your name, address, and daytime telephone number. Send your entry to: Entry, L For Literacy Contest, c/o Ilion Books, Inc. 164-11 89th Avenue, Suite 154, Jamaica, N.Y. 11432. One entry per person. All entries must be written in English. All entries must be received by January 5, 1998. For a copy of the official rules, send a self-addressed, stamped envelope to: Official Rules, L For Literacy Contest, c/o Ilion Books, Inc. 164-11 89th Avenue, Suite 154, Jamaica, NY 11432.

2. Judging of entries will take place after January 5, 1998, and will be completed by January 20, 1998. Entries will be judged on the basis of creativity, originality, and appropriateness to theme, with equal weight being given to each criteria. The judges will be qualified to apply the above standards to the entries in determining the winners. All decisions of the judges shall be final. The top 100 entries, as determined by the judges, will be finalists. Prize winners will be selected at random by LL Cool J from among the finalists. Winners will be notified by mail and

may be announced on LL Cool J's television show on UPN, *In the House.* Odds of winning in the random drawing are 1:100.

3. Prizes: one first prize—$10,000 educational grant, plus a walk-on appearance on LL's television show, UPN's *In the House,* (retail value $10,000); two second prizes—$1,000 educational grant (retail value $1,000); ten third prizes—LL Cool J's new album, assorted FUBU clothing, Najee footwear, and two LL Cool J concert tickets, at a time and date selected by sponsor (approximate retail value: $200 each). Grants will be made in four equal annual payments.

4. No transfer or substitution of prizes, except by sponsor due to prize unavailability (including final editing of broadcast programming), in which case a prize of equal value will be awarded. All taxes on prizes are the responsibility of the winners. Prizes won by a minor will be awarded to the minor's parent or legal guardian.

5. In the event that fewer than 100 entries are received that meet the minimum standards established by the judges to be a finalist, the actual number of entries that meet the minimum standards will be the finalists. Each winner will be required to sign and return an Affidavit of Eligibility and Liability/Publicity Release within fifteen (15) days of notification attempt. Failure to comply within that time period will result in forfeiture of the prize and selection of an alternate winner. By accepting prizes, winner grants to sponsor the right to use the winner's name, likeness, and entry for purposes of advertising, promotion, and other commercial purposes without further permission or additional compensation except where prohibited by law.

6. All entries, and any copyrights therein, become the sole property of Sponsor and will not be returned. By entering, entrants agree to abide by these rules, warrant and represent that their entry is their original work, and grant to Sponsor the right to edit, adapt, publish, promote, and otherwise use their entries (including their names and hometowns) without notice or compensation for any purpose whatsoever. Sponsor shall be under no obligation to use any entries submitted.

7. Employees and their families of Camp Cool J Foundation, Ilion Books, St. Martin's Press, and their affiliates and agencies are not eligible. Void where prohibited.

8. For the names of the winners (available after January 31, 1998), send a self-addressed, stamped envelope to Winner's List, L For Literacy Contest, c/o Ilion Books, Inc., 164-11 89th Avenue, Suite 154, Jamaica, NY 11432.

The L For Literacy Contest is sponsored by the Camp Cool J Foundation and Ilion Books, who are solely responsible for the contest and its administration, and is co-sponsored by Def Jam Records, FUBU, and Najee.

Don't forget to check out the LL Cool J Web site at:

www.starplanet.com

Also check out the Def Jam Web site at:

www.defjam.com

With the purchase of this book, you are eligible for free membership in the Cool to Read Book Club.

To join, please send proof of purchase and a self-addressed, stamped envelope to:

Cool to Read Book Club
c/o Camp Cool J Foundation
164-11 89th Avenue
Suite 154
Jamaica, NY 11432